THE ORIGINS OF WESTERN ART

ANN POWELL

THE ORIGINS OF WESTERN ART

with 213 illustrations

THE ARTS BOOK CLUB
READERS UNION GROUP

For my parents

THIS EDITION PUBLISHED 1973 BY READERS UNION BY
ARRANGEMENT WITH THAMES AND HUDSON LIMITED

FILMSET BY KEYSPOOLS LTD, GOLBORNE, LANCASHIRE
PRINTED AND BOUND BY TOPPAN PRINTING LTD, TOKYO

0 500 62007 5 CLOTHBOUND
0 500 63007 0 PAPERBOUND

CONTENTS

NOTE
Measurements are given in feet and inches, with
centimetres in brackets. Height precedes width.

Although animals can produce patterns, only human beings have the intelligence to create recognizable images. This is a new and important element in art which first appeared about thirty thousand years ago when modern man settled in Europe during the Ice Age. The climate was hostile but food was plentiful and man survived by hunting the great game animals which grazed on the treeless tundra. Palaeolithic hunters shaped figures and painted cave walls, representing what was most important in their lives; women who bore their children, ensuring the survival of the tribe, men and the animals they hunted. There is an almost magical quality in the accuracy of their representations, as if they were trying to recreate the living being with all its power within their images. Although this was the first phase of representational art, it is of outstanding quality.

The society which created this art collapsed when food became scarce after the climate of Europe became warmer at the end of the Ice Age, forcing the great game animals north. But this change of climate encouraged men living in south-western Asia to cultivate the native edible grasses and to domesticate sheep and goats. They lived in settled communities, close to the land they cultivated, and gradually the art of architecture was developed by these farmers who built homes for themselves and their gods.

The Neolithic farmers decorated their buildings with paintings and shaped figurines of men, women and farm animals. Although the themes are similar to those of Palaeolithic art, no connecting link has been found and they are separated by thousands of years and miles. Moreover the style is very different; art is still representational, but the artist was less interested in the accuracy of his image than in the pattern it created.

The farmers in Iran and Mesopotamia used patterns to express ideas and eventually invented the art of writing.

7

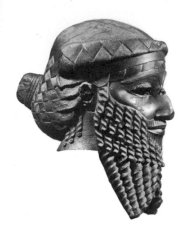

1 *Head of an Akkadian king, prob-ably Sargon (2371–2316 BC). Bronze 11¾" (29.8). Iraq Museum, Baghdad*

They experimented with fire, discovering first the art of pottery and then metal working. These discoveries prepared the way for the great Bronze Age civilizations in Mesopotamia, Egypt and Asia Minor, which profoundly influenced the culture of Europe. The arts of agriculture, pottery, metal working and writing were introduced into Europe from this region in the eastern Mediterranean. Our system of counting minutes and seconds in sixties and our alphabet show our debt to these ancient civilizations.

During the Bronze Age the small farming com-munities in Mesopotamia and Egypt were joined together into vast empires ruled by semi-divine kings living in richly decorated palaces (*Ill. 1*). The kings used the immense wealth of their empires to finance grandiose building projects which included temples for their gods and tombs to insure their own immortality. This opulent display of wealth was copied in Greece in the second millennium where first the kings of Crete and then the kings of Mycenae ruled like oriental monarchs.

But the whole of the eastern Mediterranean was disrupted by invasions and migrations at the end of the second millennium and the Bronze Age ended in Greece with the Dorian invasion. Although speaking a Greek dialect related to the language of Mycenaean Greece, the Dorian invaders were completely out of touch with Mediterranean civilization, and the Mycenaean civiliz-ation collapsed into a dark age without written records. The only art to continue was pottery.

Mesopotamia and Egypt were not so severely affected by these invasions and their Bronze Age civilizations survived relatively unchanged. The rulers of Mesopotamia still lived in vast palaces decorated with relief sculpture in stone and stone temples were being built in Egypt. These buildings must have appeared overwhelmingly magnifi-cent to the first Greek traders who ventured into foreign parts after the revival of trade in the 9th century BC, for the only buildings they knew at home were constructed out of mudbrick and wood. Eventually, with the growing prosperity of Greece in the 7th century BC, oriental techniques of stone construction, stone sculpture and bronze hollow casting were introduced into the rich Greek trading cities and began an artistic movement culminating in classical art.

There is a new element in classical Greek art of the 5th century BC which distinguishes it from that of the

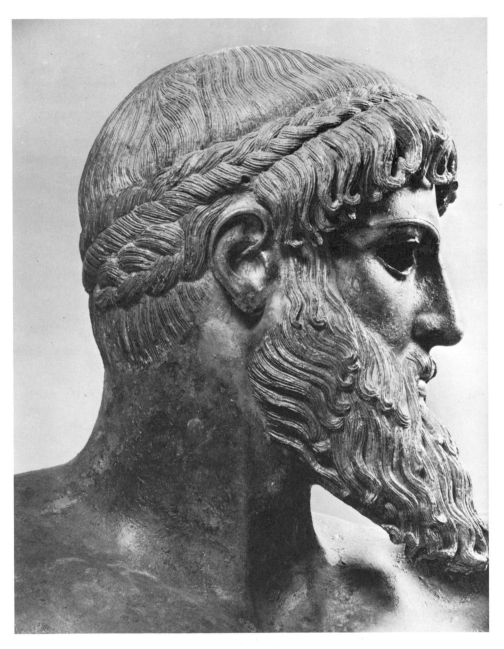

2 Head of a Greek god, probably Poseidon, from the Artemision wreck, c. 460 BC. Bronze. Height of whole statue 6′ 10¼″ (208.6). National Museum, Athens (see Ill. 114)

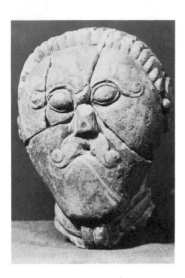

3 Head of a Celtic deity from Mšecké-Žehrovice, Central Bohemia, Middle La Tène period (2nd century BC). Limestone 9½" (25.4). National Museum, Prague

Bronze Age. Although Bronze Age art is naturalistic, it formed part of the elaborate ritual of palace life and religion. Certain fixed rules had to be obeyed when representing deities, rulers and high officials who had to be distinguished from ordinary human beings. The Athenian artist, living in an independent city state governed democratically by his fellow citizens, under the patronage of a goddess, recognized no such distinction between men and gods. Although he believed the Olympian gods to be superhuman, he represented them in human form (*Ill. 2*), their bodies controlled by the same bones and muscles found in ordinary human beings who had reached the peak of physical perfection after years of athletic training. The gods were represented as ideal types of humanity.

Greek art became increasingly naturalistic with its growing understanding of human anatomy so that artists abandoned the Egyptian conventions of pose and proportion. Its subject was not the individual human being but what was permanent and unchanging in the infinite variety of humanity. Perfectly formed bodies tend to conform to certain fixed proportions and the Greeks discovered that these simple numerical relationships were equally beautiful whether applied to the human figure or a temple.

Classical Greek art became a European style because it was inherited by the Romans who transmitted it throughout their empire. But the Romans had developed their own style of art which was interested in the individual and not in formal analysis. Moreover, the Roman empire contained many different nations, not least the Celts who had their own extremely abstracted art which distorted representations into complex curvilinear patterns (*Ill. 3*). As a result, the art of the later Roman empire is intrinsically different from that of Greece.

This change of style heralding medieval art became very noticeable after the division of the Roman empire by Diocletian and the acceptance of Christianity by Constantine. The eastwards shift of power to the new capital Constantinople, and the triumph of the new oriental religion, Christianity, entirely reorganized the ancient world. The Emperor was regarded as the earthly regent of Christ, the ruler of the Universe. Elaborate palace and church ceremonies were evolved out of the ritual of an oriental monarch. Artists were no longer

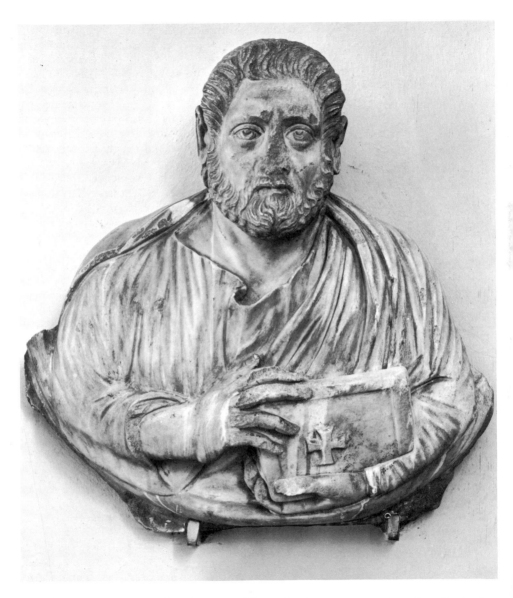

interested in representing what the eye could see, nor in what could be understood rationally, but in creating symbolic images expressing the complex spiritual hierarchy of the universe.

But the classical style never completely died, and our epilogue traces its survival (*Ill. 4*).

4 *Bust of an Evangelist found at Fatih, Constantinople, late 4th or early 5th century* AD. *Marble 27"* (*68.6*). *Archaeological Museum, Istanbul*

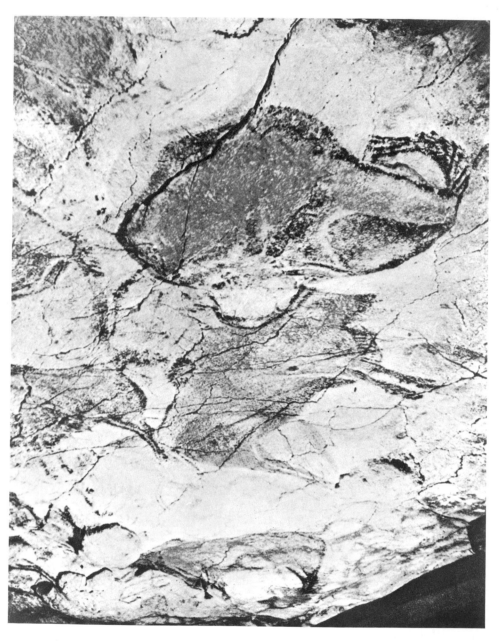

5 *Bison on the roof of the cave at Altamira, Magdalenian period (c. 15,000–9000 BC)*

The art of Ice Age Europe c. 30,000–10,000 BC

The discovery in 1879 of the bison painted on the roof of the cavern at Altamira in northern Spain (map p. 215) revealed the astonishing fact that 'modern' man had been an artist from the earliest phase of his existence, when the only tools he possessed were made of stone (*Ill. 5*). The paintings were no simple scratchings, but superb decorations in colour which expressed the noble dignity of the great beasts which roamed the valleys of south/western Europe, sheltered from the arctic winds of the last Ice Age. This was a hostile environment, yet one in which man thrived, expressing his awe at the bounty of nature by decorating deep cave sanctuaries with images of animals.

Man slowly evolved during the Pleistocene period, which began over two million years ago. There were four major periods of glaciation, and modern man, *homo sapiens sapiens*, appeared in western Europe during the last of the 'Ice Ages', about thirty thousand years ago. He was the last stage of an evolutionary development which began when one branch of the anthropoid apes left the shelter of the forests and eventually adopted an upright stance that freed their hands for using tools. At first these tools were nothing more than sticks and stones which they happened to pick up, but the tools became more efficient and could even be used as formidable weapons when these early pre/men learnt how to chip stones into sharp cutting edges. The Pithecanthropus group of pre/men, who lived 500,000 years ago, had already learnt the use of fire and so could begin to control their environment.

The tools manufactured by these early groups of pre/men exhibit a growing appreciation of form for its own sake as well as for utility. This aesthetic sense is not unique to human beings and recent work on animal behaviour has shown that animals tend to prefer patterns which are regular and symmetrical. But as human beings

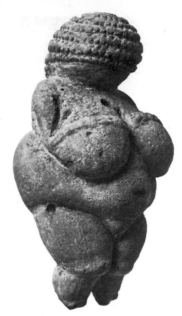

6 'Venus' of Willendorf, Gravettian period (c. 27,000–25,000 BC). Limestone with traces of red colouring, 4½" (11.4). Naturhistorisches Museum, Vienna

7 Woman with a cornucopia from Laussel, Gravettian period (c. 19,000 BC). Limestone with traces of red colouring 17½" (44.4). Musée d'Aquitaine, Bordeaux

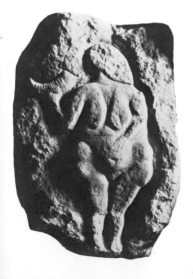

developed so did their hand axes, and more and more care was taken in shaping them.

This developing aesthetic sense is seen in the hand axes of the first real human beings, the species called Neanderthal man (*homo sapiens neanderthalensis*) after a valley in Germany where his bones were first discovered. He occupied large areas of the earth for about 150,000 years until ousted by *homo sapiens sapiens* about 30,000 BC. Neanderthal man had a very large brain, in some cases even larger than that of modern man, and he was the first being to have an awareness of death. He buried his dead with ritual, covering the body with red ochre and even placing stone tools, food and flowers within the grave, as if to prepare for an after-life. There is evidence of some form of religion; he created shrines for the bones of the cave bear he hunted, and a skull has been discovered in Italy, surrounded by a ring of stones, which may have been an object of worship. And yet, although he had this growing spiritual awareness and sense of pattern, he left no traces of representational art.

The first representational artist was *homo sapiens sapiens*, who appeared only in the Upper Palaeolithic period, when most of northern Europe was covered with the ice of the last period of glaciation. The Upper Palaeolithic is divided into four main cultural periods, identified by the types of tools manufactured and named after the sites where the remains were first discovered. The Aurignacian period began c. 30,000 BC when modern man first reached western Europe and settled in the sheltered valleys of south-western France and northern Spain. It was succeeded by the Gravettian (sometimes known as the Upper Aurignacian or Perigordian) period, which began c. 27,000 BC and lasted until about 18,000 BC. A number of small figurines were carved and modelled in this period. The Solutrean culture first appeared about 20,000 BC and was followed by the Magdalenian about 15,000 BC. The Magdalenian was the last stage of Palaeolithic culture and was the period of the major cave paintings; it ended in north-western Europe about 8500 BC. These dates are very approximate and vary from region to region.

The earliest representational works of art were small-scale carvings and models of men, women and animals. The most popular theme (as far as one can judge from surviving evidence) appears to have been a woman so fat

that she seems pregnant. The 'Venus' of Willendorf
(*Ill. 6*) was discovered in Lower Austria – a tiny figure
only $4\frac{1}{4}$ inches tall, shaped out of limestone. Her face is
featureless and she hangs her head over her ample breasts
which are pressed down by her arms as if to emphasize
their fullness. She radiates a sense of calm contentment
and seems to be more than a mere representation of a fat
woman, since she expresses fertility and prosperity in every
curve of her body.

We do not know what the subject of this work is. She is
called 'Venus' because of her nudity and also the pose
with hands on her breasts is similar to that of Phoenician
and Greek statues of this goddess. But without a written
inscription we do not know whether she is a goddess or
the woman who was most important to the artist, the
mother of his children who would ensure the survival of
his tribe. There are many complex reasons for represen-
tation, not least the simple pleasure of creating a likeness.

Unlike the earlier Gravettian sculpture, that of the
Magdalenian period tended to be used to decorate tools,
particularly by representing animals. There is a new
interest in relating one form to another so that the
functional form of the tool is enhanced by the animal
carving on it. A superb example is a ceremonial spear-
thrower from Bruniquel (*Ill. 8*) carved out of a reindeer
antler. The natural shape of the antler has been exploited
not only to create the tool, but also to suggest the profile
of a horse as it leaps into action, hindlegs straightened,
forelegs tucked into the body and head outstretched.
Though the form fits the shape of the tool so well, the
carving also shows brilliant powers of observation: a
momentary attitude has been caught and even the shaggy
texture of the animal's coat depicted.

To a certain extent, stone sculpture was used to decorate
habitation sites and the mouths of caves. Although
small-scale sculpture has been found all over Europe,
decorated caves are mostly situated in south-western
France and northern Spain. There, the climate would
have been little worse than present-day Scotland, for the
mountains of central France gave protection against the
icy arctic winds. Hunters lived in rock shelters which
they sometimes decorated with relief sculpture. At
Laussel a vast ledge over 370 feet long, facing south,
formed an open-air esplanade, fenced by blocks which
had fallen from a caved-in vault. Five of these blocks

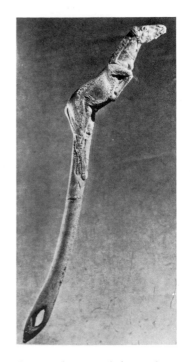

*8 Spear-thrower with leaping horse
from Bruniquel, Magdalenian III or
IV (c. 12,000 BC). Bone 12¾"
(32.4). Bétirac Collection, Mont-
auban*

15

were decorated with reliefs of human figures, each about 18 inches high. The best preserved is an obese woman holding a horn in her raised right arm, the prehistoric prototype of the cornucopia, the horn of plenty (*Ill. 7*). The relief shows that even before the invention of agriculture, horned animals were associated with prosperity.

In contrast to these habitation sites on the surface, there were deep caverns which penetrated far beneath the earth into complete darkness. Although habitation debris is only found within the reach of daylight, many of these dark caverns were decorated with painted and engraved figures. We can only speculate why men explored the darkness beneath the earth and chose to paint there by the smoky light of a guttering torch, but their motives were probably religious, tinged with belief in powerful magic.

The cave paintings are much more difficult to date than the sculpture because they are found in caves without occupation debris and so cannot be dated stratigraphically. Style is inconclusive for caves were painted over too long a period, at least seven thousand years until the end of the Magdalenian period, and possibly for twenty thousand years throughout Upper Palaeolithic times. In ten or twenty millennia there is time for many artistic movements to be born and to die, and paintings which appear crude and primitive need not necessarily be earlier than more accomplished work. But the tendency now is to place most of the major cave paintings in the last five millennia of the Palaeolithic period and carbon from Lascaux has been dated by radio-carbon methods to *c*. 13,000 BC.

Lascaux (*Ill. 9*) was discovered in 1940 in an almost perfect state of preservation, the original entrance having been blocked since the Palaeolithic period. The paintings are particularly spectacular, for the upper part of the cavern is covered with a dazzling white coat of calcite crystals which intensifies the colour of the paintings. Almost the entire cave is decorated with paintings and engravings, but the most important chamber is the large central cavern, called the Great Hall of the Bulls (3) where four great black bulls, the largest 18 feet long, form part of a frieze of animals (*Ill. 11*). On the far left a strange, pot-bellied, spotted beast, known for some reason as the 'Unicorn' (though two distinct horns project from his head), surveys the group of small red and black horses which gallop in front of him before the first great bull. He is confronted by the stately procession of the three other

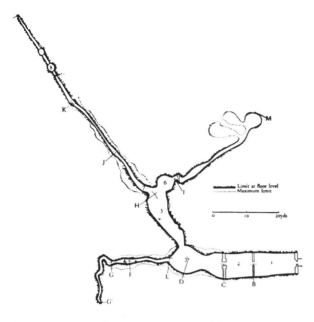

9 *Plan of Lascaux. From Annette Laming,* Lascaux Paintings and Engravings, *1959*

bulls which have been painted in firm black outline over earlier figures of stags and red cows.

The Painted Gallery (4) is a narrower continuation of the Great Hall, elaborately decorated with friezes of animals on both walls. Another passage (5) from the Great Hall leads to the Main Gallery (7), where a cornice formed by the junction of two different types of rock in the cavern is above arm-height. Most of the animals are painted or engraved above the cornice and a frieze of deer heads has been placed so that the animals seem to be swimming in water indicated by the rocky ledge. In order to reach above this cornice the artist may have had to construct some form of scaffolding, or he may have perched on the shoulders of a companion. The only paintings below the cornice are towards the end of the gallery, before it becomes almost impassable, where two bison are charging in opposite directions, the embodiment of natural energy.

The Main Gallery ends in a tunnel so low that one has to crawl along it on hands and knees, though it broadens out eventually into a succession of small irregular alcoves, decorated with a medley of painted and engraved animals, including six or seven roughly scratched felines which give their name to this chamber. The Chamber of Felines

17

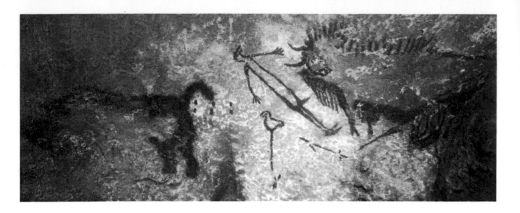

10 *A man wearing a bird mask menaced by a wounded bison, Lascaux. Early Magdalenian (c. 13,000 BC)*

(8) must have always been difficult to enter, yet the wealth of engravings within it show that it must have been frequently visited. Perhaps it was regarded as one of the most sacred places in the cavern because the tunnel continues beyond, and to the right is a narrow cleft where the floor ends suddenly in a steep drop down to the lower level of the cavern.

There is a similar profusion of engravings in the chamber which gives access to the Shaft of the Dead Man (9), another deep pit down to the lower level of the cave. At first sight the 'Chamber of Engravings' (6) seems to end in a *cul-de-sac* and is one of the least impressive parts of the cave, for the walls have been covered up to the vault with a miscellany of engraved figures superimposed on earlier paintings. At the far end a highly polished stone forms a kind of lip into a deep pit, and the domed vault over it is thickly engraved with animals and signs, no mean feat over a 16-foot-deep shaft. At the bottom of the shaft, accessibly only by means of a rope, is a painted panel over 6 feet long which represents a wounded bison menacing a bird-headed man who is prostrate before him, with a bird-headed staff lying on the ground (*Ill. 10*). A rhinoceros, painted in a completely different style, and hence perhaps not part of this scene, turns his back on the group.

The paintings of the great bulls from the Hall at Lascaux (*Ill. 11*), in which the essential nature and appearance of the animals are expressed in simple outline and areas of colour, illustrate the immediate appeal of Palaeolithic art. It is intensely naturalistic and the artist captures, seemingly without effort, the form, movement and feeling of the animals in a few keenly observed lines and washes of colour. There is even a rudimentary sense

of composition in the arrangement of the bulls as a procession, and the images are not flat but suggest volume and depth. But there was no interest in illusionistic space so landscape was ignored and most of the animals were painted as isolated images.

There is no obvious explanation why the caves were painted. This procession of bulls seems to have been painted with the aim of pleasing the eye of the artist, but decorations in other parts of the cave are almost invisible. They are in inaccessible places or have been superimposed one on top of another so as to be almost indecipherable. Certain parts of the cave, especially those leading to the lower levels, seemed to need frequent redecoration without regard for ultimate appearance, pointing to the possibility that it was the act of creation of the image, not its appearance, which was all-important. Not all the images are representational; there are a number of mysterious signs in the galleries, rectangular grids and feathered lines which defy interpretation and are perhaps magical symbols.

Although the main subject of cave art was the animals hunted by Palaeolithic man, no importance was given at Lascaux to the reindeer, his staple diet which provided food, clothing, tools and weapons. There is only one reindeer represented in the cave compared with over one hundred horses, thirty aurochs, twenty deer, ten ibex, seven bison, six or seven felines, one bear, one musk ox,

11 Detail of the frieze of animals from the Great Hall of the Bulls, Lascaux. Early Magdalenian (c. 13,000 BC)

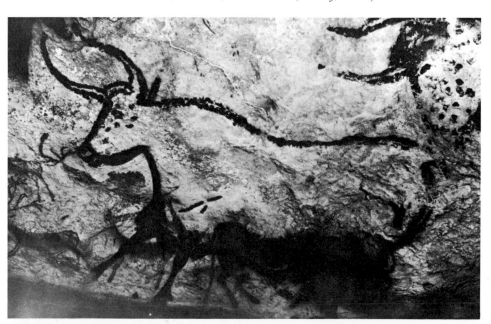

and an imaginary animal called the 'Unicorn'. Indeed, the reindeer is rarely represented in cave art and the major theme of decoration is a central panel of aurochs or bison linked together with horses. These animals were much less important than the reindeer in the diet of Palaeolithic man yet they are the major theme of cave art. To a certain extent the paintings may have been inspired by hunting magic, but it was not the sole reason for decorating the caves.

Human figures were represented within the deep caverns, although in comparison to representations of animals their numbers are small. At Lascaux there is a startling difference in style between the naturalism of the animals and the stiff figure with matchstick arms and legs painted in the Shaft of the Dead Man (*Ill. 10*). One interpretation of this painting is that the man was a *shaman*, who obtained some of his magical powers from animals but was defeated by superior animal magic, represented by the bison.

No simple explanation can be given for the cave paintings of Lascaux. They seem to have been related to the religious beliefs of the Palaeolithic hunters; but we know almost nothing about their religion except that it must have been complex, and we cannot be certain that it involved rituals which required representational images. Yet the paintings of Lascaux express a belief in the power of animals, and the aurochs and bison seem to be the embodiment of natural energy. By creating images of these animals, the hunters seem to express their admiration for this power, and they may have felt that they were gaining access to it, perhaps even controlling it.

Palaeolithic art is deeply mysterious. It appeared with modern man in western Europe and died out with the end of the Ice Age apparently leaving no heritage. Although we do not even understand its meaning, the vivid naturalism of the carving and paintings appeal immediately to the modern eye.

Agriculture and the Near East c. **9000–2000** BC

Periods of civilization are often named after the materials from which their tools were manufactured: hence the Stone Age, the Bronze Age and the Iron Age. But this classification is too simple for the first period of human civilization: many types of society existed, all using stone tools, before the development of metal working in the fifth millennium and the beginning of the Bronze Age. The Stone Age has therefore been divided into two periods, Old and New, Palaeolithic and Neolithic, separated by the change of climate, about ten thousand years ago, which marked the end of the Pleistocene and the beginning of the Holocene, or recent period of geological time. Palaeolithic societies depended entirely on hunting for their food. But as the climate became warmer at the end of the last Ice Age, societies developed which domesticated animals and cultivated crops. During the Neolithic period men became farmers.

There was an intermediate stage in European civilization after the end of the Ice Age but before the introduction of agriculture. In this Mesolithic period, men continued to live in caves; but the great oxen, reindeer and wild horses had moved further north so the hunting was for smaller game caught with the help of dogs. Fishing became important, and the fishhook and net were invented. The rock shelters, especially in southeastern Spain, were still decorated with paintings, but their subject and style were completely different from those of the Palaeolithic caves. The paintings were schematic representations of man and his society, dancing, hunting and fighting.

Agriculture was not a European discovery but was introduced from southwestern Asia where sheep and goats are still found in a wild state. The change of climate at the end of the Ice Age affected the whole Mediterranean basin, which had been thickly forested. As the temperature

rose, the forests receded and gave way to grasslands. These were ideal hunting conditions and whole herds were captured, corralled and allowed to breed. Excavations at Zawi Chemi Shanidar, in northern Iraq, show that the earliest inhabitants hunted mainly the wild goat. But a settlement developed *c*. 9000 BC which depended on large quantities of sheep, more than half of them yearlings – presumably kept in captivity and then killed for food and skins. The sheep was probably the first domestic animal.

The cultivation of cereals perhaps goes back to the Ice Age in Egypt. It reached Palestine in the ninth millennium where the Natufians, who lived in cave shelters on Mount Carmel and hunted gazelle, used flint-bladed reaping knives (*c*. 8850 BC). The wild ancestors of our cultivated wheat and barley occur naturally in this region and the edible seeds were gathered and eaten, though some were reserved for sowing the next year.

With the development of agriculture, people began to live in communities which grew into fortified towns. The development of farming had made land a precious possession which needed guarding. Among the oldest known towns is Jericho, which began as a sanctuary built by Mesolithic hunters beside a never-failing spring about 7800 BC. A thousand years later it had grown from a settlement into a town covering ten acres and surrounded by massive defence walls with towers 30 feet high. In spite of its size and the obvious complexity of its civilization, this town was without writing or pottery.

After the astonishing naturalism of Palaeolithic art, Neolithic art seems disappointingly crude. But the subject matter of art was being extended and the inhabitants of this town came close to achieving the art of portraiture. This seems to have been developed from the cult of the dead. A group of heads, discovered beneath the floor of one of the houses, had been buried separately from the bodies (*Ill.* 12). Their features had been naturalistically modelled in plaster on the skull, and one one of the restored faces there are indications in paint of a moustache. The word 'portrait' is used deliberately for these plastered skulls because in each an attempt was made to restore the individual features of the dead man, who was probably a revered ancestor.

Agriculture spread rapidly into Anatolia, and the town of Çatal Hüyük was growing barley by 6500 BC,

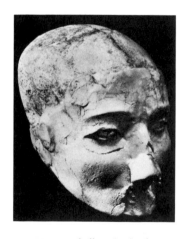

12 Human skull with the features modelled in plaster and eyes inlaid with cowrie shell from Jericho, 7th millennium BC. Amman Museum

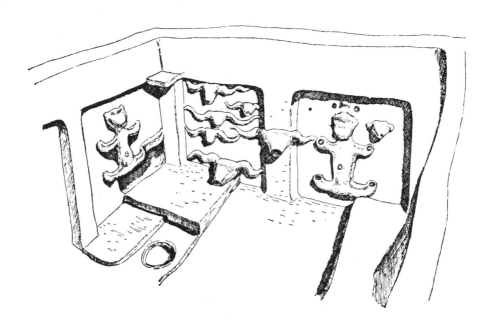

the earliest excavated level. This is the largest known Neolithic town, four times the size of pre-pottery Jericho. The houses were built of mud-brick and entered by means of a ladder through an opening in the flat roof. The furniture was built in; an oval oven and a storage recess were set into the south wall, and along the other three walls were raised platforms which could be used as couches, though buried beneath them were the bones of the previous owners.

Shrines were built on the same plan as the houses, with sleeping platforms and ancestors buried underneath, but they are distinguished by their elaborate decorations. They seem to have been dedicated to a Mother Goddess who was always represented in plaster relief, sometimes with her legs raised in the birth-giving attitude and sometimes accompanied by her daughter (*Ill. 13*). She was mistress of both life and death, for not only the bull and the other great horned animals were sacred to her, but also the vulture who stripped the flesh from the dead bodies. (In one shrine two breasts, modelled in plaster, concealed vultures' beaks as nipples). She was also mistress of the animals; a statuette represents her seated on a throne supported by leopards as she gives birth to her son. Since the harvests were under her control, her statuette was

13 Reconstruction of Shrine VI, 31, Çatal Hüyük, c. 6200

23

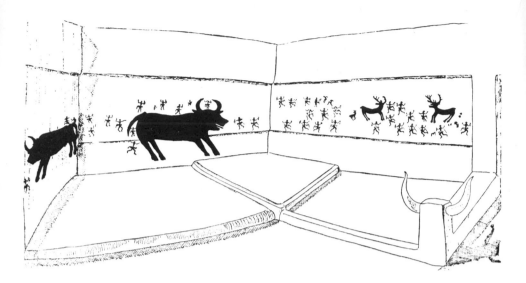

14 Reconstruction of Shrine A III, 1, Çatal Hüyük, decorated with a wall painting of a red bull and stag hunt, c. 5750 BC. Restoration by James Mellaart

placed in the grain bin to bring greater prosperity. Perhaps she was associated with the new technology, for the oldest known textiles have been discovered at Çatal Hüyük, and fabric designs still used today in Turkish carpets decorated her shrines.

Hunting was an important part of the economy of Çatal Hüyük, for the Konya plain on which it lies was once a parkland rich in red deer and wild cattle, and the wild bull is one of the most important themes in the decoration of the shrines (*Ill. 14*). It was represented in paint as part of a hunting scene and the head was modelled in plaster. The horn cores were incorporated into plaster benches and pillars as primitive *bucrania*. This cult of the wild bull is so similar to that of the painted Palaeolithic caves of south-western France that one wonders whether there can be any connection. But they are separated by more than a thousand miles and several thousand years and so far nothing has been found to link them.

The invention of pottery was one of the most important achievements of the Neolithic period. Its use began in the seventh millennium (long after the introduction of agriculture) and these early pots were built up in successive rings out of spiral coils which were scraped smooth and often burnished with a pebble. The earliest known painted decorations have been found in Cilicia, in south-western Turkey, where the pottery was covered in cream slip and motifs painted in red clay. An ovoid

24

two-handled jar from Hacilar (*c.* 5500 BC), has red circles around the handles which frame a schematically painted woman with huge breasts (*Ill. 15*).

The whole art of vase painting in the ancient world developed from these humble beginnings, culminating in the black and red figure pottery of classical Greece. Unlike later pottery, no coloured glazes were used and the decorations were painted in thin washes of red and white clay. The high gloss of Greek pottery was achieved solely by using very pure materials and the different shades of red and black were produced by controlling the amount of oxygen in the atmosphere of the kiln.

The decorations of the jar from Hacilar are very abstract. The figure of the woman (or goddess) is barely recognizable; it has been reduced to an arrow-shaped design which satisfyingly fills the shape of the pot. This is characteristic of much Neolithic art where figures and animals were simplified into decorative patterns. This was partly because the new crafts of house building, weaving and pottery demanded decoration. But the essence of pattern-making is a rhythmic repetition of a simple motif. This interest in rhythm and repetition perhaps reflects one of the great discoveries of the Neolithic period, one on which the whole of agriculture is based – that there is a pattern behind life which regulates the seasonal changes and governs the cycles of life and death.

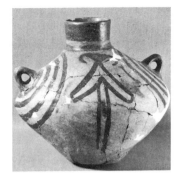

15 Vase with painted female figure from Hacilar, c. 5500 BC. Pottery 5½″ (14). Ankara Museum

THE BRONZE AGE

The development of pottery is closely related to the art of metallurgy, since both depend on the complete alteration of the properties of a substance by the application of heat. Firing a pot brings about an irreversible change from fragile clay to durable ceramic. Metals were known as a valuable rarity in the Neolithic period; cold-worked copper and lead beads of the seventh millennium have been found at Çatal Hüyük. But the art of working hot metal was probably first discovered in northern Mesopotamia in the fifth millennium, close to a region where there are copper ores. Copper is one of the easiest metals to extract from its ore because it requires a relatively low temperature. It was soon discovered that its quality was greatly improved by the addition of up to ten per cent tin to form the alloy bronze, which has an even lower

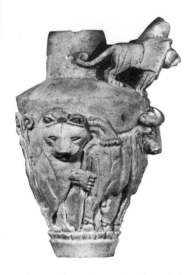

16 *Ritual jug decorated with a relief of a bull attacked by lions from the precinct of the E-Anna temple, Uruk (Warka), late fourth millennium. Limestone 8" (20.3). Iraq Museum, Baghdad*

melting point and produces better casts because it absorbs less gas when molten. In addition, bronze, unlike copper becomes harder and capable of forming a sharp cutting edge for an axe or a sword when hammered cold.

Once the valuable properties of copper had been discovered, the art of metal working was developed in countries far from the sources of the ore, first in Mesopotamia and then soon afterwards in Egypt. This was possible because long-distance trade was well established in articles such as obsidian, and the rapid development of society after the fourth millennium was partially due to the enterprise of merchants seeking new sources of copper and tin ore.

With the development of trade some form of permanent record became essential. Stamp seals had been used as early as the fifth millennium in Mesopotamia to record property. Although large Neolithic towns, such as Jericho and Çatal Hüyük, had existed without written records the new bureaucratic kingdoms of the Bronze Age were far more complex in structure. Armies equipped with bronze weapons gave them the power to control vast empires which were forced to pay taxes, and it was partly the invention of writing which made possible organization on such a scale.

Writing developed simultaneously in Persia and Mesopotamia in the middle of the fourth millennium. On a vase (*Ill. 17*) from Uruk, an important town in the southern reaches of the Euphrates, the goddess Inanna is identified by her pictograph, a curiously knotted bundle of reeds. The representation of the reeds was reduced to an abstract symbol which eventually was used to express not an idea but a sound. This discovery was soon copied by the Egyptians: the palette of King Narmer (*Ills 20, 21*) is one of the first documents in the written history of Egypt, commemorating the union of the northern and southern kingdoms by the victory of the southern king.

SUMERIAN ART

Mesopotamia (map 2, p. 216), the fertile valley between the Tigris and Euphrates, bounded to the north-west by the Taurus mountains and the highlands of Armenia, to the east by the Zagros mountains and to the west by the Syrian-Arabian desert, had long been important in human culture. It had been inhabited since the Palaeo-

lithic age and the two mountainous areas had been among the sites of the initial stages of the Neolithic revolution. The art of extracting copper from its ore and working the hot metal was developed in the north as early as the fifth millennium BC.

Although the north had been more important, the Sumerian civilization developed in the fertile land of southern Mesopotamia where the great alluvial plain between the Tigris and the Euphrates was covered with rich, stone-free soil which, combined with the hot climate, encouraged agriculture. These first centuries of the Sumerian civilization are known as the 'Ubaid period' (c. 4000–c. 3200 BC) when villages in southern Mesopotamia grew into towns and writing was invented.

Although the land was fertile, the rivers were unpredictable and there was always the double danger of drought and flood. Memories of catastrophic floods survive not only in the Sumerian epic of Gilgamesh but also in the Hebrew Bible. The Sumerian farmer could never rely entirely upon the benevolence of nature for although he might have had prodigious harvests for years, all his efforts could be wiped out in one single catastrophe. A common theme in Sumerian art is a conflict between the destructive and benevolent forces of nature. It is found on a stone ewer from Uruk of the late fourth millennium which represents a bull, symbol of prosperity to a farmer, attacked by a lion (*Ill. 16*).

In order to avoid catastrophe, the Sumerians believed that their deities had to be placated with offerings. This theme is illustrated on another early vase from Uruk, carved at the end of the fourth millennium (*Ill. 17*). It stands c. 3 feet high and the reliefs are divided into four bands. In the lower part we see the harvest, ears of barley, palm trees and a procession of naked priests carrying baskets of fruit. The high priest offers his basket to the goddess Inanna in the topmost section, hoping that she will reward him with abundant harvests in the New Year.

The goddess (or perhaps her priestess) stands before a shrine identified by her pictograph of two knotted bundles of reeds. It is represented by two lesser deities standing on towers raised up on the back of a bull. This illustrates the basic layout of Sumerian temples which were a place of offering on a raised platform. Within the early town remains of Eridu (south of Uruk on the

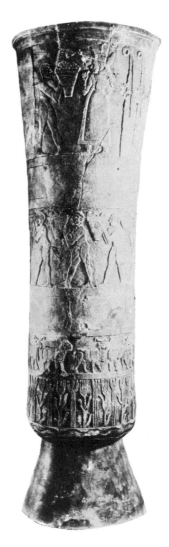

17 Vase from Uruk (Warka) decorated with reliefs of the New Year festival, c. 3100 BC. Alabaster, height c. 36″ (91.4). Iraq Museum, Baghdad

Euphrates), the town of Enki, the Sumerian water god, is a tiny shrine, only 12 feet square. It is divided into an entrance hall, containing an offering table, an inner room and a niche with a pedestal or altar for the god. This architectural arrangement allowed the worshipper to bring his offering to the god, and is intrinsically different from the Neolithic shrines of Çatal Hüyük which were no more than elaborately decorated houses occupied by the sacerdotal family. The Sumerians were not on such familiar terms with their gods but nevertheless believed that they could communicate with them by making offerings. The temple at Eridu was later rebuilt eighteen times and eventually stood on a high platform, great flights of steps led up to it and the public could enter through many doors. The temple towers, called ziggurats, were intended as staircases to the sky so that men could approach heaven. This belief survived long after the Sumerian period, and when the Greek historian Herodotos visited Babylon in the 5th century BC he saw the Temple of Bel standing on a 'solid central tower, one furlong square, with a second erected on top of it and then a third and so on up to eight. All the eight towers can be climbed by a spiral way running round the outside, and about halfway up there are seats for those who make the ascent to rest on.' (*The Histories* I, 181)

By the beginning of the early dynastic period (*c.* 2800 BC), Sumerian culture was fully formed. Writing had been invented about 3300 BC and the potter's wheel was introduced at the same time. Great advances were made in architecture at Uruk where temples were built with stone foundations and the mud-brick was fired to improve its strength. The unpleasant surface-texture of the brick buildings was improved by painting them and even covering them with mosaic. Brick columns were built imitating the forms of palm tree trunks. Because wood and stone were rare, the architects had to develop the use of brick and small stones which, despite their limited size, could be made to span wide spaces by building them into arches.

Arches have been discovered in a cemetery at Ur, dating from the early dynastic period (*c.* 2600 BC). Although most of the graves are unexceptional, seventeen are remarkable because of the lavishness of their offerings and because the bodies have been placed in stone or brick burial chambers. These all have vaulted roofs; some are

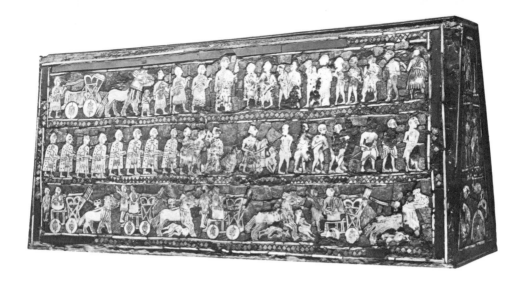

only corbelled where the horizontally laid stones project
one over the other until they meet at the top, thus forming
a false arch, but others are covered with true arches with
radial joints. The arch is a remarkable engineering
discovery since it is made out of wedge-shaped bricks or
pieces of stone, and the more pressure that is put on it from
above, the stronger it becomes. The Greeks largely
ignored it, but Roman architects used it extensively and
it became a basis for medieval architecture in both
eastern and western Europe.

The graves in Ur were filled with fabulous treasures
and because inscriptions refer to kings and queens the
cemetery is known as the Royal cemetery, even though
there is no record of these rulers in the Sumerian king
lists. Some of the royal graves were filled with the bodies
of attendants, all wearing their richest clothing and
jewellery, lying peacefully at rest as if they considered it
an honour to accompany the king. This is the only
known example of human sacrifice in Sumerian
civilization.

The grave treasures show the high standard of civiliz-
ation in Ur at the beginning of the third millennium.
The graves were filled with golden helmets, goblets and
musical instruments inlaid with precious material. The
so-called 'Royal Standard' (Ill. 18) was probably the
sounding box of a harp, or possibly a lyre similar to that
being played in the banquet scene which decorates one of
its sides. It is an oblong box, about 18 inches long,

29

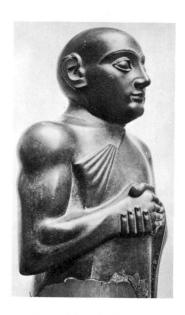

19 *Gudea of Lagash, Neo-Sumerian period (c. 2125–2025 BC). Diorite 29" (73.6). British Museum, London*

with tapering ends, decorated with cut-out limestone and shell figures set against a background of dark blue lapis-lazuli. The banquet was to celebrate the king's victory in a war represented on the opposite panel. In the lowest register the king's wagons, drawn by onagers (wild asses; the horse was not domesticated until a thousand years later), ride triumphantly over the fallen bodies of the enemy. Above, a file of prisoners is led past two executed victims and brought before the king, who has dismounted from his wagon. In the banquet scene the king and his courtiers sit drinking from goblets to the music of a lyre, while workmen bring in animals and food captured from the enemy.

Southern Mesopotamia continued to be a collection of independent and warring city-states until its conquest by Sargon (2371–2316 BC), an Akkadian ruler who united the Semitic-speaking northern half of his kingdom with the Sumerian south. Although the Akkadians were a Semitic nation, they largely accepted Sumerian culture. But they introduced a new concept of supreme kingship, which is reflected in a bronze head of an Akkadian king, probably Sargon himself (*Ill. 1*). He is represented as an idealized ruler, with firm, regular, untroubled features framed by the symmetrical curls of the beard and moustache and by the elaborately braided hair which supports a diadem. This magnificent life-size bronze head shows complete mastery of the difficult art of bronze casting.

The Akkadian dynasty was overthrown by the barbarian Guti, who sacked the plain and controlled it for some sixty years. Only one city survived this upheaval, Lagash, and its governor, Gudea (*Ill. 19*), explained its prosperity in terms of his fulfilment of the wishes of the gods. The statues of himself, which he placed as votive offerings in the temples, express the serene confidence of a truly pious man. In each the face is dominated by the huge eyes, framed by the curving eyebrows and although the details of the lips and nostrils have been sensitively shaped out of the hard stone, the forms have been simplified almost to the point of abstraction. Human beings and animals were treated quite differently in Sumerian art: animals were represented naturalistically but the human form was treated as an abstract symbol as if the artist wished to express an inner spiritual quality by ignoring outward appearances.

Order was finally restored by the Sumerians under the Third Dynasty of Ur, the neo-Sumerian period. The Akkadian concept of a united kingdom was accepted and ambitious architectural projects were undertaken, such as the ziggurat at Ur, known to have had at least three tiers. But the end of the third millennium witnessed a profound disturbance in political power in both Mesopotamia and Egypt which led to the rise of new civilizations in the Aegean.

EGYPTIAN OLD KINGDOM ART

The Nile valley (map 2, p. 216) offered a much more protected environment to developing human civilization than the plain between the Tigris and Euphrates. The river overflowed regularly and made the land fertile, happily without the attendant dangers of flood and drought which made life so uncertain in Mesopotamia. The Egyptians believed in benevolent deities who controlled nature and promised life after death. As a result provision for life after death, rather than the placation of an irascible deity, was among the major aspects of Egyptian art.

Egypt gained unity rapidly under the first ruler of the First Dynasty, Narmer (c. 3100 BC), the king of the south who conquered the northern kingdom. This important political event was recorded on his palette (*Ills 20, 21*), a ritual object originally used for cosmetics. In the upper part, the king's name is represented in hieroglyphs set in a frame between the two cow-horned heads of the Mother Goddess, Hathor. On one side the king, wearing the tall White crown of the south, brandishes his mace above a kneeling captive, while his slain enemies sprawl on the ground beneath his feet. This message is repeated in a pictograph beside the king's head. Horus, the royal falcon, grasps in his human hand a rope which holds captive the northern land, symbolized by a clump of papyri (the northern plant) growing from the sign for land which terminates in a human head.

On the opposite side, the king, wearing the Red crown of the north, inspects the enemy dead and in the lower part he is represented as a bull menacing a fortified settlement. The central depression of the palette (originally intended to hold the cosmetics), is framed by two mythical animals with long snake-necks which resemble the fabulous beasts found on Sumerian cylinder seals. They

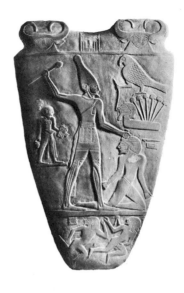

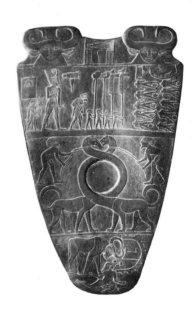

20, 21 Votive palette of King Narmer, celebrating his conquest of the northern kingdom of Egypt, from Hierakonopolis. First Dynasty (c. 3100 BC). Slate 25" (63.5). Cairo Museum

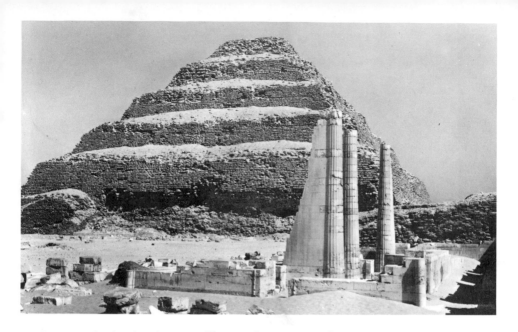

22 Step pyramid and tomb enclosure of King Zoser, designed by Imhotep, at Sakkara. Third Dynasty (c. 2686–2613 BC).

illustrate the connection between Sumerian and Egyptian art in the fourth millennium, even though they developed independently later.

One of the basic differences between Egyptian and Sumerian art resulted from the plentiful supply of fine white limestone in Egypt, which encouraged the development of both sculpture and monumental stone architecture. The use of stone was associated with the cult of the dead and the first monumental stone building in the world was the tomb complex at Sakkara of King Zoser (*Ill. 22*), the second king of the Third Dynasty (c. 2686–2613 BC). It was designed by his vizier Imhotep and is covered by a step pyramid and surrounded by a complex of courtyards and buildings in an enclosure.

The apparently simple geometric shape of the pyramid was the result of considerable experiment. It began as a square flat-topped tomb, called a mastaba, with sloping sides covering a 100-foot-deep shaft leading to the royal burial chamber. This was extended to the east to cover galleries containing the tombs and offerings of the queens and royal children. It was finally converted into a step pyramid, rising 195 feet above the desert to make it visible outside the enclosure wall.

Unlike the later pyramids, the tomb enclosure of King Zoser was modelled on that of a palace, all the buildings being translated from wood and mud-brick into stone.

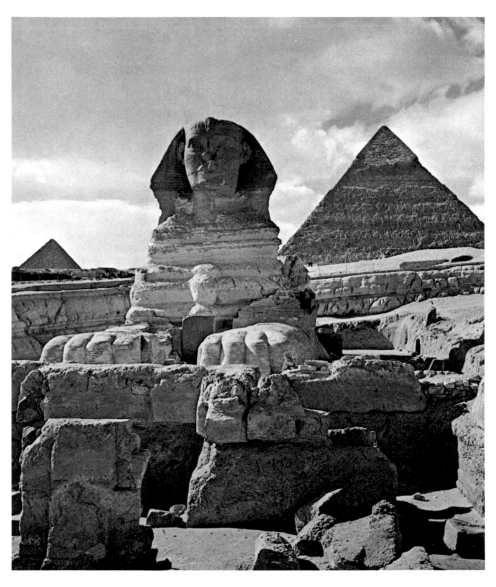

23 The Sphinx, Gizeh. Fourth Dynasty (c. 2613–2494 BC). Limestone

The courtyard to the south was used for the ceremonial race at the time of the king's jubilee and another to the east was lined with the shrines of the gods of Upper and Lower Egypt. To the north of this courtyard stood two buildings, each in its own court, symbolizing northern and southern Egypt. The northern court was decorated with half-columns in the form of papyrus reeds, the plant of northern Egypt, the stalk forming the shaft of the column and the flowers the capital.

We thus see the appearance of the column in Egyptian architecture, a translation into stone of the bundles of papyrus stalks used as supports for the roof of mud-brick buildings. Whereas the Mesopotamians developed a system of roofing their buildings with arches, the Egyptians preferred the post-and-lintel principle (trabeation). Trabeated architecture depends upon the perfection of the proportion of the upright to the horizontal members so that there is a balance between load and support. The horizontal beams must not appear to be too heavy for the columns or pillars beneath them.

The Fourth Dynasty (c. 2613–2494 BC) saw the culmination of the pyramid as a geometric, architectural form in the burial complex at Gizeh. The Great Pyramid of Cheops was the first and the largest of the group, being more than twice as high as that of Zoser. Instead of a complex of palace buildings, Cheops' pyramid is approached through a gate, or valley-temple, a covered passage and a funeral temple in front of the pyramid itself. The pyramid is a stark, undecorated tetrahedron, once completely covered in carefully dressed limestone so that the sides rose at the precise angle of 51 degrees 52 minutes. Nothing detracts from the elegant simplicity of its form which dominates the surrounding desert.

A second pyramid was built by Cheops' son Chephren, and the group was completed by Mycerinus with the smallest pyramid. They are guarded by the Sphinx (*Ill. 23*), a man-headed lion, carved out of the heart of a limestone quarry used by King Cheops for the facing of his tomb.

The aim of Egyptian funeral art was to provide for the spirit of the deceased, to give it a home, to protect its body from corruption and to provide it with other bodies in the form of stone figures. Figure sculpture reached one of its greatest heights in the funeral monuments of the Fourth Dynasty. The king was represented in a static, rigidly

defined pose which expressed not his transient humanity but eternal qualities. Individual features have been subordinated to an idealized image in which all parts are related with geometrical clarity. But at the same time anatomical details, such as the complex form of the insertion of the spherical eyeball in its socket overlaid by the eyelids, are accurately recorded.

Since the statue of King Mycerinus and his queen (*Ill. 24*) was still unfinished when he died, only the upper part was polished. The king is represented purposefully striding forward, hands clenched beside his thighs and his body is presented as a series of angular planes echoing those of his headdress. In contrast, his wife is a series of curves; her rounded wig repeats the softer forms of her body as she clasps her husband affectionately around his waist. The position of these upright figures must have given the sculptor great difficulty because he was as yet unaware of the strength of stone and so did not dare to carve too much away from their slender legs, but left a thick, supporting slab. Yet he was helping to create an image of the ideal human figure which was to survive unchanged for centuries and was copied by Greek sculptors in the 6th century BC (*Ill. 97*).

In contrast to the austere abstraction of the royal portraits, those of the nobles show far greater individuality. Rahotep was the son of King Snefru, high priest of Heliopolis and commander of the army. He is represented with his wife, Nofret, seated on high-backed, cubic thrones inscribed with their names and titles (*Ill. 25*). They are carved out of limestone and painted. He has grown a slight moustache, but is otherwise clean-shaven. A small frown of concentration creases his brow. Their eyes have been inlaid with crystal which adds to the illusion of their lifelike presence.

During the Fifth Dynasty (*c.* 2494–2345 BC) private as well as royal tombs were decorated with sculpture and these reflect aspects of everyday life. It was as if the artist had attempted to recreate on the walls of the tomb the life the dead man had left behind him. The entrance of the Tomb of Ti at Sakkara is a spacious pillared hall which leads to the burial chamber by way of a subterranean passage; a long corridor gives access to the sacrificial chamber, beside which is the statue room which contained three portraits. The sacrificial chamber is decorated with limestone reliefs showing Ti hunting hippopotami

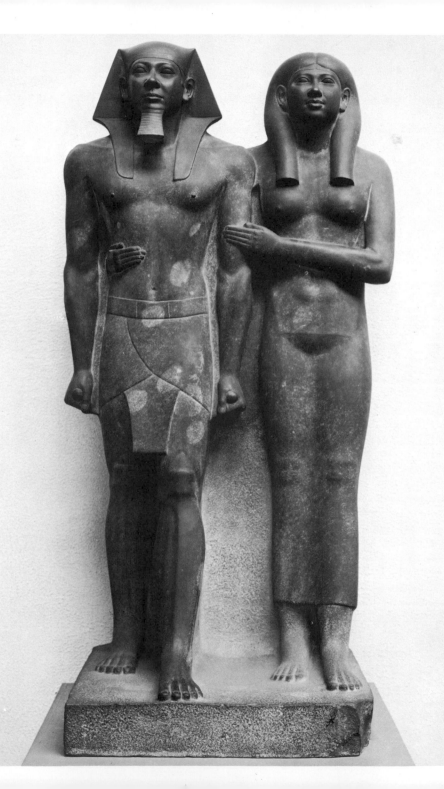

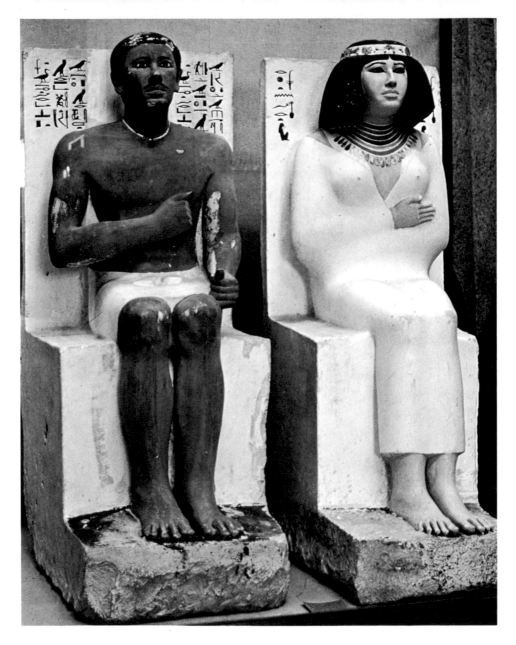

24 (left) *King Mycerinus and his queen, Chamenernebti, from Gizeh. Fourth Dynasty (c. 2613–2494 BC). Slate, previously painted, 4′ 8″ (142.2). Museum of Fine Arts, Boston*

25 (above) *Prince Rahotep and his wife Nofret. Fourth Dynasty (c. 2613–2494 BC). Painted limestone 47¼″ (120). Cairo Museum*

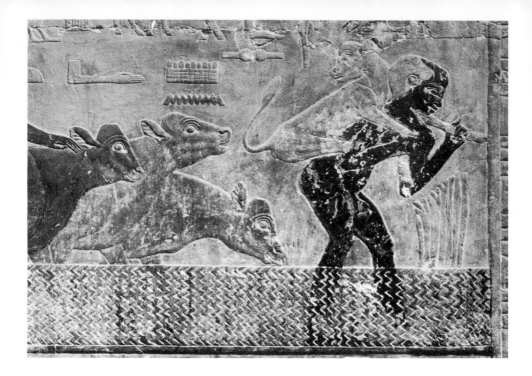

26 *A herd of oxen crossing a ford, from the Tomb of Ti, Sakkara (detail). Fifth Dynasty (c. 2494– 2345 BC). Painted limestone*

in a thicket where foxes and lizards raid birds' nests. On the other walls he and his wife supervise the activities of his estate. Donkeys thresh grain, rams trample the seed into the ground and a herd of oxen cross a ford, but a young frightened calf has to be carried since the water is too deep for it (*Ill. 26*).

Old Kingdom Egypt achieved great wealth and power in the third millennium but it all ended with the collapse of the Sixth Dynasty (*c.* 2258 BC). There was virtually a 'dark age' until the princes of Thebes gained control and established the Middle Kingdom (*c.* 2134–1786 BC, the Eleventh and Twelfth Dynasties). This was succeeded by the New Kingdom (*c.* 1570–1085 BC) and during this period Egyptian art continued to develop with the building of magnificent temples and the decoration of tombs of unparalleled beauty. At the beginning of the second millennium at the moment when Egyptian art was entering this second phase, a new and brilliant civilization appeared in Crete, whose art was influenced by that of contemporary Middle and New Kingdom Egypt, and which developed independently into the first major European civilization in the Bronze Age.

Neolithic and Bronze Age art in the Aegean c. 6200–1400 BC

The mainland of Greece had been inhabited since the Palaeolithic period but there is no direct connection between these first inhabitants and later Greeks. Their remains are buried beneath feet of sterile earth. In the Mesolithic period new people settled on the mainland, but it was the Neolithic settlers introducing the art of agriculture and pottery in the seventh millennium BC who first left a permanent impression upon the country. During the Neolithic period and the Bronze Age Greece was invaded countless times by peoples speaking different languages, some of them Anatolian dialects. They all contributed to a culture inherited by the first Greek-speaking people who invaded the mainland c. 2000 BC and developed the Mycenaean civilization (see Chapter Four).

Farming and the art of pottery were introduced at the same time at the end of the seventh millennium in Macedonia in northern Greece. But the most important early Neolithic civilization developed in the fertile Thessalian plains further south, discovered in excavations at Sesklo. The inhabitants of this village developed a beautiful painted pottery and modelled female figurines similar to those found in Anatolia. During the fourth millennium Thessaly was invaded by a new people armed with bows and arrows who built themselves a fortified town at Dimini. It is surrounded by rings of defence walls and in the central courtyard is a rectangular hall entered through a porch, a megaron (map 2, p. 217).

The art of metal working was introduced into Greece only after it had been developed in Anatolia. At the beginning of the third millennium, the Troad, the north-western tip of Asia Minor, was settled by a metal-working people of unknown origin who do not seem to have learnt the art of writing. They rapidly grew rich because their city, Troy, guarded the important passage

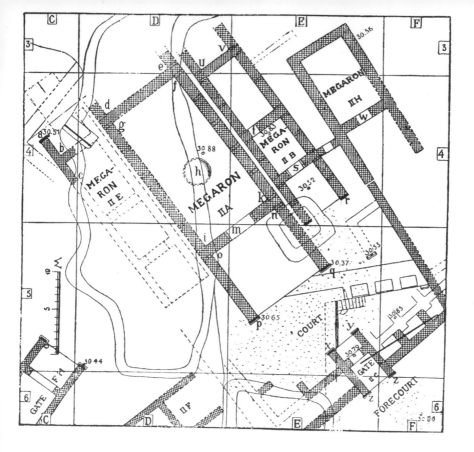

27 Plan of Troy II (c. 2500–2200 BC). After W. Dörpfeld, Troja und Ilion, *1902*

between the Aegean and the Propontis, the modern Dardanelles, which divides Europe from Asia. This was the great trade crossroads not only between east and west, but also north and south.

This first 'city' (Troy I) was a simple village, though it contained a megaron. It was destroyed by fire about 2500 BC and the second, much grander 'city' was built in the form of a fortified palace (*Ill. 27*). The main entrance through the massive defence walls on the south-east side opened into a cobble-paved court. Opposite the outer gate was an inner gateway in the form of a rectangular building with a doorway in its centre. This was to become the form of the classical propylon. It led to an inner pebble-paved court lined with a verandah against the enclosing wall. Opposite the propylon stood the most imposing building of the citadel, the great

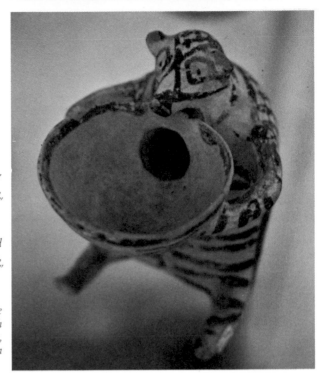

28 *Cycladic vase shaped as a bear or a hedgehog holding a bowl, from Syros, c. 2500–2200 BC. Terracotta 4½" (11.4). National Museum, Athens*

29 *(below left) Kamares style beaked jug from the Old Palace of Phaistos, c. 1850–1700 BC. Terracotta 10½" (26.7). Heraklion Museum*

30 *(below right) Kamares style three-handled pithos decorated with fish, from the Old Palace of Phaistos, (c. 1850–1700 BC). Terracotta 19½" (49.5). Heraklion Museum*

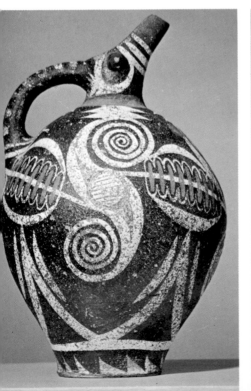

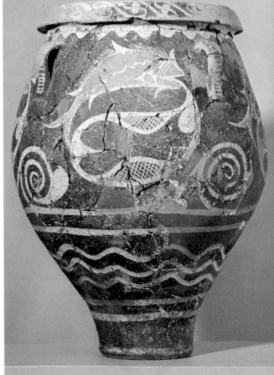

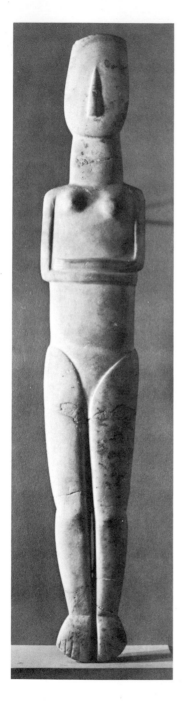

megaron, flanked on each side by smaller structures of similar plan which were perhaps the living quarters of the ruling family, the Great Hall being for court ceremonies.

The inhabitants of Troy II made enormous advances in technology. Metal was used lavishly, not only for jewellery but also household utensils; bowls and vases were made out of bronze, silver and gold. The art of making pottery on a wheel was introduced towards the end of this period. Although the city was destroyed and rebuilt three more times (Troy III, IV and V, c. 2200–1800 BC), there was no break in cultural continuity; the same type of wheel-made pottery was produced and the houses followed the plans of the earlier settlements.

It was inevitable that Bronze Age culture should spread rapidly into the Aegean islands. Crete is separated by only two hundred miles of sea from the North African coast and is linked by chains of islands to Asia Minor. At the beginning of the third millennium immigrants from Asia Minor introduced the art of working bronze together with new, painted pottery forms.

Until the Cretans built their palaces at the beginning of the second millennium, the Cycladic islanders were the artistic leaders of the Aegean. Although the local clay was of poor quality, they achieved a wide variety of forms including the mysterious 'frying pans'. These are ritual objects of unknown use but shaped like a frying pan and elaborately decorated with stamped and incised designs including spirals and ships, and almost all have a pubic triangle carved near the handle. Numerous examples have been found on the island of Syros. A unique vase has also been found in a cemetery in Syros in the form of a hedgehog (or perhaps a bear) who holds out his bowl pathetically, as if pleading for a second helping (*Ill. 28*).

The great achievement of the Cycladic islanders was to take advantage of the plentiful supply of translucent, crystalline marble on Paros and the neighbouring island. They developed marble sculpture in a series of elegant, abstract figures which were placed in tombs, not only in the islands, but also in Crete and mainland Greece. Practically all the figures are female (though a very few male and figures of indeterminate sex are known) and they correspond to the same general type. The woman is represented as a slim, elegant figure standing upright with her arms folded beneath the breast. The features have been

reduced to a minimum and the artist has concentrated on the perfect proportioning of the figure to display the beautiful quality of the marble (*Ill. 31*).

Cycladic art had no opportunity to develop after the islands came under the political control of Crete at the beginning of the second millennium. Crete had become a royal power and palaces were built for the kings emulating those of Egypt and Mesopotamia. The new Cretan art not only dominated the islands but even influenced mainland Greece.

CRETAN ART

One of the problems of studying Cretan art is that two systems of chronology are used. The most accurate is that based upon pottery styles worked out by Sir Arthur Evans, the excavator of Knossos, who divided the Cretan era into three periods, Early, Middle and Late Minoan, named after the legendary King Minos and related to the Old, Middle and New Kingdoms in Egypt. But Greek archaeologists prefer to date objects according to the construction of the palaces. In the early period these two chronologies coincide, for Early Minoan art (*c.* 2800–2000 BC) is the art of Bronze Age Crete before the palaces were built. The Middle Minoan period began *c.* 2000 BC when the first palaces were built at Knossos, Phaistos and Mallia. But an earthquake destroyed these palaces *c.* 1700 BC and new palaces were built on the same sites at the beginning of the Middle Minoan III period without any evidence of major changes in pottery style. Whereas Middle Minoan pottery has abstract decorations on a dark ground, a new type of naturalistic decoration on a light ground was introduced *c.* 1550 BC, and this marks the beginning of the Late Minoan Period. The Late Minoan I period ended *c.* 1450 BC with the catastrophic eruption of the volcanic island of Thera which destroyed all the palaces. Only Knossos was reoccupied, but by people speaking the language of Mycenaean Greece (Late Minoan II, *c.* 1450–1400 BC), and even Knossos was finally destroyed some fifty years later. The Late Minoan III period is the time after the destruction of the palaces, when Crete was under foreign domination and Minoan civilization survived in a somewhat attenuated form.

Although relative chronologies have been accurately determined by means of pottery styles, absolute chronology

31 (left) Cycladic female figure from Amorgos, c. 2200–2000 BC. Marble 4′ 10¼″ (148.5). National Museum, Athens

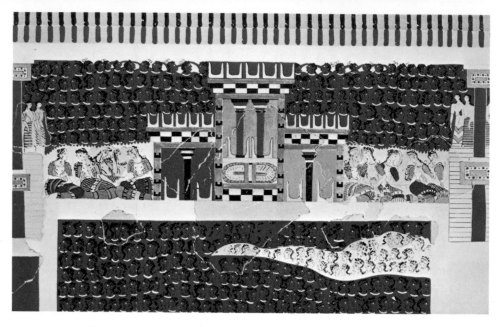

32 Restoration of the 'miniature fresco' representing the shrine in the palace at Knossos, c. 1700–1600 BC. (From Arthur Evans, The Palace of Minos at Knossos, *1930)*

33 The investiture of a king, wall painting from the Palace of King Zimri-Lim, Mari, ?1790–?1760 BC. Louvre, Paris

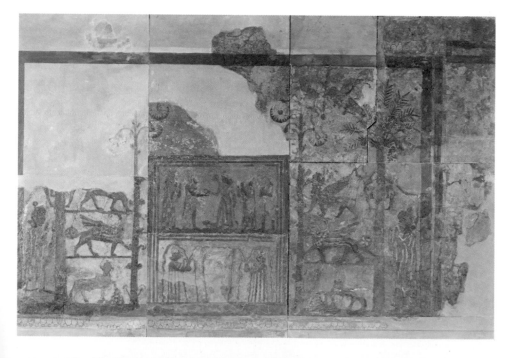

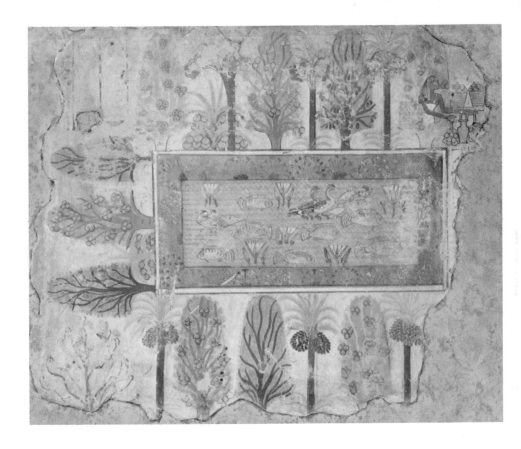

is still somewhat speculative, depending as it does upon the discovery of Egyptian or other foreign imports of known date in Minoan sites. Different authorities vary from thirty to fifty years in the dating of the Middle and Late Minoan periods, and by several centuries in the Early Minoan period.

Although Early Minoan pottery was hand-made without a wheel (which was introduced at the beginning of the Middle Minoan period), the shapes used by the Anatolian immigrants were extremely elegant, such as beaked jugs which later developed into spouted 'teapots'. Some Early Minoan pottery, that known as Vasiliki ware, has a very attractive appearance since the pot was covered with a slip mottled red and black in the firing. In the Early Minoan III period the whole pot was fired in a smoky reducing atmosphere to give a plain black ground, which was painted with simple decorations in creamy white.

34 Painting of a banquet beside an ornamental pool from the tomb of Neb-Amon. Eighteenth Dynasty (c. 1567–1320 BC). British Museum

45

The richest finds of Early Minoan art are from the tombs of Mochlos in eastern Crete. The tombs' contents show Egyptian influence: elegant vases carved from beautifully veined stones, the lid of one decorated with a sprawling hound (an almost identical lid has also been found at Zakro). The women were buried with their jewellery – golden hair ornaments in the shape of flowers and leaves.

The wealth of the tombs' contents shows that the early Bronze Age towns of eastern Crete had become prosperous during the third millennium. Suddenly, at the beginning of the second millennium, with the building of palaces at Knossos, Phaistos and Mallia, central Crete became the administrative centre.

Each of these palaces is built around a courtyard twice as long from north to south as from east to west. They are completely different from the fortified citadels at Dimini and Troy where the central megaron, or great hall, is surrounded by defence walls. There are no great ceremonial halls in Minoan palaces and the place of assembly must have been the courtyards which are their characteristic feature. Courtyards were an innovation in Cretan architecture, though common in Mesopotamia, but the closest parallel to the lay-out of these palaces is a remarkably large palace of the 19th century BC discovered at Beycesultan on the Upper Meander river in western Anatolia.

There is no evidence of painted figural decorations within these first Middle Minoan palaces. But painted pottery achieved an extraordinarily high level of artistic achievement. The major technical innovation was the introduction of the potter's wheel, which had already been in use in Mesopotamia for a thousand years. This made possible the manufacture of fine ceramics with eggshell-thin walls, known as Kamares ware after the cave sanctuary near the summit of Mount Ida where it was first discovered (*Ills 29, 30*). The pot was covered in black and the pattern painted in a pure new white together with brilliant shades of red, orange and yellow. The decorations were almost entirely abstract, based upon the spiral, though abstracted flower and fish forms were used, and they were used to emphasize the swell of the belly of the pot while the narrow neck and foot were tightly encircled by bands. The painters were extremely sensitive to the organic shape of the pot.

There was a terrible earthquake about 1700 BC which
destroyed all the palaces in Crete. Yet it did not affect the
general prosperity of the country, for the old palaces were
rebuilt, and a new royal villa, Hagia Triada, was built
close to the reconstructed old palace of Phaistos.

Knossos, on the north coast, was now the centre of
authority. Sir Arthur Evans, its excavator, identified it as
the Palace of King Minos where Theseus killed the
bull-headed Minotaur and escaped from the Labyrinth.
Some elements of truth may lie behind the Theseus
legend: there is a Carian word, *labrys*, which means
'double axe' and it has been suggested that 'labyrinth'
could be translated as 'Palace of the Double Axe' –
double axes have been found on vases and gems and
carved into the stones of the walls and pillars at Knossos.
But the most common version of the Theseus story
represents King Minos as an evil tyrant who sacrificed
Athenian captives to a bull-headed monster. Excavations
at Knossos have revealed no sadistic or sinister religious
practices though many works of art illustrate the popularity
of dangerous bull games, where athletes turned somer-
saults over the horns of a bull, which may have given
rise to the legends of human sacrifice. The Greeks
themselves, as Plutarch has pointed out, realized that their
legends about Crete were contradictory. 'This suggests
how dangerous it is to incur the hatred of a city which is
the mistress of eloquence and poetry, for Minos has
constantly been reviled and attacked on the Attic stage....
And yet we are also told that Minos was a king and a
law-giver, and that Rhadamanthus was a judge under
him and a guardian of the principles of justice which
Minos had laid down.' (*Parallel Lives: Theseus* XVI)

In contrast to the blood-thirsty image of Minos of the
Athenian legends, our impression of life at Knossos is
one of elegant luxury where a high standard of living was
maintained by commerce and trade rather than warfare.
The palace was built on a hillock considerably raised by
debris of generations who had lived there since the
Neolithic period. At the beginning of the Middle Minoan
period, the top of this hill was levelled off to form the
courtyard and the debris used to raise the north-west
corner of the site. The steep slope down to the stream bed

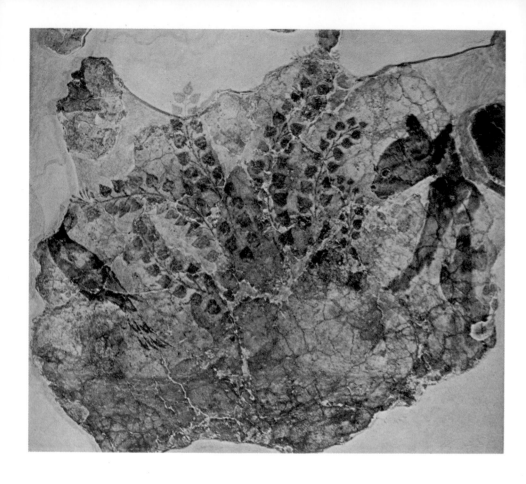

35 Cat stalking a bird, fresco from Hagia Triada, c. 1500 BC. Heraklion Museum

on the east side had a great cutting made into it for the residence of the royal family, while the state apartments were on the west. An elaborate drainage system was also constructed.

After the earthquake, the palace was rebuilt on a similar though more ambitious plan (*Ill. 36*). The state entrance was through the western porch along the Corridor of the Procession, so called from the fresco decorations of life-size youths and maidens walking in solemn procession bearing offerings. There was also a private entrance from the north courtyard past the Old Keep; it led directly to the throne room on the west side of the inner courtyard and visitors using it were expected to purify themselves in the lustral area before entering. This north courtyard was probably designed as a theatral area, surrounded by

steps on which spectators could stand to watch palace ceremonies.

The domestic quarters on the east side of the inner courtyard were completely remodelled, and the different levels were reached by a grand staircase which rose two storeys above the central courtyard and descended two storeys down to the Hall of the Colonnades (*Ill. 37*). Each floor was reached by two flights of stairs supported on columns (all Minoan columns have a reverse taper). The staircase rises magnificently around a central, unroofed courtyard which acts as a light-well to numerous interior rooms without windows. Each floor contained an audience and a reception room but the rambling nature of the lay-out gives an impression of informal elegance. The rooms were decorated in fresco and the suite even contained a bathroom with running water and a flushing w.c.

The public reception rooms were on the upper floor of the west side of the courtyard and reached by a staircase. In contrast to the spacious *piano nobile*, the throne room beneath was small and dimly lit, half filled by a sunken

36 *Plan of the New Palace at Knossos, c. 1400 BC. Drawn by Martin Weaver after Pendlebury*

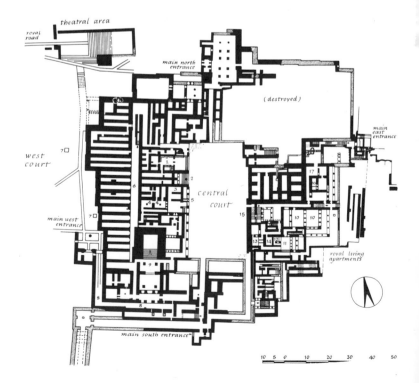

lustral area, and the only indication of regal majesty was a carved gypsum throne guarded by griffins painted on the wall behind. It formed part of a suite of rooms designed for lengthy private religious ceremonies. One must have been interrupted by the final disaster c. 1400 BC, for overturned *alabastra* (ritual oil containers) and an oil jar for filling them were found near the entrance.

Religious ceremonies obviously played an important part in the palace life of Knossos. Unlike the Egyptians and the Mesopotamians the Cretans had little religious architecture, though shrines were occasionally built, as at Keos. Sanctuaries were also constructed on mountain peaks and one of these is represented on a rhyton (a libation vase) from Zakro (*Ill. 43*). But each Cretan palace contained a shrine and at Knossos it was placed on the west side of the courtyard, close to the throne room on the opposite side of the staircase leading to the *piano nobile*.

The shrine at Knossos originally had a façade with columns on either side of a central block which in turn supported a fifth. A very similar shrine is represented in a miniature fresco which had fallen from one of the upper rooms of the palace and depicts a religious ceremony (*Ill. 32*). The courtyard is filled with male and female spectators, and seated outside the shrine are court ladies dressed in blue and gold, gaily gossiping with each other. The frieze continues on to another fragment where the courtiers are seated in an olive grove watching a cere-monial dance, treating it as a holiday rather than a solemn religious festival.

The crowds of spectators are suggested by flecks of red and white paint and this 'impressionistic' style is unique to Minoan art. It has a quality of naturalism and freshness not seen in other contemporary painting. There had been a general revival of interest in painting throughout the eastern Mediterranean. The palace of Zimri-Lim, at Mari on the upper reaches of the Euphrates in Syria, had painted decorations of the 18th century BC. The investi-ture of a king is represented in a courtyard. The wall is divided by stylized trees into compartments containing symmetrically opposed mythological animals. The figures are all in strict profile and animals and plants have been reduced to flat decorative motifs (*Ill. 33*).

In comparison contemporary Egyptian art was much more naturalistic, both in subject and style. In the Middle

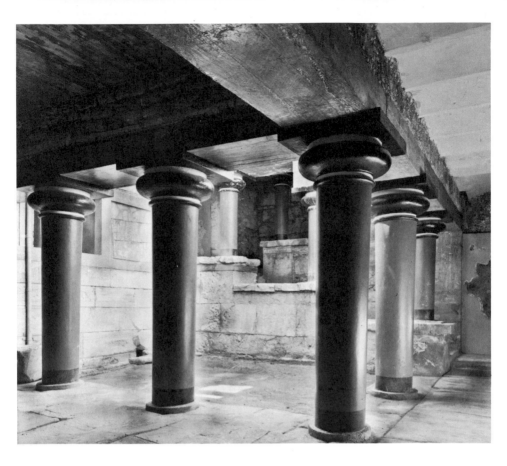

Kingdom period tombs of rich nobles at Beni Hasan were painted with scenes from their lives. After the temporary set-back caused by the invasion of the Hyksos 'Shepherd Kings' Egyptian art reached its greatest heights in the New Kingdom under Queen Hatshepsut (1511–1480 BC). Tombs of court officials cut into the soft limestone hills to the west of Thebes were painted with scenes showing the owners feasting, hunting and carrying out their official duties. Although officials were still represented in strict profile, servants could be shown in a variety of postures, even full face. The pleasures of the countryside were vividly depicted in vignettes representing the wild animals of the marshes and formally laid out gardens. Yet in spite of their wide range of subjects Egyptian artists could never abandon their intellectual and geometrical approach to representation, so that their paintings sometimes resemble a diagram. A garden scene

37 Restoration of the Grand Staircase, Knossos (c. 1700–1550 BC)

from the Tomb of Neb-Amon who lived in the middle of the Eighteenth Dynasty (*c.* 1567–1320 BC) is painted from several different points of view: the rectangular pond is seen from above in bird's-eye perspective, but the surrounding palm and fruit trees are represented upright and growing horizontally, while the ducks on the pond and the girl preparing the repast are all seen from the side (*Ill. 34*). It was only in Akhenaten's reign (1379–1362 BC) that Egyptian art achieved true naturalism.

The subjects of Minoan frescoes are often similar to Egyptian paintings but they lack their intellectual approach. The artists were not concerned with the problems of representing form in space, but introduced a new hedonistic element expressing the pleasures of court life, the excitement of the bull games and the beauty of springtime.

Unlike Mesopotamian and Egyptian painters, Minoan artists used the true fresco technique. The wall was covered in two layers of lime plaster, the design was then sketched in with orange-red paint and in turn covered with another layer of plaster to which the colours were applied. Thus, in spite of fire and earthquake, the colours have survived even though the plaster has broken into thousands of pieces creating a nightmare jigsaw puzzle.

Minoan artists were greatly interested in nature, and this interest may have been stimulated by their belief that flowers and birds were sacred objects. On the first of three large panels from Hagia Triada all sadly darkened by fire, we see a priestess kneeling among lilies, crocuses and pansies at a mountain shrine. The second panel represents the goddess seated at her shrine. In the third, a wild-cat arches its back and stalks, stiff-legged, a pheasant hiding behind the delicate fronds of a clump of ivy growing from a rock (*Ill. 35*). The artist was as interested in representing the flowers and animals as in the goddess, perhaps because these were associated with her worship.

Many of these landscape motifs can also be found in Egyptian painting but they formed only a tiny detail in the complex decorative scheme of a tomb. In contrast, a landscape could be used to decorate an entire room in a Cretan palace. A recent restoration of the paintings from the House of the Frescoes at Knossos has shown that it was composed of one frieze in which a troop of monkeys were raiding birds' nests in a landscape full of blue birds, wild roses and crocuses growing among waterfalls.

38 'Floral Style' jug decorated with grasses from the New Palace of Phaistos (c. 1550–1500 BC). Pottery 11½" (29.2). Heraklion Museum

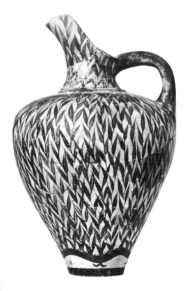

Unlike the Egyptians, the Cretans had a deep love of the sea which they expressed in marine motifs. Flying fish flashing over sun-dappled water were painted on the walls of a Minoan-type palace at Phylakopi on the island of Melos (the fresco fragments are now in the National Museum, Athens). This same pattern of water is found in the Queen's Megaron at Knossos where dolphins are represented swimming in a shallow sea gently rippled by waves.

This new interest in naturalism also influenced the decorations of vases which, at the beginning of the Late Minoan period (c. 1500 BC), abandoned the dark ground abstract decorations of the Kamares ware for naturalistic patterns on a light ground. The earliest was the 'Floral Style' with flowers and grasses gracefully covering the surface of the vase. A jug from Phaistos is covered with a dense growth of grasses whose blades seem to wave in the breeze (Ill. 38). This was soon followed by the 'Marine Style' in which dolphins, shells and octopi were combined into an undulating pattern reflecting the rippling of water (Ill. 39). After 1450 BC a rather more severe style of pottery was introduced, called the 'Palace Style' (Ill. 40), in which the decorations were treated symmetrically and became conventionalized representations of sacred axes, papyrus flowers, rosettes and even contemporary helmets. The pot was divided into zones, with the decorations in the upper part. There was a liking for the grandiose and a tendency to manufacture vases of an unmanageable size probably intended for display rather than use.

A similar change of style can be seen in painting after 1450 BC. A sarcophagus from Hagia Triada represents on one side a procession of men bringing offerings to a tomb and women pouring libations to the music of a lute player at an altar marked by double axes. On the opposite side a bull is tethered to a table in preparation for sacrifice while a priestess makes an offering at an altar before a double axe on which a bird perches in front of a shrine. The shrine is a sacred tree surrounded by a wall decorated with bull's horns. Instead of the sensitive naturalism of the earlier paintings, the figures are harshly outlined and represented in strict profile (Ill. 41).

Minoan art at its best never attempts to analyse form in space, but conveys a convincing impression of figures in movement, catching momentary attitudes and not reducing the figure to a series of stereotyped postures. But

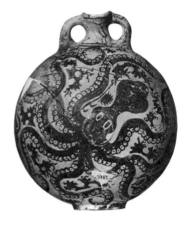

39 'Marine Style' flask decorated with octopi from Palaikastro, eastern Crete, c. 1500–1450. Pottery 11" (28). Heraklion Museum

40 Three handled 'Palace Style' vase from Knossos, c. 1450–1400 BC. Pottery 30¾" (78). Heraklion Museum

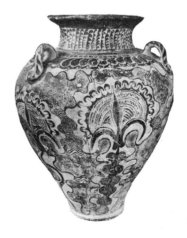

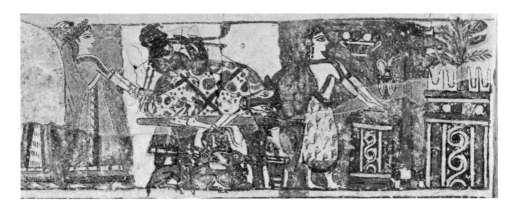

41 *The sacrifice of a bull painted on a sarcophagus, from Hagia Triada, c. 1400 BC. Limestone, length of sarcophagus 54" (137.1). Heraklion Museum*

42 *Snake goddess from the Palace of Knossos, c. 1600 BC. Faience 11½" (29.2). Heraklion Museum*

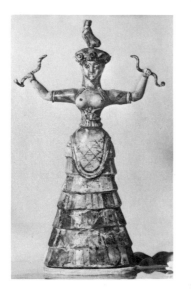

there was no interest in the plastic arts and this is perhaps one reason why no large scale stone sculpture has been discovered at Knossos, though four bronze locks of hair are evidence that the palace may once have contained a wooden statue of a deity estimated to have been 9 feet high. But there is absolutely no trace of monumental stone sculpture anywhere in Crete during the Minoan period.

Minoan artists appear to have concentrated on figurines in faience, bronze, ivory and terracotta. The style is charmingly informal; even deities, such as the faience snake goddesses discovered in a cist in the palace shrine at Knossos, are represented as ladies of fashion. A larger figure may represent the Mother Goddess (*Ill. 42*) and a smaller, her daughter or a priestess. They both wear the same costume as the court ladies in the frescoes, a full skirt and apron with nipped-in waist and an open bodice which bares their full, rounded breasts. Only their elaborate headdresses and the snakes in their outstretched arms betray their divinity.

Although they produced no monumental stone sculpture, Minoan artists excelled in carving rhytons out of steatite in the shape of the head of a sacred animal, the lion or the bull, and they also decorated them in relief. The Zakro Vase (*Ill. 43*) represents a mountain shrine, an abstract image surrounded by a walled enclosure, and seated on the lintel of the doorway are four wild goats. A pedestal stands on the flight of steps which leads up to the doorway, and in front are three altars decorated with bulls' horns. The 'Harvester Vase' (*Ill. 44*) represents a procession of farm workers carrying winnowing forks, led by a man in a cloak, with a group of four singers in

the centre, their mouths wide open as they bellow their song. Their leader holds an Egyptian type of rattle, the sacred sistrum, and at first sight the figures look as if they have been carved according to the Egyptian convention with legs in profile and shoulders facing the spectator. But here this represents the twist given to the torso when a winnowing fork is carried over the shoulder. Even though the figures are all represented in profile a wide variety of poses has been achieved; the sistrum player enthusiastically shakes his rattle above his head, but one member of the procession who has perhaps drunk too much has fallen down and the man in front turns his head to look at him.

Perhaps the most accomplished reliefs are seen in the two gold cups discovered in a tholos tomb at Vapheio, near Sparta in the Peloponnese (*Ills 45, 46*). Though found in Mycenaean territory they are obviously Cretan workmanship (*c.* 1500 BC) and their shape is reflected in certain types of Minoan pottery. The two cups represent the capture of bulls, and they are strongly contrasted in mood. On one a bull struggles violently in a net tied between two trees, thrashing upside down, while

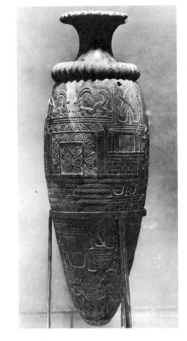

43 Rhyton decorated with a relief of a hilltop sanctuary and wild goats, from Zakro, c. 1500–1450 BC. Steatite 9½″ (24.1). Heraklion Museum

44 The Harvester Vase (detail), from the Palace of Hagia Triada, c. 1500–1450 BC. Black steatite, diameter 4½″ (11.5). Heraklion Museum

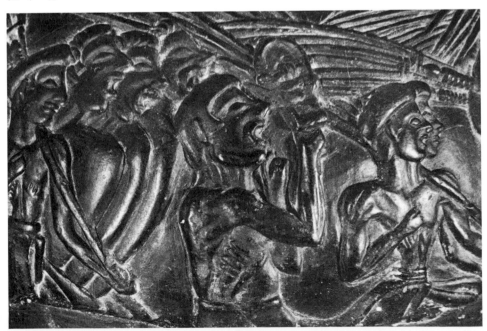

another bull impales a hunter on his horns and a third leaps to safety across the rocky landscape. The second cup is a lyrical landscape in which bulls graze peacefully among the trees, one decoyed by a cow while a hunter ropes its hind leg.

Although Minoan art is religious in theme it is infused with poetry and interest in humanity and nature so that it is completely different in character from the formal and hieratic art of Mesopotamia and Egypt. It was discovered in the period of Art Nouveau, and its lack of formality and sense of organic decoration were immediately appreciated.

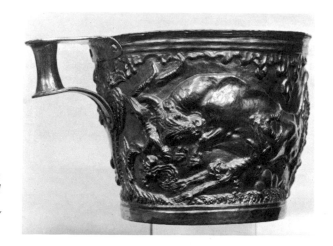

45, 46 Golden cups decorated with reliefs representing the capture of wild bulls, from a tholos tomb at Vapheio, c. 1500–1450 BC. Diameter 4″ (10.2). National Museum, Athens

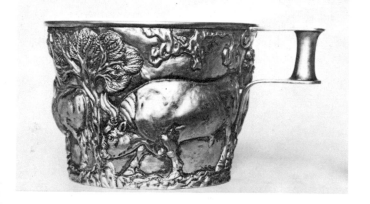

Mycenae, the first Greek art c. 1600–1120 BC

The earliest form of writing in Crete was hieroglyphic, but by 1600 BC a cursive script had been developed, known as Linear A. All attempts at deciphering these inscriptions have met with failure and it has been agreed that the language is basically different from classical Greek. After the reoccupation of Knossos, following its destruction in c. 1450 BC, a new script was introduced (Linear B). Many of the signs are similar to those of Linear A, but they seem to transcribe a different language and the identical script has been found on tablets written two hundred years later in the palaces at Pylos and Mycenae on the Greek mainland. This suggests that the new occupants of Knossos were invaders from mainland Greece. Since the early inhabitants of Mycenae had been much influenced by Cretan culture, it is not surprising that they should have adopted a Cretan form of writing. But their language was completely different from that of Crete and it has long been suspected that it was an early form of Greek. Evidence in support of this theory was first discovered by Michael Ventris, an architect and amateur philologist who had gained experience deciphering codes during the Second World War: he built up a grid of syllables which enabled him to interpret some of the symbols. A large number of tablets have remained undeciphered and the flexibility of readings allows a number of interpretations, but it is virtually certain now that the language of the Linear B tablets is an early form of Greek.

Studies of place names in Greece have shown that Greek was not the original language of the mainland. This prompts the obvious question: when did Greek-speaking people first settle in the country? The Bronze Age began in Greece at the beginning of the third millennium and in this period the Argolid, a fertile plain in the eastern Peloponnese, grew in importance and later

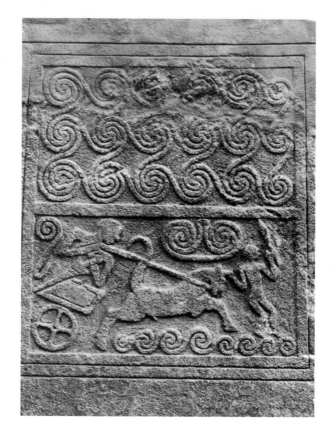

47 Stone stele with chariot scene and spirals marking shaft grave V, Circle A, Mycenae, c. 1550–1500 BC. Limestone 4' 4½" × 4' 3¾" (133.3 × 131.4). National Museum, Athens

became the centre of the Mycenaean civilization. But at the end of the third millennium and the beginning of the second there was widespread destruction throughout Greece and the pottery, architecture and burial customs which followed were completely different in style. This marks the end of the Early Helladic period and the opening of the Middle Helladic period. All the evidence points to the arrival of new people in mainland Greece, and they were probably the first Greek-speaking inhabitants.

The Middle Helladic period (c. 2000–c. 1600 BC) was contemporary with the brillant palace age in Crete. Perhaps as a consequence of the invasions at the beginning of the period, mainland Greece remained out of touch with Mediterranean civilization, but about 1600 BC we find the first evidence of cultural contact with Crete. This

was probably the time when the first palace was built at Mycenae, guarding a pass into the rich and fertile plain of Argos. Nothing now remains of this palace, but the royal family also built two circles of shaft graves filled with astonishing treasures (map 2, p. 216).

Schliemann discovered one of the grave circles at the foot of the citadel hill in 1876, six years after he had uncovered Troy, proving to the sceptical world that Homer's epics were based upon historical fact. But he did not realize the antiquity of his finds, for the bodies he had excavated were of kings who had died over three hundred years before Agamemnon, king of Mycenae, was murdered by his wife.

Nobody knows how the Mycenaeans acquired (c. 1600 BC) the wealth to fill these graves with treasures that justify Homer's epithet 'Mycenae, rich in gold'. The treasures show the unmistakable influence of the art of Crete although the tombs themselves were elaborations of the normal type of Middle Helladic grave. A rectangular trench was lined with rubble walls; earth was heaped on top of a stone roof, and the grave was marked by a carved stone stele. Several bodies were buried together, laid directly on the pebble-covered floor, fully dressed in gold-ornamented clothes, their faces covered with golden masks.

The design of the graves shows that the Mycenaeans had an individual culture of their own. Grave V, one of the richest in Circle A (the circle discovered by Schliemann; a second grave circle B, was discovered in 1951) was marked by three stelae carved with hunting and war scenes, subjects not found in Minoan art. The best preserved (Ill. 47) is divided into two registers, the upper filled with spirals, a ubiquitous decorative motif of the early Bronze Age. The lower register represents a man in a chariot drawn by a galloping horse, perhaps the earliest known representation of the horse as a domestic animal.

Grave V contained three bodies, but as one had been robbed, only two wear masks (Ills 48, 49). The masks represent two completely different types of men: one has a bony face with pinched nose, narrow lips, beard and moustache, whereas the other is middle-aged, fat and clean-shaven. They are quite individual and very different from the slim young men without beards in Minoan art.

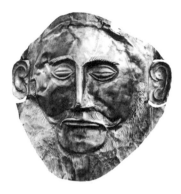

48 Funeral mask of a Mycenaean king, identified by Schliemann as the mask of Agamemnon, from grave V, Circle A, Mycenae, c. 1550–1500 BC. Gold 10¼" (26). National Museum, Athens

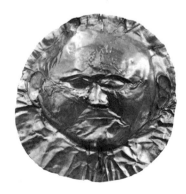

49 Funeral mask from grave V, Circle A, Mycenae, c. 1550–1500 BC. Gold 12½" (31.5). National Museum, Athens

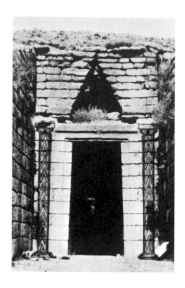

50 Reconstruction of the façade of a royal tholos tomb called the 'Treasury of Atreus', Mycenae. Early 13th century BC

Grave IV, Circle A, also contained three masked bodies, and the offerings are equally lavish. Although worked in gold and silver, the designs show Minoan influence in the rhytons of heads of the sacred animals: the bull and the lion. Golden inlays incorporated Minoan landscape and plant motifs such as a wild cat hunting duck among papyrus reeds on the blade of a dagger (cf. the fresco from Hagia Triada – Ill. 35). At the same time new themes not found in Minoan art were introduced, for the Mycenaeans were obsessed with warfare, and battle scenes were popular subjects. Another rhyton from this grave is decorated with a relief of the siege of a town.

The treasures of the shaft graves show that the Mycenaeans had been strongly influenced by Minoan culture. They even imported Minoan works of art, like the Vapheio Cups (Ills 45, 46) and copied the forms of their rhytons in silver and gold. They shared many religious motifs such as double axes, columned shrines and 'sacral knots'. But the Mycenaeans were not completely dominated by this Minoan influence and the gold funeral masks, perhaps inspired by those on Egyptian mummies, are aggressive portrayals of character. The stone stele marking the graves are carved with scenes of hunting and warfare and are completely Mycenaean both in subject, style and medium.

The late Helladic period (c. 1600–1120 BC) was the Mycenaean age, when the city of Mycenae came to control the Aegean and much of the eastern Mediterranean. Linear B tablets at Knossos indicate that people from the mainland had gained political control in Crete by 1450 BC. Trading colonies were established as far west as Italy and their influence extended beyond the Mediterranean. A Mycenaean type of gold cup has been excavated at Rillaton in Cornwall where it would have been received in exchange for valuable tin ore.

There appears to have been a change of dynasty at Mycenae about 1500 BC indicated by a change in burial customs. The royal family was no longer buried in shaft graves, but in round, beehive-shaped, stone tholos tombs. Mycenaean architects developed them into some of the most impressive monuments of antiquity: the 'Treasury of Atreus' (Ill. 51), built at the beginning of the 13th century BC, was the largest single-span building until Hadrian built the Pantheon fifteen hundred years later (Ill. 190). It was roofed by a great corbelled dome

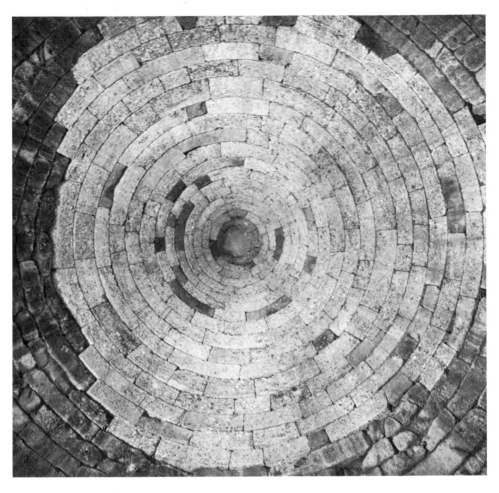

47 feet wide and 43 feet high, built of dressed stone blocks 4 to 7 feet long, set in concentric courses which gradually diminished in height and overlapped the one underneath so that the apex could be closed with a single block. The overlaps were cut away to present a smooth interior, probably decorated with bronze rosettes as in the 'Treasury of Minyas' at Orchomenos. The whole building was covered by a mound of earth supported by a retaining wall and was entered by a long passageway faced with dressed stone. At the end of this passageway stands a massive doorway flanked by half columns in green marble, translations into stone of Minoan columns, but whose capitals seem to anticipate those of the classical Doric column (*Ill. 50*).

51 The corbelled dome of the 'Treasury of Atreus', Mycenae. Early 13th century BC

Unlike Minoan palaces, which were built without fortifications and tended to ramble without much plan around a central courtyard, Mycenaean palaces like those at Troy (*Ill. 27*) had as their nucleus the Great Hall, the megaron. The megaron was surrounded by the lesser rooms of the palace and massive defence walls, creating a fortified citadel. This is the plan of Mycenae and Tiryns and only the palace at Pylos was built without fortifications.

Nestor's Palace (*Ill. 52*), discovered in 1939 on a hill overlooking the Bay of Navarino, some seventeen miles north of modern Pylos, is much more complex in plan than the palace pictured by Homer in the *Odyssey* (Book IV) where Telemachus slept on a wooden bedstead in the echoing portico while the king retired to rest in his room at the back of the high building. The site had been occupied since the Middle Helladic period, but at the beginning of the 13th century BC the summit of the hill was levelled off and a royal residence built on it. The entrance was through a simple propylon near which was probably the tax collector's office, for over one thousand tablets with Linear B inscriptions were found in two small rooms nearby. This led into an open courtyard, and opposite the gateway was the columned portico of the state apartments. On the left of the courtyard was a waiting room beside a pantry well stocked with winecups, and on the opposite side of the courtyard was the bathroom.

Once admitted, the visitor would have passed through a vestibule within the megaron to the throne room. Unlike the throne room at Knossos, which was small and dark and half-filled by a sunken lustral area intended for religious ceremonies, the throne room at Pylos was a spacious hall large enough to accommodate the king's nobles and warriors at their feasts. In the centre was a ceremonial circular hearth with decorated border, surrounded by four great columns supporting a balcony and a high clerestory; the smoke from the fire escaped through a terracotta pipe. The throne, in the centre of the right-hand wall, was flanked by paintings of magnificent griffins with supporting lions which framed the enthroned king.

These griffins resemble the ones in the throne room at Knossos, which may date from the time of the Mycenaean occupation. Minoan and Mycenaean palaces were decorated with similar themes, for example the procession

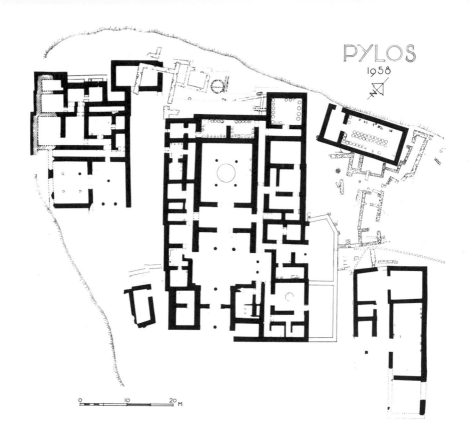

of women wearing Cretan costume with open bodices and flounced skirts in the palace at Tiryns. But in spite of the similarity of the subject matter, the style is distinctly Mycenaean. The figures are stiff and formal, lacking the playful elegance of those in Knossos. Landscape and animals were not enjoyed for their own sake but as an opportunity for hunting. A fresco from Tiryns represents ladies in chariots watching hounds pursue a wild boar. Mycenaean interest in warfare, never found in Minoan art, is reflected in the battle scene from the vestibule of the megaron at Mycenae, with warriors and grooms preparing the horses.

Mycenaean pottery is completely different in shape from Minoan pottery and in the later period was sometimes decorated with figures. The 12th century BC Warrior Vase (*Ill. 53*) from Mycenae represents a woman bidding farewell to a troop of armed men.

The 13th century BC was a period of great unrest in the whole Aegean area, which explains why military subjects

52 Plan of Nestor's Palace, Pylos, 13th century BC. By courtesy of Professor C. W. Blegen and the Department of Classics, University of Cincinnati

63

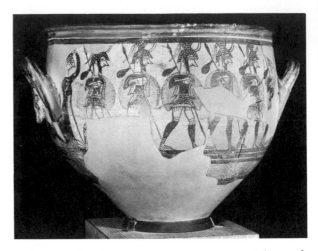

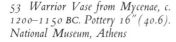

53 Warrior Vase from Mycenae, c. 1200–1150 BC. Pottery 16″ (40.6). National Museum, Athens

were popular in Mycenaean art. Troy, Mycenae's traditional rival, was destroyed in this period. A new and greatly enlarged city had been built on a completely different plan from the earlier ones *c.* 1800 BC (Troy VI). It was destroyed by an earthquake *c.* 1300 BC and the new city (Troy VIIa) was designed as if to withstand a siege. It was overcrowded and the small houses huddled within the massive defence walls of Troy VI were all equipped with storage jars. It was violently destroyed by fire in the middle of the 13th century BC and human bodies were left unburied in the debris. The survivors tried to restore the city (Troy VIIb), but it was taken over, apparently without conflict, by some unknown barbarian nation.

According to Homer, the city was besieged and sacked by a Greek army led by Agamemnon, king of Mycenae. There is no archaeological evidence that it was a Greek army which destroyed Troy, and it may even have been the barbarians, for poetic tradition confused people and places. Nevertheless, the city was destroyed and within a short time all the major centres of civilization in the eastern Mediterranean were under attack. Egypt barely survived invasion by the unidentified 'Sea Peoples'. At the beginning of the 12th century BC even the mighty military power of the Hittites, who had dominated central Asia Minor, succumbed to one of these barbarian invaders.

It is therefore not surprising that during the 14th and 13th centuries BC the Mycenaeans should have fortified their palaces in the manner of the Hittites, the greatest

54 (right) Lion Gate, Mycenae, c. 1250 BC. Limestone relief 9′ 11″ (302)

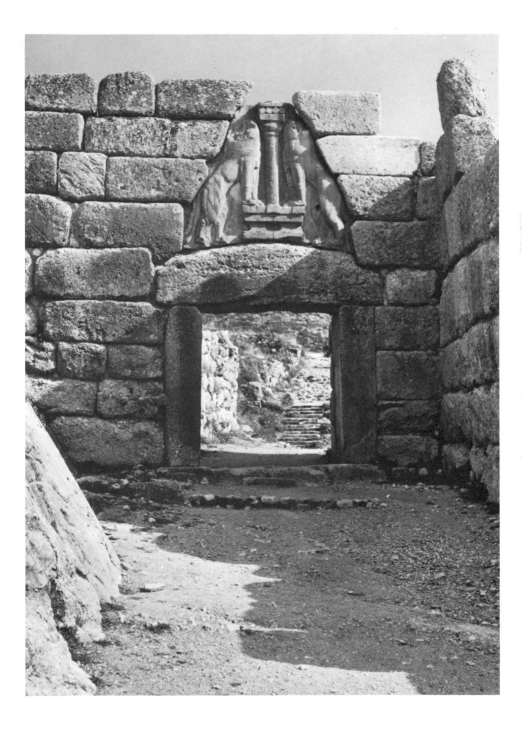

Mycenae, the first Greek art
c. 1600–1120 BC

military architects of antiquity. The first *enceinte* at Mycenae was built *c.* 1350 BC, surrounding the upper part of the citadel. It was considerably enlarged in the 13th century so that it even included the early royal cemetery, Grave Circle A. The walls were constructed of huge, unmortared blocks of stone which were so massive that later Greeks believed that they had not been laid by mortal men but by giants, and so called them Cyclopean. It was at this time that the monumental Lion Gate was constructed (*Ill. 54*). The triangular slab filling the corbelled relieving arch over the lintel was carved with two mighty lions reared up on an altar supporting a Minoan column. These lions at Mycenae are the first example of monumental stone sculpture in Greek art. Although guardian lions were a common theme in both Mesopotamian and Egyptian art, their combination with massive defence walls was a Hittite invention and is found in the Hittite capital city, Hattušaš (Boghazköy) (*Ill. 55*) built in the 14th century BC.

In spite of their defences, Mycenae and Tiryns were eventually conquered. There was widespread destruction in the Peloponnese *c.* 1200 BC, when the unfortified palace at Pylos was destroyed. Mycenae and Tiryns survived until *c.* 1120 BC and then they too fell and Mycenaean civilization rapidly declined into a 'dark age'.

55 Lion Gate, Hattušaš (Boghaz-köy), 14th century BC. Limestone

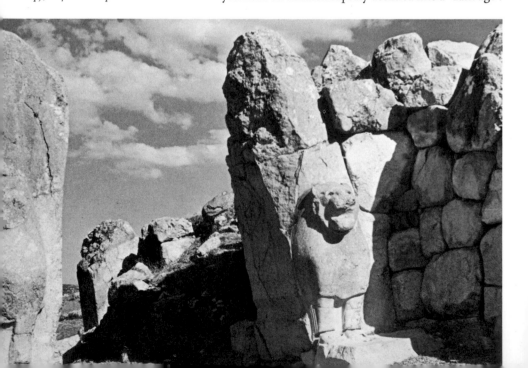

Northern Europe and the Mediterranean

Primitive hunting and fishing communities inhabited Europe after the Ice Age until agriculture was introduced not later than 5000 BC by settlers from Anatolia in northern Greece, the Balkans and the great Danubian and Hungarian plains. They brought with them the art of painted pottery, made clay figurines of women and farm animals, and used stamp seals. During the fifth millennium agriculture spread across central and north-western Europe where the settlers first had to clear the land of forests. Although they retained some contact with the Mediterranean, importing seashells for ornaments, they developed a distinctive pottery decorated with lines incised into the damp clay. Another group of settlers occupied the Ukraine and northern Rumania; they developed a remarkable painted pottery, at first white on red, and later painted with black outline (map 2, p. 217).

The main artistic activity of these early peasant farmers was decorated pottery, but in regions close to the Mediterranean there was also figural art. Two pottery figurines from a grave in Cernavoda in Rumania date from the 2nd half of the fourth millennium (*Ills 56, 57*). Covered in blackish-brown burnished slip, they represent a seated man and woman. The woman is a calm and placid pear shape, tilted slightly forward as she supports herself against her knees, a pose common in seated figures in the Near East. In contrast, the man is slim and muscular and is seated on a stool, his head resting on his hands in a deeply thoughtful attitude. There is no known ancient parallel to this representation of man as a thinker.

Agriculture also spread westwards along the sea routes of the Mediterranean and the movement of the settlers can be traced by remains of their pottery, decorated with impressed patterns and found in southern Italy, Sicily and eastern Spain. Colonists from Sicily reached Malta

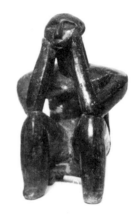

56, 57 Seated man and woman from Cernavoda, Rumania, late 4th millennium BC. Pottery covered in blackish-brown burnished slip. Man 4½" (11.5), woman 4¼" (10.8). National Museum, Bucharest

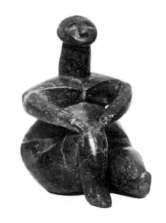

towards the end of the fourth millennium, and between
2750 and 2000 BC there was a period of intense building
activity. Temples were constructed with trefoil ground-
plans, probably copying the forms of rock-cut tombs.
The earliest temples were built of undressed stone, but in
the later phases, such as at Hal-Tarxien, the facing slabs
were carefully smoothed.

Three temples were built at Hal-Tarxien which show
the advances in construction and also the importance of
sculpture. The third temple had a slightly curved façade
facing an enclosed courtyard containing a colossal stone
statue, originally at least 8 feet high, of a seated woman.
The temple was decorated with elegant reliefs, not only
abstract spirals typical of Bronze Age art in the eastern
Mediterranean, but also representations of sacrificial
animals, the bull and the sow.

The Hypogeum or underground sanctuary at Hal-
Saflieni reproduces in three levels below ground the main
features of the temples above ground. The so-called

*58 Apse of the Hypogeum at Hal-
Saflieni, Malta. 3rd millennium BC*

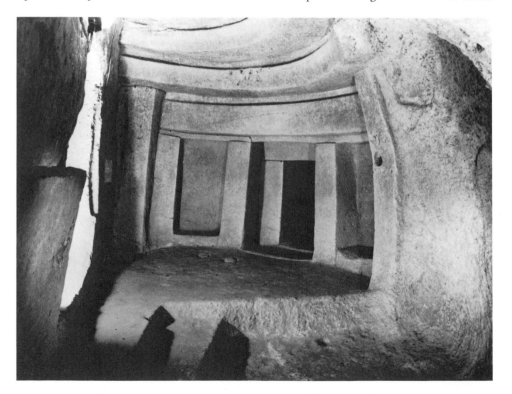

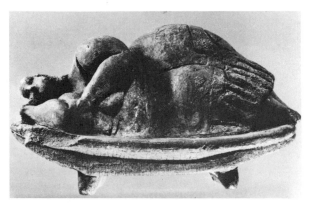

59 Sleeping woman, votive figure from Hal-Saflieni, 3rd millennium BC. Terracotta 4¾" (12). National Museum, Malta

'Oracular Chamber' has a ceiling painted in a spiral pattern resembling the entwining branches of a tree. This leads to a second painted room whose walls are also covered with a spiral pattern. The 'Holy of Holies' is an apse with a doorway leading to a finely cut chamber, from which a staircase descends to a lower level (*Ill. 58*). Although it was later used as a tomb, this complex of underground rooms seems to have been constructed originally as a place where worshippers could spend the night underground and have their dreams interpreted by priests. A statuette of a sleeping woman found in one of the pits was probably a votive offering for guidance from the goddess (*Ill. 59*). The rounded, bulging forms of her hips and arms clearly illustrate the preoccupation in Malta with curves used to express fecundity.

There seems to be some indirect connection between the art of Malta and that of the megalithic tombs built in south-western Spain, Portugal, a large section of France, Britain, parts of Holland, Germany and Scandinavia. These were monumental collective stone-chambered tombs, the first architectural monuments of western Europe. They were constructed out of large, usually undressed stones (megaliths) and were built and used for well over two thousand years, from the beginning of the fourth to the end of the second millennium.

There are four distinct types of megalithic monument: the chamber tomb, sometimes called dolmen; the single standing stone, or menhir; grouped standing stones in straight lines; and in the British Isles, banked circles of standing stones called henges. Unlike Cyclopean construction in Greece, in which huge stones are piled on

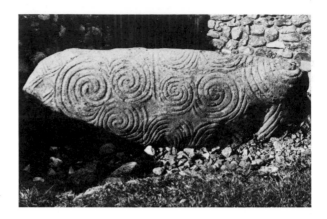

60 Carved kerbstone from New Grange, third millennium (?)

61 Plan of New Grange. From S. P. O'Riordain and Glyn Daniel, New Grange, after Coffey

top of each other, megalithic monuments usually consist of a basic unit of one large slab balanced on two or more upright walling stones, combined in various forms.

The chamber tombs were built either at the end of a long passage or as long galleries. New Grange in Ireland (*Ill. 61*) is a passage grave in which the chamber is approached by a passage 62 feet long walled with megaliths set on edge, and roofed by huge megalithic slabs. The height of the passage gradually rises to 7 feet as it approaches the large cruciform chamber. This is over 19 feet high and covered with a splendid, steeply corbelled vault. The whole construction was covered by a circular mound 45 feet high, and this barrow is an impressive monument in its own right.

The whole question of Mediterranean influence is under debate. The revised dates obtained by radio-carbon methods indicate that chamber tombs used for collective funerals were introduced into northern Europe before the Aegean. But at the entrance to the passage at New Grange stood a kerbstone carved in spirals and lozenges which suggest some form of Mediterranean influence (*Ill. 60*). Also an *oculus* design, another Mediterranean motif, decorates the roofing stone of the north side chamber.

There is only scanty evidence as to the nature of the religion of the builders of the megalithic tombs. The most spectacular megalithic religious monument is Stonehenge on Salisbury plain. Although the site was used for burials, the monument was oriented to the midsummer sunrise and seems intended as a temple of the sun (*Ill. 62*).

There were three periods of construction at Stonehenge, beginning about 1900 BC, when the Neolithic Windmill

Hill people constructed a great circular ditch and piled up the chalk rubble into a bank, which was left open at the north-east to form an entrance to the enclosure. They placed the Heel Stone, a 20-foot slab of unworked natural sandstone called sarsen from the nearby Marlborough Downs, slightly south-east of the line of entrance. It marks not only the point where the midsummer sun rises but also, every eighteen or nineteen years, where the mid-winter full moon rises. It has been suggested by Professor Hawkins in *Stonehenge Decoded* that in order to keep track of the movement of the moon, which brought with it the danger of eclipse when aligned with the sun, the circle of fifty-six Aubrey Holes (named after their discoverer, the 17th century antiquary) was dug just inside the inner embankment. It was probably during this period of construction, though after the Aubrey Holes had been dug, that the four Station Stones were erected which point to the rising and setting points of the winter and summer sun.

The next stage of construction was by the Bronze Age Beaker people who converted the monument into a rather conventional megalithic sanctuary by importing, at vast labour, at least eighty-two Blue Stones from Pembrokeshire, each weighing about five tons, which they erected in a double circle but with an entrance pointing to the Heel Stone.

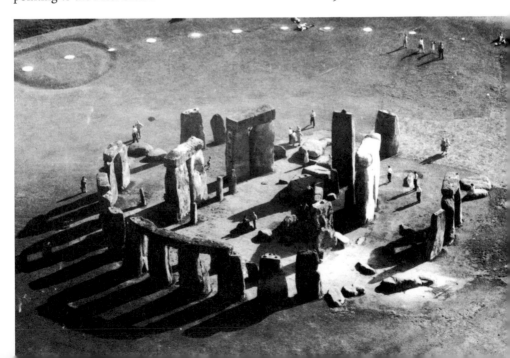

62 Stonehenge, Wiltshire, begun c. 1900 BC

The Blue Stone sanctuary was begun about 1750 BC but never completed since the Wessex people took over about 1700 BC. They were excellent craftsmen, as well as being rich and prosperous, partly through trade contacts with the Mediterranean. They seem to have realized immediately the astronomical significance of the original plan which the Blue Stone circle negated. They therefore dismantled it and laid the stones aside, replacing them with sarsen boulders in a completely different pattern. Close to the centre of the monument they built a horseshoe of five trilithons, unique to Stonehenge, consisting of two uprights only a foot apart, supporting a lintel. These were beautifully dressed, the uprights being slightly tapered and the lintels held in place by the 'mortise and tenon' system. On the top of each upright was a knob which corresponded to a hollow in the lintel and the meeting edges were dished and chamfered. These narrow trilithons frame important events in the solar and moon year. The first trilithon on the east side frame the winter sunrise, when the sun is at its maximum declination south. The next frames the summer moonrise. The trilithon opposite the Heel Stone frames the winter sunset, and on the west side the trilithons frame the winter moonset and the summer sunset.

A circle of thirty sarsen stones was then erected enclosing the horseshoe, but its centre was displaced 3 feet from that of the Aubrey circle to allow a view of the summer sunrise over the Heel Stone. The stones support a continuous lintel which was also fixed by the 'mortise and tenon' system. Later, the discarded Blue Stones were erected in an oval within the sarsen horseshoe and almost immediately pulled down again and removed. A series of pits was dug around the sarsen circle. Finally, the Blue Stones were again set up, this time as a horseshoe at the centre of the monument and as a circle inside the outer circle.

The beautiful shaping of the stone at Stonehenge suggests contact with the Mediterranean. There is no doubt that Britain was in trade contact with Mycenaean Greece, for the Rillaton Cup, found in a barrow in Cornwall, has ribbed walls and a riveted handle identical with a cup discovered in Shaft Grave IV of Circle A at Mycenae. Moreover, some thirty carvings of axeheads and one Mycenaean-type dagger have been discovered on the sarsen stones at Stonehenge. But this contact with

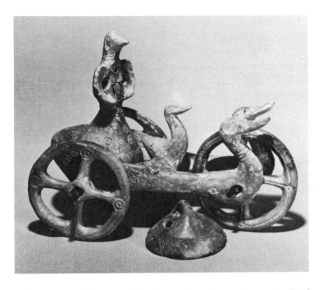

63 *The chariot of the sungod (?)
drawn by waterbirds, from Duplaja,
Yugoslavia. Late 2nd millennium BC.
Terracotta c. 4" (10). Belgrade
Museum*

Mycenaean Greece took place after the major period of
construction of Stonehenge was completed.

Mycenae became one of the main Mediterranean
trading nations after 1450 BC. Its greatest problem was to
find enough copper and tin ore for bronze tools and
weapons. This led to ever-widening trade contacts with
barbarian nations, who in turn developed their own
metal-working industries. During the 14th century BC a
new metal-working culture had evolved in central
Europe; the dead were cremated rather than buried and
the incinerated bones were placed in urns in fields. Its
art was confined to metal work and pottery and the
favourite decorative motif was a water bird seen, for
instance, in a votive chariot from Duplaja where a god
is drawn in a chariot by two ducks *(Ill. 63)*. The Urnfield
culture spread rapidly, not only into eastern Germany but
also south into Italy, where it developed into the
Villanovan culture (see Chapter Twelve).

THE IRON AGE

Iron is not an easy metal to work for although the ores
are plentiful, a very high temperature is required to extract
the metal and if a cutting edge is required, the metal has
to be further processed after casting by hammering and
quenching. So it is not surprising that the first metal tools
were manufactured out of bronze, for although the copper

64 Detail of cow and calf on rim of vessel from Grave 671, Hallstatt Cemetery, Upper Austria. Bronze, length of cow 5¾" (14.4)

and tin ores are rare, the metal is easily extracted. But pure iron occurs naturally as meteoric fragments and even in the third millennium, at the beginning of the Bronze Age, a dagger was manufactured from smelted iron and placed in a tomb at Alaca Hüyük. The Hittites, in central Anatolia, were producing iron on a commercial scale by the 15th century BC and it is mentioned in the diplomatic correspondence of the 13th century. After the destruction of the Hittite empire the art of working iron was introduced into Europe and from the 11th century BC onwards, graves in Athens contained iron swords.

Iron working was introduced into continental Europe by a new culture which invaded Bohemia, Upper Austria and Bavaria in the 8th century BC. It is named after a cemetery excavated at Hallstatt in Austria, where the dead warriors were laid uncremated on a wagon usually enclosed within a wooden chamber beneath a barrow. The warrior was equipped with his iron sword, spears, equipment for his horses as well as pottery, joints of beef and pork, and this form of burial is completely different from that of the earlier Urnfield people. We are not certain of either the correct name or language of these Hallstatt people, but it has been suggested that they were the warrior ancestors of the Celts, the first historical civilization of Europe.

Although obviously a military culture, these people were not without art, and among the grave offerings at the Hallstatt cemetery is a superb bronze bowl decorated with a cow and her calf walking over its rim (*Ill. 64*). A bronze ritual vehicle from a grave at Strettweg, Graz, is crowded with animated figures, soldiers, mounted warriors and deer, while in the centre is a towering female figure supporting an offering stand (*Ill. 65*). This bronzework is closely connected with the art of the early Iron Age inhabitants of Italy, for a similar carriage has been discovered in Etruscan territory in the necropolis of Olmo Bello at Bisenzio near Lake Bolsena.

While the Hallstatt warriors were moving west, conquering Europe (by the 6th century BC this type of burial is found in France), a new people, the Scythians, emerged out of central Asia and became their eastern neighbours. Herodotos describes them as 'a people without fortified towns, living . . . in wagons which they take with them wherever they go, accustomed one and all to fight on horseback with bows and arrows, and

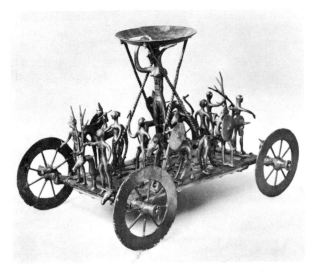

65 *Ritual vehicle with human and
animal figures from Strettweg, Graz,
Austria. Hallstatt Culture, 7th cen-
tury BC (?). Bronze, height of
central figure 8¾" (22.2). Landes-
museum Johanneum, Graz*

dependent for their food not upon agriculture, but upon
their cattle' (*The Histories*, IV, 46). In Herodotos' day the
Scythian territory stretched as far west as the Danube, the
Scythians and the Celts being the two major barbarian
nations of Europe.

Because they were a nomadic nation, the most im-
portant aspect of Scythian art was the gold ornaments
worn by the kings and warriors and buried with them at
death. The royal burial ceremony is described by
Herodotos:

'When the king dies they dig a great square pit and when it is
ready they take up the corpse which has been previously
prepared. . . . The funeral cortège after passing through every
part of the Scythian domains, finds itself at the place of burial
amongst the Gerrhi, the most northerly and remote of Scythian
tribes. Here the corpse is laid in the tomb on a mattress, with
spears fixed each side to support a roof . . . while in various
parts of the great square pit various members of the king's
household are buried beside him: one of his concubines, his
butler, his cook, his groom, his steward and his chamberlain
all strangled. Horses are buried too, and gold cups . . . and a
selection of his other treasures. The ceremony over, everybody
with great enthusiasm sets about raising a mound of earth, each
competing with his neighbour to make it as big as possible.'
(*The Histories*, IV, 71)

A golden buckle from Siberia, once part of Peter the
Great's collection now in the Hermitage, must have been

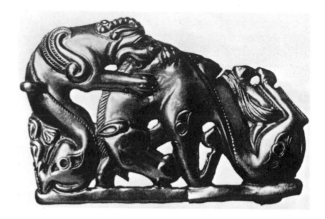

66 *Belt buckle representing a lion
attacking a horse, from Siberia, 5th
century BC. Gold 4½" (11.4). Her-
mitage Museum, Leningrad*

discovered in such a grave (*Ill. 66*) It is typically Scythian
in that it is decorated with animals converted into a
fantastic abstract pattern. A lion has attacked a horse
which is so twisted that its head is bowed to the ground
while the hind-legs point up into the air, creating a linear
pattern.

This barbarian animal style of the Scythians had a
powerful impact upon the art of the Celts who controlled
much of western Europe until the Roman conquest.
Celtic armies even invaded Italy, sacking Rome in 390
BC, and threatened Asia Minor. Attalos I of Pergamon
celebrated his victory over them in 241 BC with a

67 *The Dying Gaul, a Roman
copy of a bronze monument set up by
Attalos I in Pergamon c. 241 BC.
Marble 36½" × 73" (93 × 185).
Capitoline Museum, Rome*

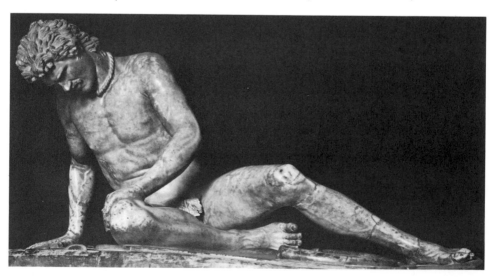

monument which included the *Dying Gaul* (*Ill. 67*), an accurate representation of a Celtic warrior.

Didorus Siculus tells us that although the normal costume was trousers, shirt and striped coat fastened by a buckle, some of the more daring warriors went into battle naked except for the gold torque around their necks. Their hair was bleached with lime water which left it stiff and spiky, and the nobles wore moustaches. For armour they carried 'long shields, as high as man, which were wrought in a manner peculiar to them even having figures of animals embossed upon them.' (*The Library of History* V, 28)

The *Dying Gaul* accurately represents a Celtic warrior, but the style is unmistakably Greek. Celtic figural art is extremely abstract; the artist was not interested in expressing emotions, analysis of form nor in displaying knowledge of human anatomy. Human figures were treated in the same way as those of animals and converted into abstract patterns which have their own vitality. The features of the head from Mšecké-Žehrovice (*Ill. 3*) have been reduced to spirals, yet the result is an impressive figure with wild, staring eyes and dynamically curving moustache.

The major artistic achievement of the Celts was to combine animals and human figures into an abstract pattern. A pair of beaked bronze flagons from Basse-Yutz, Lorraine, have concave sides which form an entirely original shape. The spouts are decorated with a water bird, reminiscent of the art of the earlier Urnfield culture. But two fabulous monsters recline on each side of the neck and the handle is in the form of a leaping wolf whose hind-legs mysteriously join together into a spiral pattern resembling a bearded human face (*Ills 68, 69*).

Although Celtic culture was so completely different from that of the Mediterranean, there were trade contacts with both Greeks and Etruscans. This was encouraged by the Celts' passion for drinking wine, and they imported all the necessary equipment, a notable example being a bronze krater, nearly 6 feet high, found buried in the grave of a Celtic princess at Vix. They also imported round Etruscan mirrors, which they later copied and decorated with their own abstract ornament.

The Desborough Mirror (*Ill. 71*), a 1st century BC Celtic mirror from Northamptonshire, combines an Etruscan shape with a rhythmic decorative pattern of

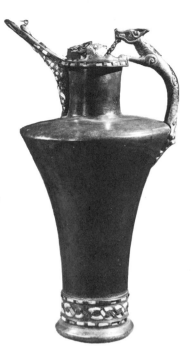

68, 69 Beaked flagon from Basse-Yutz, Lorraine, France, and (below) a detail of the handle. Early La Tène period, 4th century BC. Bronze, coral and enamel 15¼" (38.7). British Museum, London

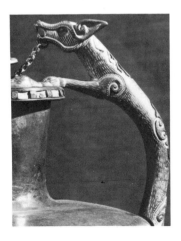

70 *Initial XPI from the* Book of Kells, *f. 34r, Irish, 8th century* AD. *Illumination on vellum* 13" × 10¼" *(33 × 26). Trinity College Library, Dublin*

71 *(below) The Desborough Mirror, 1st century* BC. *Bronze* 13¾" *(35). British Museum, London*

swirling curves which fills the entire surface. This combination of Mediterranean forms with Celtic ornament became one of the characteristics of European art long after the conquest of Julius Caesar had reduced the Celts from a powerful nation to a subject people. The *Book of Kells* is a Gospel written in Ireland in the 8th century AD; one of its pages is entirely filled with the three initial letters of Christ's name in Greek: XPI (*Ill. 70*). But the ornament has nothing in common with contemporary Byzantine art in Greece; it is a development of the spiral decoration found on the Desborough Mirror.

In other manuscripts of this school fantastic animals writhe and twist over the parchment, ferociously devouring each other. These are the direct descendents of the Scythian animal style which the Celts copied and introduced into the tradition of European art.

The rebirth of Greek art c. **800–600** BC

There was a 'dark age' in Greece after the breakdown of the Mycenaean empire in the 12th century BC. The invasions and migrations which had disturbed the whole eastern Mediterranean led to the rise of piracy and the disruption of trade. Trade was the major source of wealth within the Mycenaean empire and after it was curtailed, Greece began to lapse into poverty. It was in this period that the Dorians invaded the Peloponnese. Little is known about them except that they were Greek-speaking people from the north, but they were completely out of touch with Mediterranean civilization and were illiterate. Their invasion completed the breakdown of the Mycenaean civilization.

The immediate result of the Dorian invasion was a general depopulation of the mainland. People fled to safety, both to Attica, which according to tradition was never invaded, and to the islands and then eventually to the west coast of Asia Minor. This Ionian migration was made possible by the breakdown of the powerful Hittite empire, which left Asia Minor open to immigration. While the Ionians settled in the Cycladic islands and the Aegean coast of Asia Minor, the Dorians settled in the Peloponnese and eventually occupied the southern islands and the south-west coast of Asia Minor. The general pattern of these migrations was resettlement in an old Mycenaean colony or trading post after a short period of abandonment.

It was only at the beginning of the 9th century BC that Greek civilization began to recover and trade renewed. The Mycenaean empire had broken down into many separate independent city states, but united by a common language. This language contained different dialects, to a certain extent corresponding to the different ethnic groups which made up the Greek nation, and cities tended to form alliances with those speaking the same

dialect. Athens recognized a bond between herself and the Ionian cities of the islands and Asia Minor, whereas Sparta regarded herself as the leader of the Dorian cities in the Peloponnese. But in spite of these differences in dialect, Greek was one language and people who did not speak it were barbarians. Only Greek speaking people were admitted to the national festival in honour of Zeus held every four years at Olympia (map 3, p. 217).

This festival was immensely important to the Greeks, and to win at the Olympic games was to achieve immortal fame. A list of the winners was recorded, beginning in 776 BC, which became the basis of Greek chronology. These records were possible because the Greeks had adopted the Phoenician alphabet at the end of the 9th century BC, improving it by the addition of signs for vowels. With the reintroduction of writing, a major development took place in literature and it was during this period that Homer wrote his epics, the *Iliad* and the *Odyssey*.

These epic poems are not concerned with contemporary events but with the Trojan war, one of the last major events in Mycenae's history at the end of the Bronze Age (see p. 64). Although almost four centuries had passed between the breakdown of the Mycenaean empire and the revival of Greece in the Geometric period, there were still tenuous links connecting the two civilizations. They spoke the same language and worshipped many of the same gods in sanctuaries often built on Mycenaean foundations.

The ritual of worship of the Olympian gods centred around the burning of an offering of food on an altar before the image of the god. On Samos, an island off the coast of Asia Minor, a miraculous image of the goddess Hera was discovered in a river bed entwined in the branches of a lygus bush. At first the image must have been protected by some form of simple shelter which has left no trace, but as early as the first millennium a plain stone altar was built, measuring 8 by 4 feet, on which sacrifices were offered to the image. The altar was enlarged and then it was decided to build a great house for the statue, the earliest known Greek temple. Its date is still a subject of debate, for although its excavators claimed that it was built at the beginning of the 8th century on the evidence of pottery found on the site, the dating of eastern Greek pottery is not completely estab⁄

lished. Unfortunately, even this evidence has been lost in the upheaval caused by the Second World War.

This first temple was an extraordinary building. Its builders had never attempted anything before on such a scale and they lived in fear of the roof collapsing. Although it was impressively long, 100 Samian feet, it was only 20 feet wide and even so the roof was supported by a row of posts down the centre of the cella. The cult image had to be placed slightly to one side of the temple because the posts would have obscured her view towards the altar.

About fifty years later the fragility of the building materials must have caused great concern. Although the cella walls had stone foundations, the upper parts were of mud-brick which needed protection from the winter rains. As a result the roof was extended and supported by a row of wooden posts which completely surrounded the whole building, seven at the front and back and seventeen down each side. This was the humble origin of the peripteral temple, a temple surrounded on all sides by columns.

We cannot yet talk about any order of architecture, for the Doric order was only established in the later 7th century BC (our earliest surviving example is the Temple of Apollo at Thermon, see p. 89; *Ill. 82*) and the first Ionic temple was begun at Samos at a much later date, *c.* 560 BC (*Ill. 87*). But simple peripteral temples can be traced back to perhaps as early as the 8th century BC when the peristyle was still structural, wooden posts supporting an overhanging roof. So far our evidence is too scanty to allow any one region of Greece to claim the invention of this significant form of architecture. But underneath the Temple of Apollo at Thermon in Aetolia in western Greece, built *c.* 640 BC, there is an earlier megaron surrounded by an oval peristyle of thirty-six wooden posts, which cannot be much later in date than the peristyle of the first Temple of Hera on the island of Samos, on the opposite side of the Greek world. The peripteral temple was a Greek invention, for no other nation surrounded their temples completely with columns, and the Greek orders developed from the attention architects gave to the details of the peristyle, in which the proportion of each part is carefully calculated.

The only other art to be continued from the Mycenaean period was pottery. Vases were left as grave offerings in

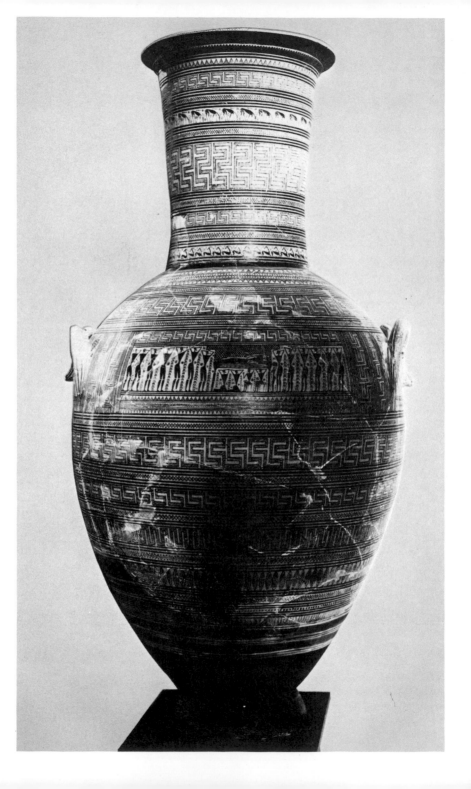

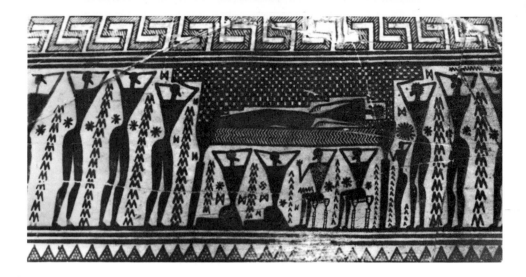

the Kerameikos cemetery in Athens all through the 'dark ages' following the Dorian invasion. Because Athens had escaped this invasion there was no abrupt change of style, but the flaccid sub-Mycenaean forms of the 11th century BC were gradually replaced by precisely drawn designs in the 10th century BC Proto-geometric period. During the 9th century BC the full Geometric style developed in Attica, lasting for two centuries, when the whole vase was covered with bands of geometric ornament. In the 8th century BC Attic vases achieved monumental proportion and the great funeral vases from the Kerameikos cemetery are over five feet tall (Ill. 72).

It was at this date that figural compositions were introduced into the vase decorations. Because they were grave offerings, the main scene represented the funeral with the dead man on his bier surrounded by mourners. The art was schematic, reducing figures to patterns with triangular torsos and knob-like heads, repeated mechanically to fill all the available space exactly like the abstract geometric ornament. It was not the intention to show natural appearances but to express the true nature of things, so that the cloth covering the dead man had to be cut away to reveal the body beneath (Ill. 73).

GREECE AND THE ORIENT

Because Athens had never been occupied by the Dorians it was the first city to recover from the succeeding 'dark ages' and in the Geometric period (9th to 8th centuries

72, 73 (left and above) Attic Geometric amphora from the Kerameikos cemetery, Athens, 8th century BC. Pottery 5′ 1″ (155). National Museum, Athens

BC) Athenian pottery was the most important in Greece. But in the 7th century BC the situation changed completely. Sparta, in the Peloponnese, had already gained control of the fertile territory of the Messenians (the first Messenian War is traditionally dated 734–724 BC) and so became the largest and most powerful city state. The other cities in the Peloponnese, in particular Corinth, were increasing in wealth because of their trade with the Near East. Rhodes and many other islands close to the rich eastern markets were also involved in this trade. Moreover, the Greek world was expanding; it was no longer confined to the shores of the Aegean. During the 8th century BC colonies were founded in southern Italy and Sicily (Magna Graecia) and in the 7th century BC this expansion continued northwards into the Black Sea. Athens played no part in this colonizing movement and as a result lapsed into a small provincial city without international contacts.

74 (right) Proto-Attic amphora from Eleusis decorated with paintings of Perseus and the Gorgons and the blinding of Polyphemus. Mid-7th century BC. Pottery 4′ 7¾″ (142). Eleusis Museum

This state of affairs is clearly illustrated in the development of painted pottery. Towards the end of the 8th century BC figural decorations became increasingly important in Attic vases and mythological subjects were introduced. The vases are monumental and daringly imaginative but the painting has lost its earlier precision and becomes slap-dash. This is seen in a 7th century BC Proto-Attic vase in Eleusis (a neighbouring town to Athens where there was an important sanctuary to the mother goddess Demeter) (*Ill.* 74). On the neck Odysseus thrusts his spear into the eye of the giant Polyphemus while the Gorgons pursue Perseus around the body of the vase. Although the bold, slashing paint strokes express the ferocity of the subject, the effect is coarse and clumsy. In contrast, the Chigi Vase, a contemporary work from Corinth, represents in minute detail an army marching into battle accompanied by a flautist. The figures are painted in black silhouette, touched with colour, and the detail engraved in with delicate precision (*Ills* 75, 76).

75, 76 (far right, above and below) Proto-Corinthian vase, the Chigi Vase, from Formello near Veii, decorated with a frieze of hoplites going into battle and a hunting scene, c. 640 BC. Pottery 11″ (27.8). Villa Giulia, Rome

Unlike Athens, Corinth was playing an increasingly important part in the trade with the Near East. Large quantities of Corinthian pottery have been found at Al Mina, a very early Greek trading post at the mouth of the Orontes in nothern Syria. When Al Mina was founded this territory was part of the Urartian empire, but it was conquered in 720 BC by Sargon II of Assyria.

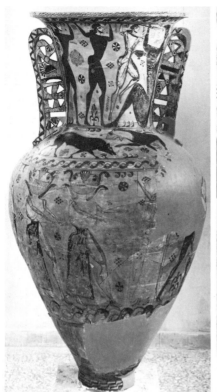

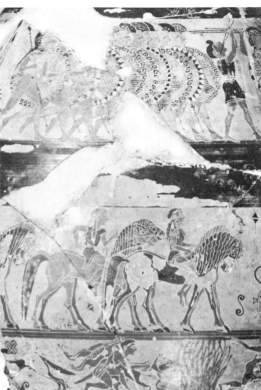

The Assyrians, in northern Mesopotamia, dominated the eastern Mediterranean and as a result their art was enormously influential. Their kings lived in vast palaces decorated with paintings and relief sculpture. The Assyrian palaces of the 9th to 7th centuries BC continued the Mesopotamian tradition that the residence of a city's king, the representative of the city's god, should be of equal importance to the temple of the gods and the ziggurats, which were incorporated into its architectural complex. The palace of Sargon II (742–705 BC) at Khorsabad stood in a city in the form of a vast square enclosed within walls a mile long, and oriented to the points of the compass. The façade of the palace was decorated with coloured tiles, and in the gateway winged man-headed bulls, guardian spirits, surveyed the approaching visitor with an awesome display of power. Inside the palace were more than life-size reliefs representing the king, courtiers and tribute scenes (*Ill. 77*).

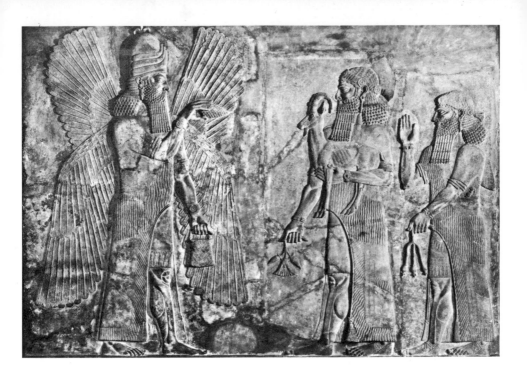

77 Relief from the palace at Khors-
abad representing Sargon II and a
courtier offering a goat. 742–705 BC.
Alabaster 5′ 5″ (267). Louvre, Paris

78 The Helmet Maker, c. 700 BC.
Bronze 2″ (5.1). The Metropolitan
Museum of Art, New York

Assyrian domination extended as far as Egypt and
Assurbanipal invaded the country in 663 BC. Egypt had
become very weak during the Twenty-first and Twenty-
second Dynasties (1085–730 BC) and in 730 BC the
country was occupied by the Kushites from the Sudan
(Nubia) who founded the Twenty-fifth Dynasty (c. 750–
656 BC). They built important temples in the Sudan,
deliberately copying Old, Middle and New Kingdom
forms. This Kushite dynasty was ended by the Assyrian
invasion, but the Nile Delta was governed independently
by princes living at Sais. Psamtik I (664–610 BC)
founded the Twenty-sixth Dynasty and regained his
country's independence from the Assyrians with the help
of Ionian mercenary soldiers. It was in this period that the
Greek trading city Naukratis was founded near the mouth
of the Nile a little to the north of the capital city, Sais. In
spite of the fact that this was an Ionian venture, the earliest
datable pottery (c. 620 BC) is Corinthian.

Oriental influences began to appear in Greek art as
early as the 8th century BC. An ivory figure of a girl from
the Kerameikos cemetery in Athens was obviously
modelled upon a Phoenician Astarte figure (Ill. 79). But

the figure is carved with restraint and lacks the blatant voluptuous beauty of the oriental fertility goddess.

A number of works on a small scale were cast in bronze in Greece during the Geometric period. To a large extent the figures were simplified into geometric shapes, resembling the forms on painted pottery. But the *Helmet Maker* (*c.* 700 BC) is exceptional in the way in which the artist has expressed the movement of the figure squatting on the ground, hard at work (*Ill. 78*).

These small votive figurines were cast out of solid bronze because the art of hollow-casting, a technique invented in the third millennium, had been forgotten in Greece. Solid bronze casting limits the size of the figure both because of the weight and the expense of the metal. Large scale sculpture was still made of wood up to the 7th century BC when artists began to experiment with more durable materials for their cult images. One such experiment is a cult image of the god Apollo, standing over 2 feet tall, from his temple at Dreros in Crete, which had been hammered out of bronze over a wooden core, and is a stiff and static figure. The difficulty of working in bronze was overcome when the art of hollow-casting was reintroduced from the Near East. We first see it in mid-7th century votive cauldrons at Olympia which were decorated with hollow-cast griffin heads, an oriental monster combining an eagle with a lion (*Ill. 80*).

The second major technical innovation in the 7th century BC was the introduction of stone, both in architecture and sculpture, through the influence of Egypt. One of the earliest known Greek stone temples was built at Prinias in Crete, towards the end of the 7th century BC. Its plan is reminiscent of a Mycenaean megaron, being rectangular and entered through a porch supported by a pillar. Inside there was a sacrificial pit containing burnt bones flanked by two columns supporting the roof. Because there are no outside columns, this temple belongs to no recognizable order, even though the Doric order had been established in mainland Greece. But on the mainland temples were still constructed of mud-brick and wood whereas the Cretan temple was built of stone. Moreover, it was decorated with stone sculpture: the lintels over the porch and doorway are carved with friezes of horsemen and animals. Seated over the doorway are two goddesses who face each other in rigid symmetry like Egyptian queens (*Ill. 81, cf. Ill. 25*).

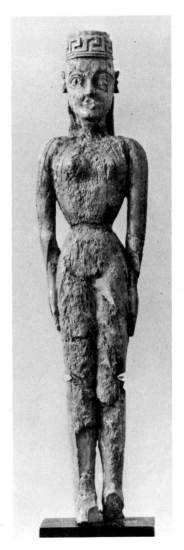

79 Statuette of a goddess from the Kerameikos cemetery, Athens, 8th century BC. Ivory 9½″ (24). National Museum, Athens

87

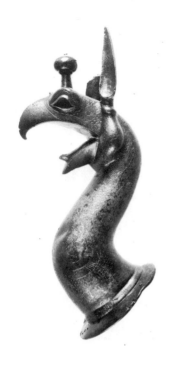

This style of 7th century BC sculpture is called Daedalic, named after the legendary Athenian sculptor who worked for King Minos. Although Crete was important in this early period, stone sculpture was appearing at the same time in the other islands and in the Peloponnese. The earliest figures represent standing girls (*korai*) wearing long dresses with shawls over their shoulders, while the young men (*kouroi*) were always naked, striding vigorously forward, arms clenched by their sides. They were carved for a variety of reasons: as cult images, attendants to the gods and as memorials to the dead. They represent ideal men and women, not individuals.

The poses of these early statues are obviously Egyptian, and can be traced back to Old Kingdom models, such as the figures of King Mycerinus and his wife (*Ill. 24*). But at this date in the 7th century BC Greek sculpture did not display the elegance and understanding of human anatomy of the Egyptian models. Nevertheless the theme was developed throughout the 6th century BC until with growing interest in human anatomy, the artist was able to break out of the rigid form of the archaic *kouros* into the balanced composition of classical art.

80 Griffin head from a votive cauldron, c. 650 BC. Hollow-cast bronze 10″ (25.4). Olympia Museum

81 Doorway with two seated goddesses from the temple at Prinias, Crete, c. 630–580 BC. Stone, height of figures c. 30″ (76.5). Heraklion Museum

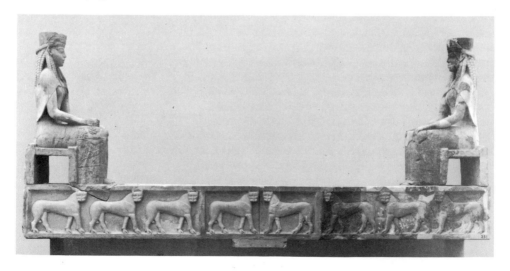

After the slow development of Greek art in the Geometric and Orientalizing periods (c. 800–600 BC) there was a sudden outburst of creative activity in the 6th century when new temples were built in stone, decorated with sculpture, and Greek painted pottery was exported all over the Mediterranean.

The Doric order had evolved during the 7th century BC in temples built out of mud-brick and wood with terracotta decorations. One of the earliest examples of a temple with definitely Doric features is the Temple of Apollo at Thermon, built about 640 BC, which has a cella with no porch at the front but one at the back (opisthodomos) and a roof supported by a central row of columns. It was surrounded by a peristyle of five columns back and front and fifteen along the sides which supported an entablature divided into architrave, frieze and cornice (*Ill. 82*). The frieze had painted terracotta panels, called metopes (*Ill. 83*), separated by triglyphs, which were grooved blocks. Thermon in western Greece had never been an artistic centre so there is no question of seeking the origin of the Doric order there. The metopes had been painted by a Corinthian artist and it is very probable that the architect came from the same city.

The great achievement of the 6th century was the translation into stone of the forms of these mud-brick and wooden temples. These materials were still used in the building of the very important Temple of Hera at Olympia c. 600 BC in which a new symmetry was given to the Doric plan and established the use of six columns at the front of the temple. But the contemporary Temple of Artemis, on the island of Corfu, a Corinthian colony, was constructed out of stone. This is one of the earliest stone peripteral temples known to us, and it was decorated with stone sculpture. The pediment was filled with a relief representing an enormous flying Gorgon (*Ill. 84*),

in the half-kneeling position used to express any rapid motion in the archaic period. Her head is wreathed in snakes and her tongue lolls out of her hideously grinning mouth; she was so horrific that anyone who looked upon her was immediately turned into stone. She is flanked by her sons and the winged horse Pegasos born from the blood of her decapitated head. On either side crouch two

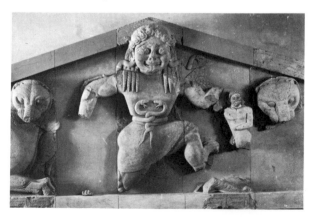

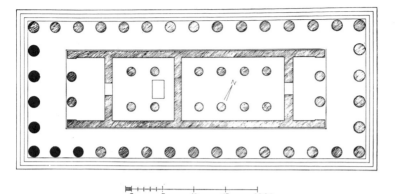

leopards and in the angles are scenes from the Trojan war
and the battle between gods and giants.

The earliest surviving stone pteron in mainland
Greece, seven columns of the mid-6th century Temple
of Apollo, is in Corinth (*Ills 85, 91*). Its plan reflects
the symmetry introduced into the Doric order by the
architect of the Temple of Hera at Olympia at the
beginning of the century. There are six massive columns
at the front and back and fifteen slightly more slender
columns along the sides. The side columns are placed a
little closer together than those at the front. The front
columns are so heavy that they are only just over four times
as high as their lower diameter (4.15:1) and they are
carved out of one single block of stone, nearly 21 feet high.
The capital, a separate block, is a broad-spreading,
flattened form which seems compressed by the weight of
the architrave above, though the delicate rising curve of
its profile expresses a springy resilience.

The dramatic use of stone in heavy columns which
support an equally heavy entablature emphasizes the
design of the whole temple which is a balance between
opposing vertical and horizontal forces. This balance
was achieved by avoiding any juxtaposition of forms
exactly at right-angles to each other; horizontal and
vertical lines were subtly modified into imperceptible
curves, and always led to another line turning in the
opposite direction. The temple stands on a four-stepped
platform which rises at an angle of 45 degrees from the
horizontal plane of the earth. The edge of this platform is
slightly curved, not only to help drain away rainwater,
but also to create a subliminal upward movement along

*85 Plan of the Temple of Apollo,
Corinth, c. 540 BC. After Gert
Kaster, 1961*

this strongly marked horizontal line. The vertical columns are tapered, growing narrower towards the neck, but the echinus of the capital spreads out in a flattened curve, anticipating the horizontal line of the architrave above. The vertical movement of the columns is repeated in miniature in the row of triglyphs in the frieze above the architrave and the conflict between horizontal and vertical in finally resolved in the triangular form of the pediment (for the meaning of these terms see *Ill. 86*).

The columns are not equally spaced: not only are the side columns placed more closely together but also those at the corners. This gives visual strength to the angles of the building, where the columns would be silhouetted against the sky, and at the same time solved the 'triglyph problem'. This problem was caused by the custom of placing triglyphs in a Doric frieze not only over and between every column, but also at each end to serve as a frame. But unless the angle triglyph was exactly the same width as the architrave, it could never be placed exactly over the centre of the angle columns and as a result the neighbouring metope had to be stretched. If the angle metope was noticeably larger than the rest it disturbed the harmony of the frieze, and at Corinth only two inches have been added to it. The discrepancy was avoided by placing the angle columns $10\frac{1}{2}$ inches closer together.

Although architecture was still experimental in the 6th century BC, especially in Sicily and southern Italy, it is still possible to talk about a Doric order which controlled every detail of a temple. But it is difficult to see any such controlling design in the temples built in Ionia which have a freedom and variety of plan unknown in the Greek mainland.

The first temple we know of with Ionic columns was built about 560 BC on the island of Samos by the architect Rhoikos (*Ill. 87*). This was the third Temple of Hera on this sanctuary (an earlier temple is discussed on pp. 80–1). At almost the same time King Kroisos of Lydia paid for the marble columns surrounding the temple of Artemis at Ephesos, on the mainland of Asia Minor opposite Samos. An architect called Theodoros worked on both buildings and they have certain features in common. Unlike Doric temples on the mainland, they were both enormous and surrounded by two rows of columns. The temple at Ephesos measures about 180 feet wide and 377 feet long, more than twice the size of

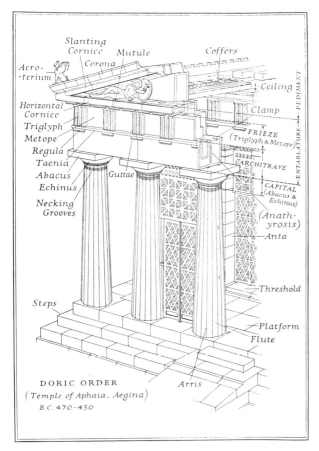

DORIC ORDER
(*Temple of Aphaia, Aegina*)
B.C. 470-450

Slanting
Cornice Mutule Coffers
Acro- Corona
-terium
Horizontal Ceiling
Cornice
Triglyph Clamp
Metope FRIEZE
Regula (Triglyph & Metope)
Taenia ARCHITRAVE
Abacus Guttae CAPITAL
Echinus (Abacus & Echinus)
Necking (Anath-
Grooves yrosis)
 Anta

 Threshold
Steps
 Platform
 Flute
 Arris

86 The Doric order (Temple of Aphaia, Aegina). After A. W. Lawrence, 1957.

the contemporary temple of Apollo at Corinth (70 foot 6 inches by 176 foot 6 inches). The front of the temple was emphasized not only by placing the columns further apart (there are only eight columns at the front and ten at the back) but also by placing rows of columns within the porch. But at Ephesos the entrance was from the west, instead of the customary east, and this western entrance was further accentuated by the unique sculptural decoration of the bottom drums of the columns. Whereas at Samos the roof of the cella was supported internally by two rows of ten columns, there is no evidence of any internal columns at Ephesos. We are forced to the surprising conclusion that this temple could never have been roofed because this span of more than 60 feet is much too wide to be covered without internal support. The

87 Plan of the Temple of Hera III, c. 560 BC. E. Buschor and H. Schleif, 1930

93

temple at Ephesos was an open courtyard, a sekos, surrounded by a magnificent dipteral peristyle (*Ill. 88*).

Unlike Doric columns, the marble Ionic columns of the temple of Artemis at Ephesos stood on bases and their proportions were much more slender. It is now estimated that they were approximately 12 times the height of their lower diameter whereas the contemporary Doric columns at Corinth were only 4.15 times their lower diameter. The shafts are fluted in a different manner; in Doric columns the flutes meet in sharp arrises but in Ionic columns they are separated by flat fillets. The echinus of a Doric capital is left plain, while that of an Ionic capital is decorated with an egg and dart moulding and spiral volutes are wrapped around it.

Although there was only one form of the Doric entablature, Ionic temples could be designed with either a frieze or a row of dentils (a row of small square blocks which imitated the beam-ends of the roof). At Ephesos the architrave was carved into three horizontal bands called fasciae and was crowned with an ovolo moulding (a decorative band with a curved cross section). Above there was probably a row of dentils, and the figural decoration was carved on a heavy marble gutter which ran around the edge of the roof.

The earliest known Ionic frieze is in a treasury dedicated by the Ionian island of Siphnos in the oracular sanctuary of Apollo at Delphi *c.* 525 BC (*Ills 90, 100*). It is a tiny structure, only 20 feet wide and 28 feet long, but it was one of the first buildings entirely of marble in the Greek mainland. Its form is based upon that of a temple, consisting of a cella and porch, but no peristyle, and instead of Ionic columns between the antae of the

88 Plan of the Temple of Artemis, Ephesos, c. 560 BC.

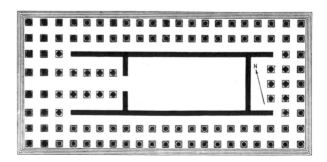

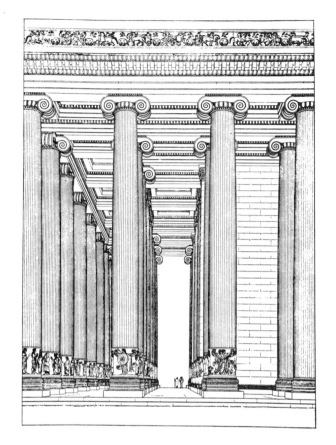

89 The porch of the Temple of Artemis, Ephesos, begun c. 560 BC. Reconstruction by F. Krischen, 1938

90 Reconstruction of the Siphnian Treasury, Delphi, after W. B. Dinsmoor, 1913, c. 525 BC.

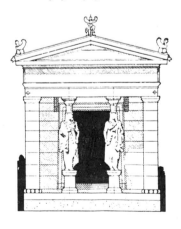

projecting walls, there are statues of women (caryatids). They support an entablature divided into architrave and a continuous frieze carved with scenes from the Trojan war over the entrance. Above it is a small pediment carved in high relief with the contest between Herakles and Apollo for the tripod at Delphi, a mythological account of the Dorian invasion.

It was about this time that marble construction was introduced into the Doric order. The Temple of Apollo at Delphi was burnt down in a fire in 548 BC and the whole of Greece contributed to its reconstruction. Judging from the style of the temple, it must have been rebuilt between 530 and 520 BC, although its excavators date it to 513 BC on the evidence of Herodotos. An exiled Athenian family, the Alkmaionids, who were

hoping to return to Athens, enhanced their personal prestige by paying for the front of the temple to be built of marble instead of poros. This innovation was developed by Athenian architects who preferred to use marble instead of limestone for though more expensive, it could be cut with an accuracy of a fraction of an inch. One of the first all-marble Doric temples, the old Parthenon on the Acropolis, was begun in Athens about 490 BC (see p. 122).

ATHENS

Athens had played no part in the great colonizing ventures of the 8th and 7th centuries BC. As a result it had become a small provincial town of no importance in either the political or artistic world. Several factors, however, brought it to prominence in the 6th century BC. Solon, after he became magistrate in 594 BC, reformed the constitution so that wealth instead of birth became the qualification for the chief administrative offices. He encouraged trade, probably introducing coinage for the first time, and developed the olive oil industry. Moreover, Peisistratos, a noble who siezed power in 561 BC, paved the way for democracy by redistributing the estates of the old landed families and thus ending their control of the government. Although a tyrant, he and his sons, Hipparchos and Hippias, changed Athens into a city with power and prestige. The prestige of Athens was further increased after his family were ousted from power in 510 BC and Kleisthenes laid the true foundations of Greek democracy.

As a concomitant of growing power and prosperity, Athens became once more an important cultural centre. The religious festivals were reformed so that they could rival those of the great international sanctuaries at Olympia and Delphi. These reforms led to the development of classical drama out of the hymns and dances in honour of Dionysos. Peisistratos organized the first competition for writing a tragedy in Athens in 532 BC, and it was won by Thespis.

Even before Peisistratos' rule, the great Panathenaic festival, held every four years, was reorganized in 566 BC, resulting in an ambitious building programme on the Acropolis. This limestone outcrop in the centre of the city had been the site of a royal palace in Mycenaean times, Homer's 'strong house of Erechtheus', and in the

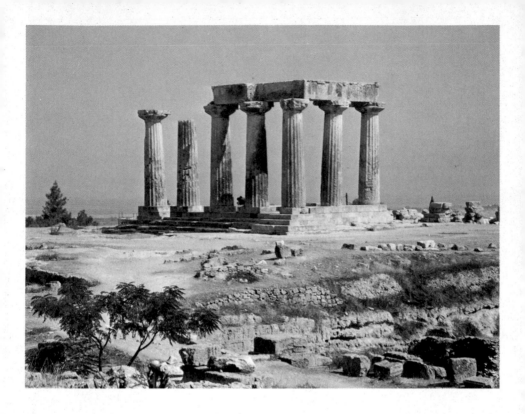

Geometric period a temple dedicated to Athena had been built over it. From the time of Solon onwards a number of temples were built on the Acropolis, but we can only speculate about their positions because they were completely destroyed by the Persians when they sacked the city in 480 BC. The debris was carefully preserved and what could not be re-used was buried within the sacred enclosure. A number of pedimental groups, carved out of limestone, have been excavated, among them three colossal works obviously designed for some major temple. This was probably the Hekatom-pedon, the 'hundred-foot temple', which is believed to have stood on the site of the Parthenon, built for the inauguration of the new Panathenaic festival.

The pedimental groups from the Acropolis show the importance of Athens in the development of sculpture in the 6th century. The early pediments, such as the one from the Temple of Artemis on Corfu (*Ill. 84*) were in low relief. But the three colossal groups from the Athenian temple were carved in high relief displaying a thorough

91 Temple of Apollo, Corinth, c. 540 BC. Limestone

97

92 The Moschophoros, c. 560 BC. Marble from Mount Hymettos, 56" (168). Acropolis Museum, Athens

understanding of three-dimensional form. The angle of the pediment was filled by a three-bodied deity, Nereus, the spirit of the sea, who could change his shape at will and was one of the adversaries of Herakles (Ill. 95). The upper part of his triple body is human but winged; below the waist he becomes three twining serpents. Instead of representing him as a horrific monster, the sculptor has emphasized his human aspect and he reclines in his corner with a broad, benevolent smile on all his faces. They are carefully placed at different angles so that the nearest faces the spectator, the second is in three-quarter view while the furthest away is in profile.

Peisistratos continued this building programme on the Acropolis by reconstructing the Old Temple of Athena (c. 530 BC), a temple on ancient foundations on the site of the Mycenaean palace. Although destroyed in 480 BC and partially covered by the south porch of the Erechtheion, the foundations and fragments of the pediment have survived. It was a Doric temple which derived its plan from the Temple of Apollo at Corinth, but it is possible that the end of the cela was decorated with an Ionic frieze. For the first time the pediments were filled with sculpture in the round, carved out of marble from the island of Paros, representing at the east end the battle between gods and giants (Ill. 93).

The temples of Athena on the Acropolis were surrounded by votive offerings. The *Moschophoros*, carved about 560 BC, represents an Attic farmer bearing his offering of a calf to the temple (Ill. 92). Although the forms of the figures have been simplified into geometric shapes, the figure is alert and expressive. He strides forward, wearing only a thin cloak over his shoulders, and the calf is slung across his back. The man grasps the animal's legs and the cross-shaped pattern formed by their arms and legs draws attention to their contrasted heads.

The *Moschophoros* was carved by an Attic sculptor out of local marble from Mount Hymettos. Many Greek cities were developing their own schools of sculpture in the first half of the 6th century BC and there is a marked difference in style between the work of Dorian and Ionian artists. But Athens was proud of her independence during the Dorian invasion and regarded herself as the starting point of the Ionian migrations. Although the major temples in Athens were in the Doric order, the

93 Athena and a fallen giant, from the pediment of the Old Temple of Athena, Athens, c. 520 BC. Parian marble 6′ 7″ (200). Acropolis Museum, Athens

severity of the style was tempered by Ionic elements and Athenian artists managed to combine the best features of the Dorian and Ionian worlds.

The Dorian world, dominated by Sparta, was noble and serious, and its temple architecture has gravity achieved through carefully calculated proportions. In contrast, the Ionians had a reputation for brilliant wit and frivolity, and their temples were lavishly decorated. Moreover, they admired feminine charm. As H. D. F. Kitto has pointed out, nobody could imagine a Dorian poem including the line, 'I hate a woman thick about the ankles.' Under Peisistratos a number of statues of handmaidens (*korai*) by Ionian sculptors were dedicated in the temples of Athena on the Acropolis. They are extremely sophisticated girls with elaborately-dressed hair trailing over their shoulders in ringlets, and they clutch their brightly-embroidered skirts to reveal their slim figures (*Ill. 94*). Alas, their ankles rarely survive, but they were obviously as elegant as their figures.

In contrast, the *Peplos Kore* (*Ill. 96*), an Attic figure of about 530 BC, wears Dorian costume and stands with grave dignity in her heavy woollen tunic, her hand outstretched in offering. She lacks the *élan* and rather artificial elegance of her Ionian counterpart, but the radiant expression on her face is exquisitely modelled

94 Kore from the Athenian Acropolis, c. 530 BC. Marble from Chios 47½" (121). Acropolis Museum, Athens

95 Triple-bodied deity, Nereus, from the corner of a temple pediment on the Acropolis, Athens, c. 560 BC. Painted limestone 28" (71). Acropolis Museum, Athens

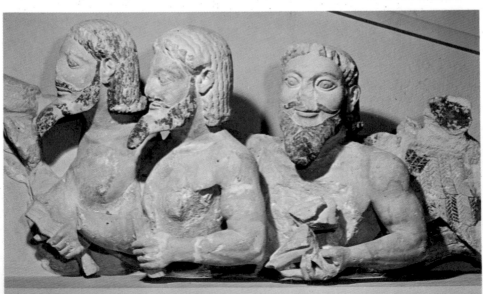

and there is a delicate balance between youthful freshness and gravity which anticipates early classical sculpture.

During the 6th century BC Greek sculpture became increasingly naturalistic. The *kouros*, the naked standing youth, was the most popular subject, both as a votive offering and as a cult image of Apollo. It retained its stiff Egyptian stance, but the modelling of the figure came to resemble more and more that of the human body instead of being treated as an abstract pattern. It reflects the Greek preoccupation with the human body derived from their religious festivals which included athletic contests. This began at Olympia where the funeral games in honour of Pelops were transferred to the cult of Zeus. By 720 BC naked athletics had become the established ceremony after the winner of the foot-race had accidentally dropped his loin-cloth. Herodotos realized that the Greeks were exceptional in their admiration of the naked male figure, 'for with the Lydians, as it is with most barbarian races, it is thought highly indecent even for a man to be seen naked'. But to the Greeks the naked athlete represented a fusion of supreme personal achievement combined with piety, for the athletic competitions were religious festivals performed in honour of the gods. The perfectly developed male figure became the standard for the whole of Greek art.

The early figures, such as the *Kouros* of Sounion carved about 600 BC to stand before the Temple of Poseidon at the most eastern tip of Attica, is impressive because of its sheer size and abstraction of form (*Ill. 97*). Muscles are indicated by incised lines and the face is framed by ears resembling volutes. The *Kouros* of Anavysos, carved some sixty years later, is standing in the same pose, but the proportions are no longer colossal. Each detail of the human figure is a separate problem to be solved: the spiral of the ear, the insertion of the eye and lips into the planes of the face. Although the hair is still treated as a formal pattern, the body is beginning to suggest the soft texture of flesh.

But the *kouros* lost its rigidity only at the end of the century with the development of large-scale hollow-cast bronze sculpture. The *Kouros* of Piraeus (*Ill. 98*) is a statue of Apollo, holding a bow in his bent left arm. The right is outstretched, and so the rigid *kouros* position with hands clenched beside the legs is relaxed. Instead of gazing outwards into space, the god looks slightly

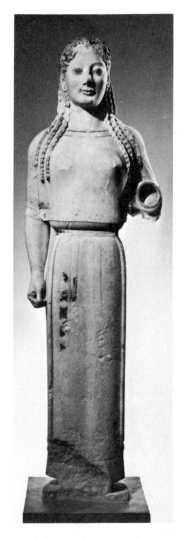

96 The Peplos Kore *from the Acropolis, Athens, c. 530 BC. Parian marble 48" (121). Acropolis Museum, Athens*

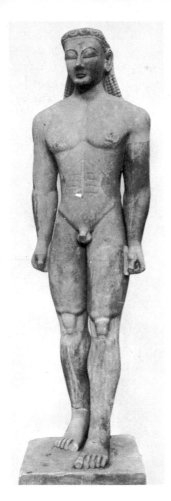
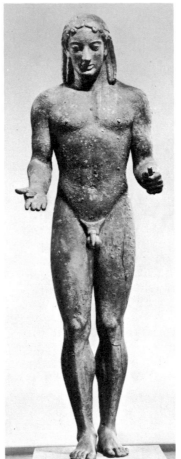
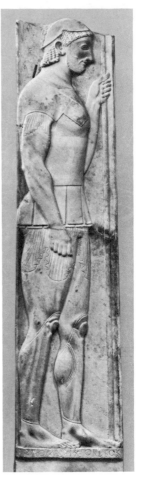

97 Kouros of Sounion, c. 600 BC. Marble, over lifesize, c. 10′ (305). National Museum, Athens

98 Kouros of Piraeus, c. 520 BC. Bronze, lifesize. National Museum, Athens

99 Grave stele of Aristion by Aristokles, c. 500 BC. Marble, over lifesize, 8′ (244). National Museum, Athens

downwards, as if aware of the worshipper. He stands in a calm, effortless position with feet close together, in contrast to the vigorous striding attitude of the earlier figures. The hair now falls in soft ringlets over the shoulders, which are modelled to express the form of the muscles beneath the skin. The sculptor has now mastered the details of the stomach muscles and the trunk is no longer given an unnatural three-part division.

Unlike oriental gods, who were represented as super-human beings in rigidly defined postures, Greek gods were presented as idealized men and women. The frieze of the Siphnian Treasury at Delphi, carved about 525 BC, represents an animated council of the gods at the out-break of the Trojan war (*Ill. 100*). The Olympians are so passionately involved in the argument that they turn round to dispute with those behind them. In the battle scenes between gods and giants along the sides of this building no distinction was made between human being and divinity, and all fight with furious abandon. The twisted poses have been carefully modelled in relief to suggest the solid volumes of the body set at different angles.

The ability to represent the human figure in relief is seen in the Athenian tombstones of the end of the 6th century BC which exhibit a new restraint and simplicity: the shaft becomes much shorter and is surmounted by a simple palmette. The stele of Aristion, signed by the sculptor Aristokles (*Ill. 99*) represents him fully armed cheerfully guarding his own grave.

This increasing interest in the human figure is also found in Athenian vase painting which, during the 6th century BC, became the most important in Greece. The Athenian painters borrowed the black-figure style, with

100 The Council of the Gods, from the east frieze of the Siphnian Treas-ury, Delphi, c. 525 BC. Parian marble, height of frieze c. 25″ (63). Delphi Museum

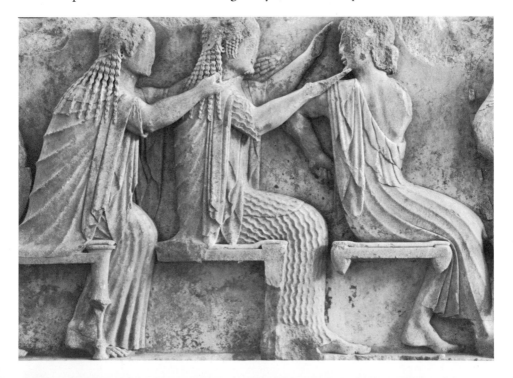

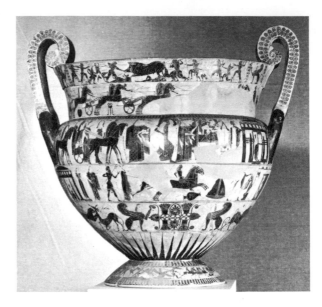

101 The 'François Vase' from Chiusi by the potter Ergotimos and the painter Kleitias, c. 570 BC. Pottery 27" (66). Archaeological Museum, Florence

its refinement in handling the decorations, from the Corinthians and developed it into a monumental style of their own.

One of the most important of these early vases is the 'François Vase' (*Ill. 101*) signed by the potter Ergotimos and the painter Kleitias. Like so many Greek vases, it was discovered in an Etruscan tomb in Chiusi and shows that, even as early as 570 BC, the Athenians had begun an important export trade in their pottery. It is a volute krater, a bowl for mixing wine and water (the Greeks never drank their wine undiluted) with handles curving in volutes over the rim. It is divided into narrow bands filled with nearly two hundred minutely painted figures which clearly reveal Athens' debt to Corinth. The range of subjects shows the vast repertoire of Athenian painting even at the beginning of the 6th century BC: on the lip is the return of Theseus from Crete and the Caledonian boar hunt; in the next band is the battle between centaurs and Lapiths and the funeral games of Patroklos; the main band around the shoulder is slightly broader and is decorated with the wedding of Peleus and Thetis and the arrival of their guests; underneath is the return of Hephaistos to Olympos and the ambush of Troilos. The bottom frieze is decorated with oriental animals, sphinxes and griffins face to face, and the base is covered with a

fight between pygmies and cranes. Even the handles are decorated with two scenes: above, the Mistress of the Animals holds a panther and a deer, while below, Ajax staggers beneath the weight of the dead body of Achilles. In spite of its overcrowded compositions, the individual figures are painted with a feeling for movement and life, with contrasts in mood from comedy to tragedy.

Black-figure painting reached its climax with the work of Exekias, who began his career about 550 BC. Abandoning the profusion of figures in the early vases, he returns to the large simple designs of the Proto-Attic vases (*Ill. 74*), yet paints with the refinement and elegance of the Corinthian ware (*Ill. 75*). A black amphora from a tomb in Vulci is relieved by two large red panels in the middle of each side filled with monumental figures, drawn in black silhouette (*Ill. 102*). On one side the Dioskouroi, Kastor and Polydeukes, are greeted by their parents, Leda and Tyndareos. A hound leaps up to welcome Polydeukes while Kastor, wearing a travelling cloak, holds his horse and his father caresses the animal's muzzle. Helen of Troy was the Dioskouroi's sister and her abduction had been the cause of the Trojan war. A scene from the long siege during this war is illustrated on the opposite side where Achilles and Ajax are represented playing dice (*Ill. 103*). Achilles has just won the throw, for he calls out four while Ajax has only three. They lean forward over the gaming board, holding their spears which form a great V-shape in the centre of the composition. This is counterbalanced by the backward tilt

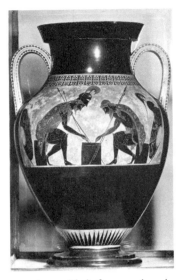

102, 103 Black figure amphora by Exekias, c. 550–540 BC. Pottery 24″ (61). Vatican Museum. (below) Detail of Achilles and Ajax playing dice

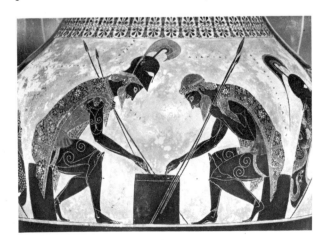

of the shields behind the figures, so that the whole panel is harmoniously filled without being overcrowded. The black silhouettes are delicately relieved by the marvellously intricate engraved detail.

The subjects emphasize the humanity of the Homeric heroes. Although two men playing a game would appear to be a trivial subject, it represents a peaceful moment before the tragedy of the coming death of both Achilles and Ajax. Achilles was killed in battle, and Ajax committed suicide. There is an underlying sense of tragedy in this work which anticipates the gravity of 5th century painting.

Black-figure painting created a very effective decoration on the vase, but the figures tended to be treated as patterns, rather than human beings. It is a measure of the greatness of Exekias that within the limitations of his technique he could create such monumental figures, but later painters felt the need for greater naturalism. There was a simple and obvious answer, and that was to abandon the black figures and paint the background black instead, leaving the figures the natural red colour of the clay, close to the colour of sunburnt human flesh, which could then be modelled with graded lines and washes of black paint.

The red-figure technique was invented about 530 BC by an artist named after the man who made and signed his vases, the Andokides painter. He worked in both techniques because the black-figure decorations were much too effective to be abandoned immediately. Both styles existed side by side for more than a decade before the red-figure style finally triumphed as a result of the increasing interest in naturalism, which affected not only sculpture but also painted pottery. The relationship between painting and sculpture can be seen in the work of Oltos, at the end of the 6th century BC, who painted a large cup now in the National Museum in Tarquinia (*Ill. 104*). The inside is decorated with a medallion of a warrior wearing a leopard skin and a Corinthian helmet, and holding a shield with the device of a crouching lion. On one side of the outside rim, Dionysos mounts his four-horse chariot accompanied by satyrs and maenads. On the opposite side, the gods on Mount Olympos are seated around the enthroned figure of Zeus. As in the frieze on the Siphnian Treasury (*Ill. 100*), they are all represented in profile, but deeply involved in an animated conversation.

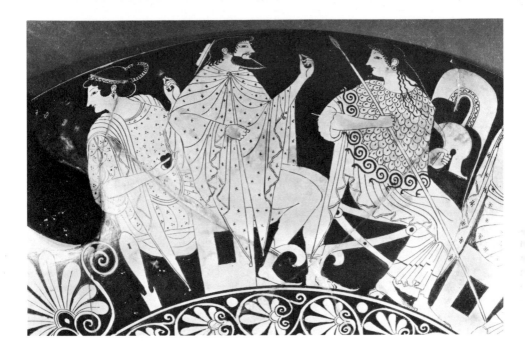

One of the greatest painters at the end of the 6th century BC was Euphronios, who was interested in representing the human figure in action. Like Exekias, Euphronios used a variety of subjects, and one of the most attractive of all Greek vase paintings is a cup in the Antikensammlung in Munich (*Ill. 105*). The outside is decorated with one of the Labours of Herakles, in which he captured the cattle of Geryon, and the straining, muscular figures are modelled in carefully graded lines of black paint.

In contrast the medallion inside the cup represents a horseman, perhaps an idealized painting of the boy Leagros, son of Glaukon, who later became an Athenian general. The young horseman is dressed in the height of fashion, wearing a sunhat and a brightly patterned cloak. Although young and beautiful he has the strength to curb his restless mount who prances with arched tail. There is balance between physical beauty, refined taste which enjoys ornament, and animal strength. It is a painting which can be enjoyed for its own sake, yet at the same time it is a perfectly composed decoration which fills a circular medallion in a drinking cup.

The decorations of Greek vases are unique in being expressive works of art which also enhance the shape of

104 The gods on Mount Olympos by Oltos, c. 515–510 BC. Pottery, diameter of cup 20½" (52). National Museum, Tarquinia

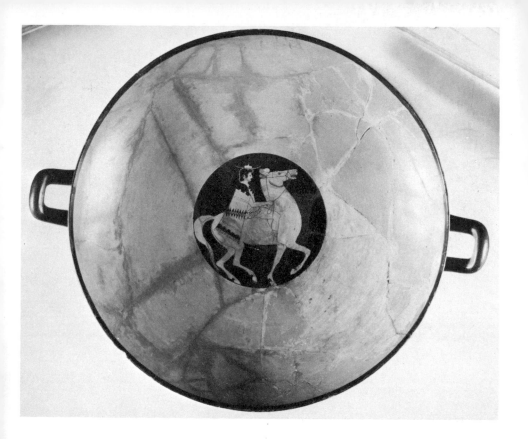

105 Cup interior with a horseman by Euphronios, c. 510–500 BC. Pottery, diameter of cup 17″ (43). Antiken-sammlung, Munich

the pot on which they are painted. Yet the technique was only a refinement of the methods of the Neolithic potters (see pp. 24–5) in which the colours were obtained by painting with washes of clay which were fired first in an oxidizing atmosphere to create a red colour, then in a smoky reducing atmosphere to produce the blacks, and finally again in an oxidizing atmosphere to restore the reds. The high gloss of Athenian vases was achieved solely by the purity and fineness of the clay without the use of glazes.

Although Athenian vase painters were using a technique which had originally been invented by Neolithic farmers more than five thousand years earlier, the style of their paintings was completely new. Vase painting, with its change to red-figure decorations, seems to have been the first art to make the breakthrough into greater naturalism which distinguishes the classical art of the 5th century BC from that of the archaic period.

A new oriental power now dominated the eastern Mediterranean. From the middle of the 6th century BC Persia had expanded westwards, occupying first Lydia and then the Greek cities along the Ionian coast. The Ionian cities revolted in 498 BC and appealed to Greece for help; only Athens and Eretria responded but the Persians realized that if they were to control Asia Minor they would have to conquer Greece. The Persian king Darius sent a huge army and fleet to sack Athens and Eretria in 490 BC, but this was defeated by a small army of Athenian and Plataean soldiers at the battle of Marathon (in Attica, close to Athens). This seemed to be only a temporary set-back and Darius' son Xerxes planned an ambitious expedition ten years later to attack Greece along the coast from the north. The Spartans attempted to halt their advance at Thermopylae, but

106 Temple of Aphaia, Aegina, begun c. 510–500 BC. Limestone

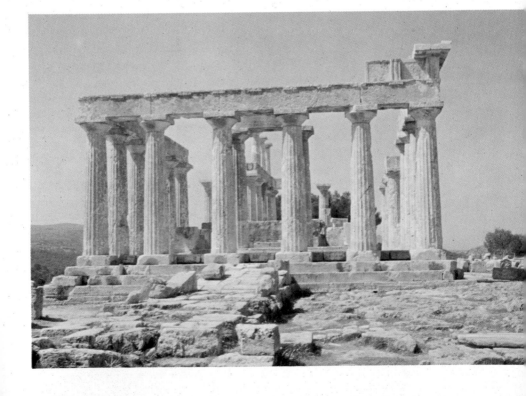

were defeated, and so Athens was occupied. The city and the Acropolis were sacked, though the Athenian army and navy were safe on the island of Salamis. This was the last obstacle the Persians had to overcome before crossing the isthmus of Corinth into the Peloponnese and thus controlling the whole of Greece. But the Persian navy was trapped in the confined waters between Salamis and the mainland, and having been tricked into fighting a decisive battle, was defeated by the Greek fleet led by Athens. The Greek army, led by the Spartan general Pausanius, then defeated the Persian land forces in the battle of Plataea in 479 BC. For the first time the united forces of Greece had been combined in a great national victory against an overwhelming danger.

During this period of crisis Greek art gained a new self-confidence and no longer harked back to the example of the surviving Bronze Age civilizations. We see this change of style first in the Temple of Aphaia at Aegina, an island off the coast of Attica, which though independent of Athens, was influenced by Attic art (*Ills 86, 106, 107*). The temple was begun between 510 and 500 BC; it is a delicate and precise building with a completely clear and logical structure in which all the major features are related to each other in simple geometric proportions. The plan is already inherent in the foundations: the columns stand in the centre of every other stylobate block. There are six columns at the front and twelve along the sides, spaced 8 Doric feet apart (the interaxial is from the centre of one column to the centre of the next) and are 16 feet tall. The diameter of the bases is 3 Doric feet so the space between the edge of one column to the edge of the next is 5 feet, producing a simple numerical relationship of 3:5 between column diameter and intercolumniation.

The columns are unusually light. Whereas Peloponnesian architects chose enormously heavy Doric columns (e.g. Corinth 4.15:1), the Athenians preferred a more slender form, perhaps because of Ionic influence. The height of the columns at Aegina is 5.32 times their lower diameter, resembling the 5.48:1 proportion of the later Parthenon. The lighter proportions give grace to the building and new refinements were added: the columns lean inwards about $\frac{3}{4}$ inch and the angle columns, silhouetted against the bright sky instead of the dark cella, are $\frac{3}{4}$ inch thicker and placed $8\frac{1}{2}$ inches closer together.

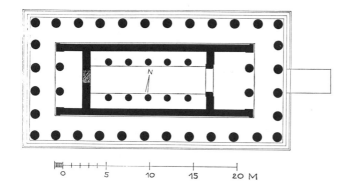

107 Plan of the Temple of Aphaia, Aegina. After E. Fiechter, Aegina, 1906

The building was lavishly decorated. Even though the cella was so small that there was no structural need for internal support, it contained two rows of five columns supporting an architrave and a second row of columns. They formed a magnificent frame to the goddess's statue.

The pediments were filled with sculpture carved out of marble from the island of Paros. The east pediment was replaced between 490 and 480 BC, perhaps because the original group had been damaged by lightning. Figures from both pediments were discovered in 1811 and acquired by Ludwig of Bavaria who had them restored by the neo-classical sculptor Thorvaldsen. New excavations in 1901 uncovered the original sculpture of the east pediment which is now in the National Museum in Athens. Both represent scenes from the Trojan war, with a figure of Athena at the centre. But in the later eastern pediment the style of the sculpture has changed from archaic to classical. The movement of the earlier figures is jagged and the sculptor is uneasy about the articulation of the body. In contrast, the dying warrior from the second pediment collapses with sagging arms and head, expressing the pathos of death (*Ill. 108*).

Early classical temple architecture and sculpture reached its apogee in the Temple of Zeus at Olympia, one of the most important sanctuaries in the Greek-speaking world. Until 470 BC the sanctuary had been controlled by the local city of Pisa, but the city of Elis captured it and built a new temple dedicated to Zeus out of the proceeds of the sack of Pisa.

The building was designed by a local architect, Libon of Elis, and was built of the local limestone though the roof tiles and sculpture were of marble. It shows an almost

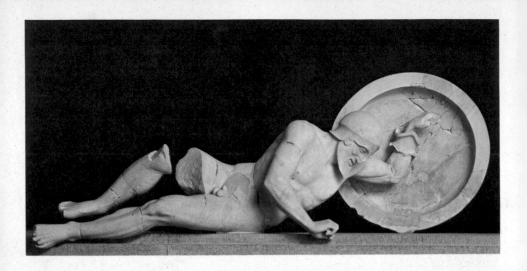

*108 Dying warrior from the east
pediment of the Temple of Aphaia,
Aegina, c. 490–480 BC. Marble
6′ 1″ (185). Glyptothek, Munich*

obsessive interest in proportion. The surrounding pteron
has six by thirteen columns, corresponding to the formula
which provides the best mathematical proportions: if you
have *n* columns along the front, then there should be
$2n + 1$ columns along the sides. Libon took the Olympic
foot (slightly larger than our own), as his unit of measure-
ment: the total length is 200 feet, the height of the external
columns 32 feet, the normal interaxial (it was narrowed
at the corners) 16, the width of the abacus 8, the distance
between triglyph centres 8, and all other measurements
show a similar simple numerical relationship.

The sculpture expresses national pride even though the
references are local. The twelve metopes represent the
Labours of Herakles, a local theme, but with national
significance. Herakles, son of Zeus and grandson of
Pelops, while carrying out his labours, had marked out
the boundaries of the Altis, the sacred enclosure of the
Sanctuary of Zeus at Olympia. He was not only a local
hero; he represented the ideal athlete, with a perfectly
developed body used for the benefit of humanity. The
sculpture of the metopes carefully analyses the movement
of the human body. In one panel (*Ill. 109*) Herakles sup-
ports the universe while Atlas fetches the golden apples
of the Hesperides. This Labour taxes his strength to the
utmost, even though the task is made a little more
comfortable by placing a cushion on his shoulders. But
Athena, beside him, effortlessly raises one arm to assist
him with his burden. This action displaces the drapery
of her peplos, so a slight fold appears at the neck and a

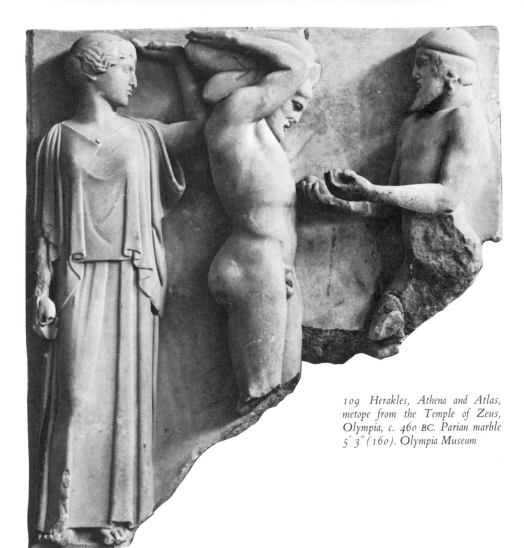

109 *Herakles, Athena and Atlas, metope from the Temple of Zeus, Olympia, c. 460 BC. Parian marble 5' 3" (160). Olympia Museum*

series of catenary curves are formed between the breasts. The skirt falls in simple, vertical folds except where the relaxed, bent right leg catches the material and pulls the drapery to one side. The play of the folds has been rigorously simplified to express the *contrapposto* position of the figure beneath.

The east pediment over the entrance represents the start of the chariot race in which Pelops made himself master of Elis by defeating Oinomaos, thus giving his name to

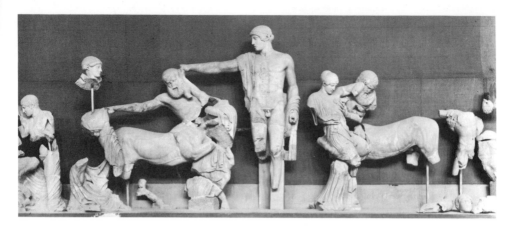

110, 111 Apollo directing the battle between Lapiths and Centaurs, from the west pediment of the Temple of Zeus, Olympia, c. 460 BC. Parian marble. Olympia Museum. (below) Detail of a Lapith woman

the whole Peloponnese. This may refer to the recent victory of Elis over Pisa.

The back of the temple was decorated with a battle between centaurs and Lapiths at the wedding feast of King Pirithous, grandson of Zeus. Zeus' son, Apollo, comes to the aid of the Lapiths by directing the fight (*Ill. 110*). He stands in the centre of the seething mass of struggling centaurs, their faces distorted by the passion of battle, as a calm and curiously archaic figure. His figure was obviously modelled on that of a *kouros*, but his head is turned dramatically at right-angles and his arm is imperiously outstretched beyond the confines of the block of marble from which the figure was carved. He is given this position of prominence in his father's temple because he was an essentially Greek god. As patron of the arts he represented all that made life humane and decent, and his presence ensured the continuation of civilization.

The unique character of Greek sculpture at this date just after the Persian war can be seen by comparing it with contemporary work in Persia. The stiff formal figures of Darius giving audience, which decorate the treasury at Persepolis (*Ill. 112*), have nothing in common with the vigorous striding figures of the *Tyrannicides* (*Ill. 113*). Although originally both Greek and Persian artists were very much influenced by Assyrian sculpture (*Ill. 77*), only Greek artists had developed a new style which no longer accepted the conventions of Bronze Age art.

A group by Antenor had been set up in the Athenian Agora to celebrate the restoration of the democracy after the murder of Peisistratos' son, Hipparchos. The statues

had been carried off by the Persians after the sack of the city in 480 BC and a second group was modelled in bronze by Kritios and Nesiotes between 477 and 476 BC. The attacking figures have been idealized and the two men are strongly contrasted. Aristogeiton is represented as a mature man, holding his sword in his lowered right hand while his left arm with cloak and scabbard is out/ stretched before him. Harmodios is younger and beard/ less, and his sword is raised violently above his head. Each detail of the figures has been compared and con/ trasted, so that in spite of the violent movement, the dynamic composition is balanced.

Having solved the problems of representing each different part of the body, one of the main concerns of sculptors at the beginning of the 5th century BC was with the expression of movement. There was no distinction between the representation of men and gods, and it was the actions of the athletes which gave sculptors their poses. *Poseidon* in the National Museum in Athens, cast about 460 BC, is represented hurling his trident in exactly the same pose as a javelin thrower (*Ill. 114*). He stands poised, left foot advanced, right arm outstretched behind him, with the trident balanced on his fingers as he looks at the enemy he is about to annihilate. It is only the over/ whelming power of the figure, achieved through superb flow of movement and powerful modelling of the torso and head, which distinguishes him as a god.

According to Pliny, Myron was one of the pioneer artists who broke away from the severe forms of the early 5th century BC 'by having more rhythm in his art'. The

112 Relief from the treasury, Per/ sepolis, representing Darius giving audience before two fire altars, 521– 486 BC. Stone, length 20′ (610). Archaeological Museum, Teheran

113 The Tyrannicides, Roman copy of a bronze group by Kritios and Nesiotes, 477–476 BC. Marble 6′ 8″ and 6′ 4¾″ (203 and 195). National Museum, Naples

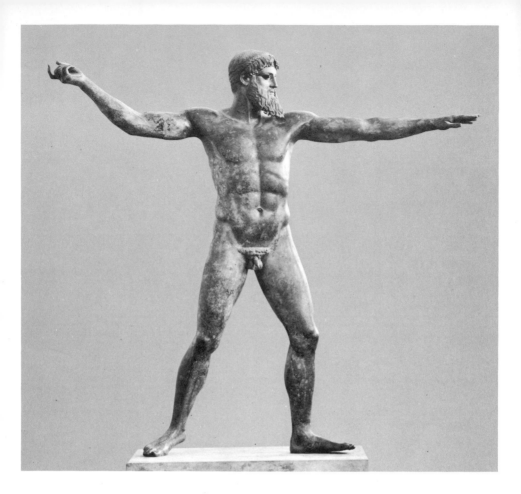

114 Poseidon *from the Roman ship-*
wreck off Cape Artemision, Euboea,
c. 460 BC. Bronze 6′ 10¼″ (208.6).
National Museum, Athens (see Ill. 2)

Diskobolos, originally a bronze statue of *c.* 450 BC, has
survived only in poor Roman copies in marble which
give little idea of the powerful movement of the original
(*Ill. 115*). Myron expresses movement by choosing that
fraction of a second when the body is stationary before the
direction of an action is reversed. The athlete is at the end
of his wind-up, the disk swung around to the back of the
body before being projected forward. The imminent
forward motion is expressed by the arms which frame the
head and torso like waves from a ship's bow, yet he
himself looks backward. The whole torso is twisted,
with shoulders virtually frontal, while the legs are in
profile. This gives the figure dynamic tension, Pliny's
'rhythm', yet at the same time there is equilibrium between
the opposing forces.

This new freedom of movement led to the end of the *kouros* as a votive figure. A standing boy (*Ill. 116*) discovered among the rubble of the Acropolis from the Persian sack of the city, has been attributed to Kritios because of the resemblance of the head to that of Harmodios, the younger *Tyrannicide* (*Ill. 113*). The boy, carved just before 480 BC, was a victor in the Panathenaea. Instead of being represented in the conventional striding position, he is standing at rest, his weight on his left leg and the right leg relaxed, bent at the knee. As a result, the pelvis is tilted at a slightly different angle from the shoulders. This creation of a *contrapposto* position is the essence of classical sculpture; the artist shifts the axes of the figure by carefully contrasting the positions of the arms and legs. The planes of the figure are clearly defined and this is helped by the change of hairstyle. In the 6th century BC youths wore their hair trailing in ringlets over their shoulders, but the hair of the 'Kritian Boy' is rolled

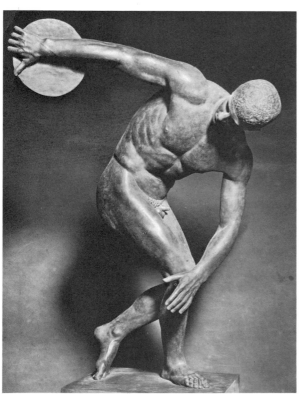

115 *The* Diskobolos, *a reconstruction from Roman copies of the bronze statue by Myron, c. 450 BC. Bronze 5′ ¼″ (153). National Museum, Rome*

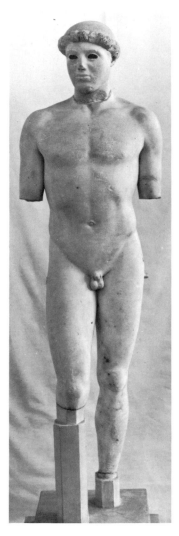

116 The Kritian Boy, *before 480 BC. Marble 33" (84). Acropolis Museum, Athens*

up above his ears, forming an emphatic horizontal line above his brow. Having defined the planes of the head, shoulders and pelvis, the artist has set himself the problem of explaining their articulation.

The *contrapposto* position is most clearly seen in the work of Polykleitos, a sculptor from Argos who worked mainly in bronze. His major work is the *Doryphoros, c.* 440 BC (*Ill. 117*), the spear-bearer, which has survived in innumerable Roman copies. It represents a young man holding a spear over his shoulder in his raised left hand. His weight is entirely on his right leg and only the toes of the left touch the ground. As a result the pelvis is strongly tipped while the shoulders slope in the opposite direction, emphasized by the tilt and turn of the head to the right. These movements are much more strongly marked than in the 'Kritian Boy', carved forty years earlier, and the articulation of the opposing planes of shoulders and hips is explained by the clearly defined muscles of the torso.

The statue is obviously a very carefully worked-out study in proportion; the main divisions of the body, such as the pectoral muscles and the iliac crest at the tip of the pelvis, come at distances equal to the length of the head. Polykleitos wrote a book on proportion, called the *Kanon* or 'measuring rule', and used one of his own statues, probably the *Doryphoros*, to illustrate his principles. This text has been lost and so far we have been unable to reconstruct the details of his system from measurements of the Roman copies. This may be due to the inaccuracy of the Roman copies, but Polykleitos is credited with a rather obscure statement that 'perfection very nearly is engendered out of many numbers' (Philo Mechanicus, *Syntaxis* IV, 1). He seems to imply that although beauty has a geometrical basis it must transcend pure mathematics.

Greek sculpture in the 5th century BC was confined almost entirely to one subject, the human figure. Although the Olympian gods were remote figures, they were given human form and emotions. A wide gulf separated mankind from the gods, but they were not intrinsically different and it was possible for exceptional human beings, such as Herakles, prince of Tiryns, to become gods. The Athenian philosopher Protagoras (*c.* 485–415 BC) suggested that there must be a divine element in human nature because man 'was first of all the only creature to believe in gods because of his kinship

with the godhead'. He also claimed that 'man is the measure of all things'.

Greek artists were not interested in individual men but in humanity and the structure of the human body. As a result of this growing understanding of human anatomy, Greek art became increasingly naturalistic. No artistic writings have survived from this period, but leading artists wrote treatises and their theories must have influenced Plato and Aristotle in the 4th century BC. Both defined art as *mimesis*, usually translated as 'imitation', though the word 'representation' renders the sense more accurately. Human actions could be represented in verse, song and dance, while the visual arts represented appearances.

Both Plato and Aristotle were concerned with the problem of representation for they realized that if a work of art exactly imitated appearances it would lose all artistic value, becoming a mere copy. Plato's philosophy is dominated by his awareness that appearances change according to the point of view, although the geometrical form which governs these fluctuating appearances remains unchanged. This unchanging reality cannot be experienced directly through the senses but its existence can be deduced rationally. He pictured the inhabitants of this world of the senses as prisoners in a cave chained so that they could never see the entrance or the world outside. They could only see flickering shadows cast by objects carried in front of a fire at the entrance and so had no idea of what the world was like outside. The artist who copied appearances would be making a shadow of a shadow, taking us one step further from truth and reality. But the true artist should create an ideal image, not an imitation of appearances, that would recreate the real form.

As a result Greek artists were not interested in the individual, but in mankind in general and the gods who represented ideal human beings. No woman on earth could be entirely beautiful, so to give a true idea of beauty it would be useless to represent one individual woman. 'When you copy types of beauty,' Socrates tells the painter Parrhasios, 'it is so difficult to find a perfect model that you combine the most beautiful details of several, and thus contrive to make the whole figure beautiful.' (Xenophon. *Memorabilia* III, X, 1)

Plato had no doubt about the nature of beauty: 'The qualities of measure and proportion . . . invariably

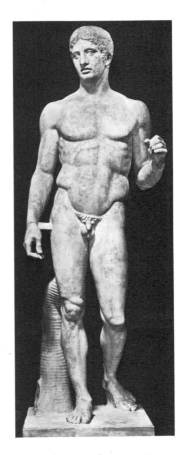

117 The Doryphoros, *a Roman copy of the bronze statue by Polykleitos, c. 440 BC. Marble 6' 11½" (212). National Museum, Naples*

constitute beauty and excellence.' This is repeated by Plotinus seven hundred years later: 'In things seen, the beautiful is the symmetrical and proportioned.' The Greeks had always been interested in geometrical shapes, as we can see in the decorations of Greek pottery in the 9th and 8th centuries BC (Chapter Six). But geometrical proportion, where a line is divided at a carefully calculated point, was a new·element which came into Greek art in the 6th century. It can be related to the philosophy of Pythagoras, who had discovered that musical intervals corresponded to the geometrical proportions into which a stretched string was divided. If it was divided in half, i.e. 1:2, the tone was raised an octave, 2:3 a fifth, 3:4 a fourth, 8:9 the whole tone. This discovery that music had a rational basis which could be expressed in math-ematical formulae was extended into the visual arts. Pythagoras believed that this was only a small portion of the underlying mathematical order of the universe, which was reflected in the arts.

Greek artists therefore searched for the simple geo-metrical harmony behind the confusion of sense impressions, and represented the natural details as they corresponded to this harmony. The result was an economy of expression in which the basic pattern was stressed in order to suggest the full complexity of life derived from this basic order. To the artists of the 5th century BC there was no conflict between appearance and reality, for appearances reflected a universal order when interpreted by a rational mind.

Proportion was therefore of supreme importance to the Greek sculptor and architect. The Greek temples we see today are superficially very different from the buildings when they were dedicated, with their gaily painted decorations and smoking altars. But they retain the same geometrical forms, the main concern of the architect, forms so refined that they were carried through to the minutest detail of the ornament. Though Greek architects were profoundly interested in the mathematics of their art, they soon learnt that there was a difference between geometrical and aesthetic form. They introduced 'refinements', deliberate irregularities, sometimes to counteract optical effects, but resulting in the destruction of the mathematical rigidity of their designs. These minute, incalculable variations within the crystalline structure transfigure Greek art.

The Persian War in 480 BC left the Acropolis and the city of Athens a shattered ruin. Although the city was gradually restored and Kimon rebuilt the Agora, the destroyed temples on the Acropolis were left untouched as a reminder of Persian impiety. Persia had been defeated in 479 BC but still remained a military danger. Athens therefore formed a defence league with the other Ionian cities. The strength of this league lay in the Athenian navy, though the other cities made an annual contribution of money which was stored on the sacred island of Delos. The Delian League soon ceased to be a voluntary alliance and began to take the form of an empire domi‑ nated by Athens, whose navy controlled the Aegean. The treasury was transferred to Athens in 454 BC and after peace was finally signed with Persia in 449 BC, Perikles decided to use the surplus money to rebuild the Acropolis, the most ambitious architectural complex in Greece (*Ill. 118*).

Although the new temples on the Acropolis were intended as visible proof of the supremacy of Athens, the total effect was one of restrained elegance. It was an enormously expensive project, the workmen were the most skilled in Greece, and citizens and slaves alike were paid. Moreover the temples were constructed entirely out of marble. But the expense was due to the precision of workmanship rather than materials and ornament. Work continued after the outbreak of the disastrous Peloponnesian war and it is only then that we see an increasing use of ornament in the Erechtheion.

The sculptor Phidias, a friend of Perikles, was responsible for the complete replanning of the Acropolis. He also designed the sculpture of the first temple to be rebuilt, dedicated to Athena Parthenos, the Virgin. The architects were Iktinos and Kallikrates and work began in 447 BC.

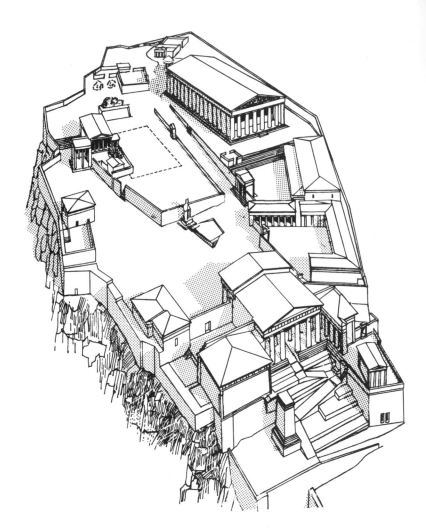

118 *Reconstruction of the Acropolis, Athens, as it was in AD 100. After Stevens. Drawn by D. Wilsher*

The Parthenon was built on the foundations of an earlier unfinished temple which had been abandoned when the Persians sacked the city in 480 BC. This temple had been begun after the battle of Marathon (490 BC) and probably replaced the 6th century Hekatompedon, the 100-foot temple. The old Parthenon stood on a high platform on the south side of the Acropolis. Its plan is similar to that of the Temple of Apollo at Corinth (*Ill. 85*), the cella divided into two rooms, and surrounded by a peristyle of six by sixteen columns. It was constructed entirely of marble from the newly opened

quarries on Mount Pentelikon, and even though the Persians had burnt the scaffolding, the platform and many unfinished marble drums still remained intact.

The new Parthenon was built on this original platform which was only slightly enlarged on its southern side, creating a great rectangular area measuring 101.32 feet wide and 228 feet long, a proportion of 4:9. This classical proportion, corresponding to the formula $n:2n+1$, was applied to the whole temple. The peristyle was increased to eight columns at the front (an extremely unusual feature found only in Ionic temples and the grandiose buildings of Sicily) with seventeen along the sides. The columns were placed a little more than 13 feet apart, giving a ratio of 4:9 between the diameter of the column at its base and the interaxial. This proportion is repeated in the height of the strongly marked horizontal lines of the cornice to the width of the building. As a result, all the major dimensions of length, breadth, height and distance between columns were linked together in one harmonious design (*Ills 119, 120*).

Even by Athenian standards, the columns are un-usually slender, their height being 5.48 times their lower

119 *Plan of the Parthenon. After Gert Kaster*

120 *The Parthenon, Athens, 447–432 BC. Pentelic marble*

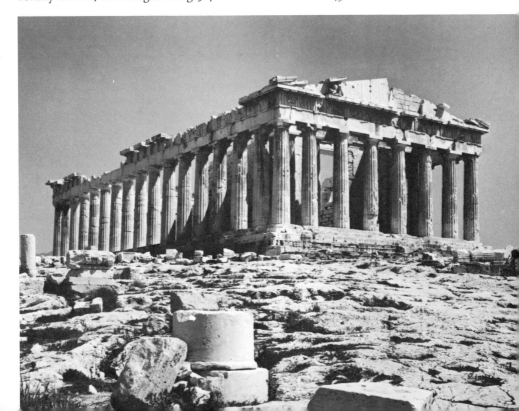

diameter. But the entablature they support has been lightened proportionally and the columns are placed closer together (the distance between the centre of each column is only two-and-a-half times its lower diameter). Because the columns are so close together, the passageway between the peristyle and the cella wall, only one interaxial deep, is very narrow and further reduced by double angle contraction. The corner columns have been placed over 2 feet closer together instead of 1 foot calculated by theory (see p. 92). The dense texture of the building is further emphasized by a second row of columns at the front and back of the cella, a prostyle inner portico of six columns. As a result there is a balance between the compact plan of the building and the slender elegance of the columns which surround it.

A large number of refinements were introduced into the plan of the Parthenon, which contains no straight lines, for all are subtly curved. The edges of the platform rise 4 inches at the centre and this curve is repeated in the entablature. The taper of the columns is again a curve, called entasis, and the columns are not vertical but lean slightly inwards, the corner columns having a diagonal slant. This inward lean is found also in the cella walls and the entablature: if they were projected upwards they would all meet at a point about a mile above the temple. Refinements were introduced into refinements and minor portions of the building, such as the abacus face, have a slight tilt the other way. In this case it is only one sixteenth of an inch, but it is sufficient to change the play of light thus contrasting it with the architrave above, leaning in the opposite direction.

These minute refinements prove the accuracy of the marble cutting, yet irregularities were deliberately introduced: the capitals of the front and sides are not exactly the same size, the intercolumniations are not completely consistent and the blocks of the architrave do not meet exactly at the centre of the column. These variations are so small that one is only consciously aware of the grace of the forms. The architect must have realized that precision can be deadly and so gave life to the building through subtle irregularity which defies analysis.

There are also a number of irregular features in the overall design of the Parthenon which bring Ionic features into a Doric plan. The prostyle porches of six columns placed closely behind the front and back of the

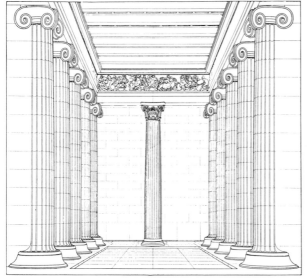

121 Interior of the Temple of Apollo Epikourios, Bassae, c. 450–420 BC. Limestone and marble. After F. Krischen, 1938

peristyle give the impression that this building is sur-rounded by two rows of columns, like a dipteral Ionic temple. Moreover, the slender porch columns support an entablature decorated with a continuous Ionic frieze. This frieze was high up and ran all round the cella, half hidden in the dark shadows of the peristyle. It contradicts the clarity and simplicity of the Doric order in which all is self-evident. The architects have taken advantage of the greater decorative effect and almost organic quality of the Ionic order in which the entrance of the temple was reached through a forest of lavishly ornamented columns in which nothing could be clearly seen.

The cella of the Parthenon was unusually broad (5 interaxials) and contained the great cult statue of Athena by Phidias, made out of gold and ivory and standing nearly 40 feet tall. Her dominating presence was not allowed to overpower the sanctuary because the interior columns ran not only along each side of the room (as at Aegina) but also behind the back of the cult statue. The figure was therefore completely framed by the two-tier colonnade.

The treatment of the interior was developed even further by Iktinos in a smaller temple dedicated to Apollo Epikourios at Bassae in Arcadia (*Ill. 121*). The outside is of cold grey local limestone and has an old-fashioned peristyle of six by fifteen columns imitating the 6th

122 Plan of the Temple of Apollo Epikourios, Bassae

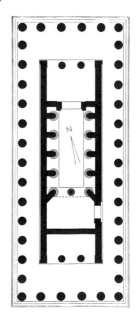

century BC Temple of Apollo at Delphi. But the cella, divided into two parts, is decorated with attached Ionic columns supporting a frieze, which, where it crosses the entrance to the inner room, is supported by a slender, free-standing column with the earliest known Corinthian capital (*Ill. 121*). The building therefore presented an extraordinary contrast between the stark Doric exterior and the richly ornamented Ionic interior, and had a great influence upon later architecture.

Phidias had created the chryselephantine statue of Athena within the Parthenon. There were at least three figures of the goddess by him on the Acropolis, each contrasted with the others in character. The earliest was the Athena Promachos, the Champion, cast from the bronze armour taken from the Persians at Marathon. She was dressed as a warrior holding a spear so tall that sunlight flashing on its point was the first sight of Athens seen by sailors after they had rounded Cape Sounion, the most easterly point of Attica. In contrast to this heroic warrior goddess, the Athena Lemnia, dedicated by the colony of Athenians on the island of Lemnos, represented her gentle aspect, standing unarmed and holding her helmet in her outstretched hand. The idealized beauty of her face is preserved in a copy in Bologna. The Athena Parthenos represents the goddess at her most majestic. She was standing, wearing a richly decorated helmet and holding in her left hand a spear and shield, against which her foster-child, the serpent Erichthonios, was coiled. In her outstretched right hand she offered the people of Athens a winged victory.

It is paradoxical that, although he created images of ideal beauty which were to have a permanent influence on Greek and Roman cult statues, Phidias introduced portraits into the complex of his design. He is said to have represented himself as a bald old man in the Battle of the Amazons which decorated the outside of the shield of Athena and which can still be seen in the copy now in the British Museum. This self-portrait led to a charge of sacrilege, a danger sometimes encountered by innovating artists.

Although no original work by Phidias has survived, for like most 5th century artists, he worked mainly in bronze, the sculpture of the Parthenon was carved under his supervision and clearly shows the innovations of his style.

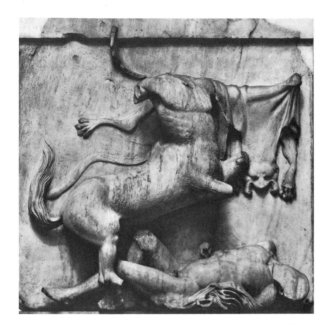

123 Battle between Centaur and Lapith, metope no. 28 from the Parthenon. 447–432 BC. Pentelic marble 4′ 8″ × 4′ 2″ (142 × 127). British Museum, London

The earliest works were the metopes, originally ninety-two in number, representing the mythological battles between gods, giants, Greeks, Amazons, Trojans, Centaurs and Lapiths. They symbolize the conflict between reason, civilization and anarchy, sometimes ending in the defeat of civilization. In metope number 28 from the south side of the Parthenon, a Centaur prances triumphantly over the slumped body of a Lapith whom he has killed with a wine jar (*Ill. 123*). Compared with the metopes from Olympia, carved about thirty years earlier (*Ill. 109*), there is much more contrast in movement and the drapery is handled more dramatically.

The Ionic frieze which ran around the outside walls of the cella was a complete innovation, representing a contemporary event. The Panathenaic procession was held every four years to bring a new sacred robe, the *peplos*, to the archaic figure of Athena in the Old Temple on the Acropolis. Over the entrance porch, the robe is ceremonially folded in the presence of the twelve Olympian gods who sit enthroned as guests (*Ill. 124*). To the right and left are two companies of citizens and magistrates and two troops of maidens who head the procession along the sides of the sanctuary. In front are the sacrificial animals followed by offering bearers; then come

musicians, elders, chariots and, finally, young men on horseback.

Whereas the 6th century sculptor who carved the gods in the frieze of the Siphnian Treasury (*Ill. 100*) expressed the forms of their clothing in linear folds, the sculptor of the Parthenon frieze analyzes the effects of massed drapery. The seated deities are wrapped in cloaks which fall in a complex of folds, some created by the position of the limbs, but others created by the weight and texture of the material. Artemis is dressed in an almost transparent chiton which covers her body in a complicated maze of pleats, in contrast to the smoother, deeper folds of her brother's woollen cloak.

Although the pediments have been severely damaged, not only by conversion into a church in the 5th century AD, but also by an explosion in 1687 caused by the Venetian bombardment of the Acropolis, their composition has survived in drawings by Jacques Carrey. He was a draughtsman in the suite of the French Ambassador in Turkey, visiting Athens in 1674.

124 Poseidon, Apollo and Artemis from the east frieze of the Parthenon, 447–432 BC. Pentelic marble 24" (61). Acropolis Museum, Athens

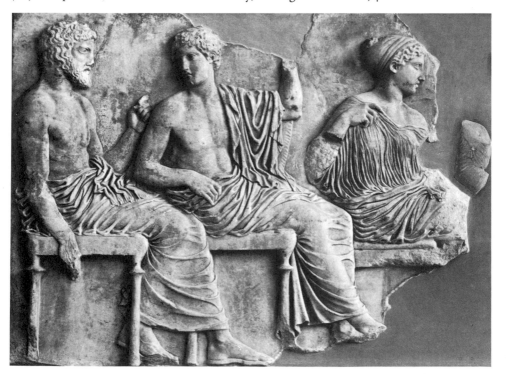

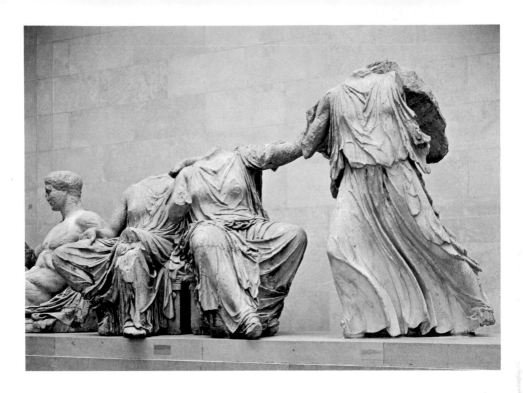

The east pediment represented the birth of Athena. The central section, already missing when Carrey visited Athens, can be reconstructed from a Roman circular altar, now in the Archaeological Museum in Madrid (sometimes called the 'Madrid well-head'), which copies the composition. Zeus is seated in the centre of the pediment and Athena strides away from him to be crowned by a winged Victory. She had been born from the head of her father, split open by Hephaistos, who stands behind him. Behind this group are the three Fates who preside at every birth. The surviving sculpture is in the British Museum. A young girl messenger runs towards Demeter and Persephone, seated on a chest covered with a folded cloth (*Ill. 125*). Behind them is a reclining figure on a lion skin who may personify Mount Olympos, thus locating the scene, or may be one of the divinities witnessing the birth, Herakles or Dionysos. In the angle Helios, personification of the rising sun, drives his chariot out of the sea. On the opposite side there are three goddesses reclining on a long, drapery-covered rock, and beyond, the moon goddess Selene and her exhausted horses sink beneath the horizon.

125 Demeter, Persephone and a messenger, from the east pediment of the Parthenon, 447–432 BC. Pentelic marble, tallest figure 5′ 8″ (173). British Museum, London

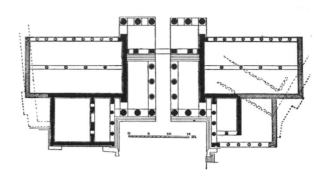

Although the west pediment survived the 1687 explosion, it was virtually destroyed by the attempts of the Venetian general Morosini to loot the statues. His tackle broke as he was lowering the central group and the figures smashed to the ground. But Carrey's drawings clearly illustrate the composition which represented the competition between Poseidon and Athena for the land of Attica. Poseidon and Athena have driven to the site in chariots, escorted by Hermes and Iris and watched by an audience of divinities. They leap into action in the centre of the pediment; Poseidon strikes the Acropolis with his trident, creating a miraculous salt water spring (which is said to have survived until the 2nd century AD) but Athena wins the contest by giving Athens the first olive tree.

The forms of the pedimental figures are soft and fluid, with minutely delicate transitions of plane, in contrast to the unnaturally clear articulation of Polykleitos' figures (*Ill. 117*). Movement is expressed by drapery, rather than by any new observation of human anatomy in action. The anxious haste of the running messenger from the east pediment (*Ill. 125*) is expressed in the curve of her costume swung away from her body by the movement of the figure. Phidias was one of the first sculptors to realize the importance of drapery to express form, movement and emotion. There is an explosion of energy at the centre of each pediment and the action ripples through each of the figures, uniting them into a single composition.

As soon as the major construction of the Parthenon was completed in 438 BC, the rebuilding of the Propylaea was begun by Mnesikles (*Ill. 126*), but it was brought to a hasty conclusion because of the outbreak of the Peloponnesian war between Athens and Sparta in 431 BC. The

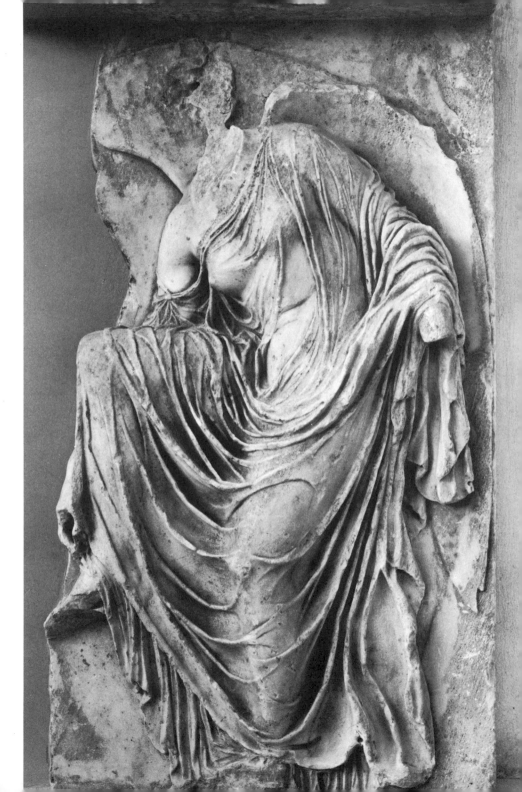

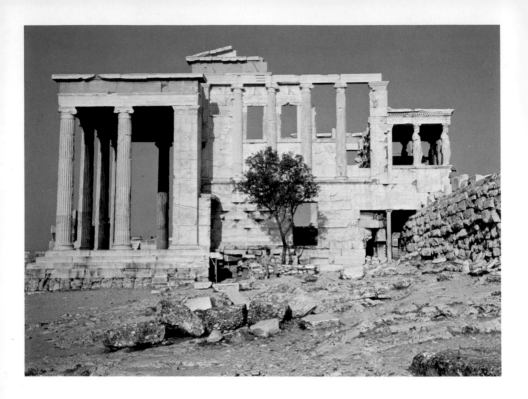

128 *The west side of the Erech-theion, the Acropolis, Athens, begun c. 421 BC. Pentelic marble*

monumental entrance to the Acropolis was deliberately designed to harmonize with the Parthenon, reflecting new ideas in town-planning introduced by Hippodamos of Miletos. It is an elaboration of the normal classical propylon block, a building with a gateway in its centre and porches at each end. But the porches consist of six prostyle columns, resembling the façades of a temple, and their proportions are similar to those of the Parthenon. It is built on two levels, the entrance being lower than the side facing the Parthenon, and the road running through it is flanked by two rows of three Ionic columns. Unlike the earlier propylaea it has side wings, which were intended originally to be symmetrical, but the south wing encroached on the Sanctuary of Brauronian Artemis and also on land set aside for the Temple of Athena Nike, which had been projected in 449 BC. As a result the south wing remained a façade to balance the north wing, which contained the picture gallery, the first known building specially designed for the display of works of art.

Although a decree of 449 BC authorized Kallikrates to design a Temple of Athena Nike to celebrate the peace

treaty negotiated with the Persians, it was not built until after the outbreak of the Peloponnesian war. Perikles had died of the plague in 429 and his circle of artists had dispersed. Iktinos went to Bassae and Phidias was in disgrace. Work probably did not begin until the Peace of Nikias (421–414 BC) but Kallikrates' design was followed faithfully. The temple is dramatically poised over a sheer drop beside the Propylaea, on a bastion of the Mycenaean fortifications. It is a simple Ionic temple with four columns prostyle at each end but these have unusually heavy proportions (7.82:1) to harmonize with the Doric columns of the neighbouring buildings. Although the Athenians regarded themselves as Ionians, this is one of their earliest buildings in a purely Ionic style. The Attic form did not copy that of Asia Minor but was very much influenced by the small and elaborately decorated treasuries dedicated by the Ionian islands at Delphi. The entablature usually contains a frieze, and in the Temple of Athena Nike it represents a battle between Greeks and Persians, referring to the Greek victory at Plataea.

After the temple was completed, about 410 BC, the pavement was covered in marble and surrounded by a sculptured parapet representing Winged Victories as attendants on Athena (*Ill. 127*). One Victory stoops to remove her sandal, because she is entering sacred ground, and her garment slips from her shoulder. We see the influence of Phidias in the treatment of the thin, almost transparent drapery which envelops the figure in curving folds. But the figure has a sensual charm which is new in Greek art.

The last temple to be built on the Acropolis was the Erechtheion (*Ills 128, 129*), begun in 421 BC to replace the Old Temple of Athena, and completed after 406 BC. It is an extremely complex building for it contains relics of the contest between Athena and Poseidon, the sacred olive tree and the trident marks, and is thus their joint shrine. The contest was judged by the first king of Athens, Kekrops, whose daughters were entrusted with the care of Athena's foster-child, Erichthonios son of Hephaistos and Earth. When he grew up he became king of Athens and instituted the Panathenaea. His grandson Erechtheus also became king. Since at some time his cult was identified with that of Poseidon, the temple was dedicated to Athena and Poseidon-Erechtheus.

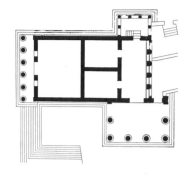

129 Plan of the Erechtheion

133

It is an Ionic temple without a peristyle but with three porches on the east, north and south sides. Each porch has a completely different design and yet this curiously asymmetrical building has a harmony and balance of its own. It is entered through a normal Ionic prostyle porch of six columns on the eastern side. But the ground at the back, where the sacred olive tree of Athena grew, is at a much lower level. In the centre of the west wall there is a small doorway which leads to a basement room and above it is a ledge on which stand four Ionic columns framing windows. The north porch, covering the trident marks of Poseidon, consists of four slender Ionic columns along the front, and two along each side which support a roof at the level of the frieze of the central hall (there is a hole in this roof over the trident marks). In contrast, the south porch, facing the Parthenon, is small and massive, for the entablature is supported by caryatids instead of columns. They stand on a low parapet, the folds of their long Ionian tunics echoing the fluting of the Doric columns of the Parthenon opposite.

The entablature over the south porch has a course of dentils, in the manner of Asia Minor. Around the rest of the building runs a frieze of grey Eleusis limestone to which figures of white marble were attached. This may have been a measure of economy to avoid carving large slabs of marble in relief. But the effect would be a lavish imitation of the painted blue background of normal reliefs. The whole building is richly ornamented and anticipates the over-decoration of the 4th century temples.

In contrast to the noble dignity of the Parthenon there is a disturbing element of prettiness in the Erechtheion which suggests decadence. It was built during the suicidal Peloponnesian War (431–404 BC) and it is surprising that there was any building at all during this period of stress. The war had been caused by the growing power of Athens which controlled most of the Ionian maritime cities of the Aegean, and had converted the Delian League into an Athenian empire. It challenged the traditional role of Sparta as guardian of the Dorian cities of the Peloponnese and a war which divided the whole Greek world became inevitable.

Greek art after the Peloponnesian War 404–323 BC

The Peloponnesian War, after dragging on for twenty-seven years, ended in 404 BC in a victory for Sparta, a result of mistakes made by Athens rather than Spartan military superiority. The war had solved no problems, for Sparta no longer had the strength to maintain her leadership over the Greek city-states and the country was impoverished and exhausted. It is therefore not surprising that little building took place on the mainland during the 4th century BC and that the major art markets were in the east, even those parts which remained under Persian domination.

Whereas the Doric order was at its height in the 5th century BC, there had been little building in Ionia after the disastrous revolt against the Persians in 499 BC. But in the 4th century BC the Ionic order achieved its fullest development. The 6th century Temple of Artemis at Ephesos, one of the two great buildings which had initiated the Ionic order (*Ill. 89*), was burnt down in 356 BC by a maniac in search of immortal fame. It was rebuilt on the same foundations, virtually repeating the same plan, though the platform had to be raised, giving an extra flight of steps surrounding the building and thus adding to its impressive exterior. As in the old building (*Ill. 88*), thirty-six of the entrance columns had sculptured bases and, according to Pliny, one was carved by Skopas (*Ill. 140*).

Except for a few architectural fragments in the British Museum and a large hole in the ground in Turkey, nothing now remains of this temple which was once one of the Seven Wonders of the World. But one of the architects, Paionios of Ephesos, is said to have helped design the Temple of Apollo at Didyma, a little further south along the coast (*Ills 130, 131*). The extensive remains clearly show the magnificence of the great Ionic temples founded in the 4th century BC.

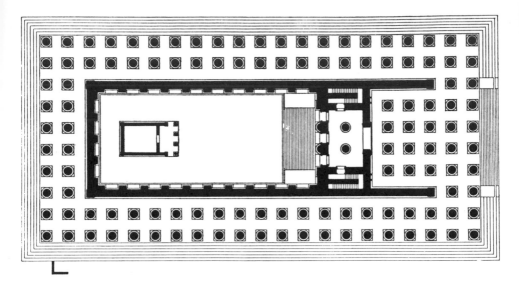

130 Plan of the Temple of Apollo, Didyma. After H. Knackfuss, Didyma I, 3, 1940

131 Temple of Apollo, Didyma, begun end 4th century BC, completed 2nd century AD. Marble

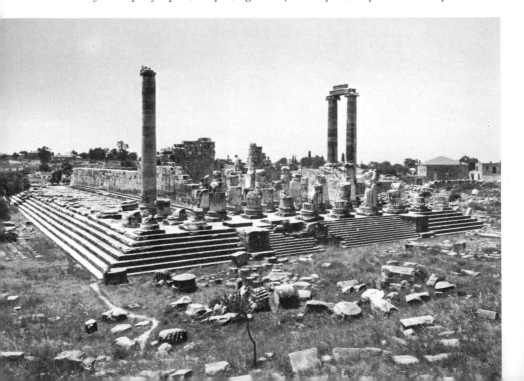

The earlier temple at Didyma had been destroyed by the Persians in 494 BC, but it was not replaced until after Alexander the Great had conquered the city in 332 BC and building continued spasmodically until the time of the Roman emperor Hadrian in the 2nd century AD. The plan is very similar to that of Ephesos, and was clearly inspired by the archaic building. It consists of a small shrine standing in an open courtyard surrounded by a massive double pteron of Ionic columns. The whole temple stands on a high platform raised above the ground by seven huge steps. A great flight of steps leads up to the entrance which is filled with a forest of columns. But there was no central doorway; in its place was a window raised 5 feet above the floor of the porch at which the oracular priest would stand to deliver the god's prophecies. This window was in the centre of a room where the oracles were interpreted by priest-scholars. Although overlooking the porch it could not be entered directly from the outside of the temple. Side doors gave entrance to the courtyard down a barrel-vaulted passage-way. Another flight of steps within the courtyard led up to the oracular chamber.

In contrast to the extravagant temples at Ephesos and Didyma which copied 6th century BC forms, the temple at Priene is small and symmetrical, betraying Attic in-fluence (*Ills 132, 133*). Priene had been re-founded in the 4th century BC because the river Meander had silted up the harbour of its original site, which is now completely lost. The new city, under the protection of Athens, was laid out on the steep flanks of Mount Mykale with a grid-iron street plan of the type evolved by Hippodamos of Miletos in the 5th century BC. But the ground sloped so steeply that the streets running north-south had to be cut into steps. Houses were built in rectangular blocks, and space was reserved for the major public buildings including a theatre and a temple. Although it was never an important town, the citizens of Priene invited the leading architect of the Ionian world, Pythios, who at that time was working for King Maussollos of Caria, to design their temple.

The temple of Athena Polias has a very symmetrical plan laid out on a platform divided into squares of 6 Attic feet (about half an inch shorter than the British foot). The columns, on 6-foot plinths, stand on alternate squares. There are six columns at the front and eleven

132 Plan of the Temple of Athena Polias, Priene. After T. Wiegand and H. Schrader, Priene, 1904

133 Temple of Athena Polias, Priene, c. 335 BC

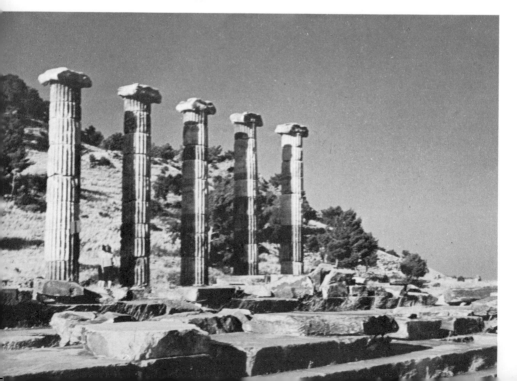

down the sides, an apparently asymmetrical number but one which gives five by ten interaxials. The distance between the centre of each column is 12 feet, so the axial dimensions of this temple are 60 by 120 feet. Instead of the n:2n+1 proportions of the Parthenon, Pythios has evolved a system based upon the ratio of n:2n, and all the other dimensions of the temple are in simple numerical relationship. Yet in spite of this Athenian attention to mathematical proportion, Pythios chose to give his columns the type of base developed in Asia Minor and the entablature had a course of dentils instead of a frieze.

The extreme classicism of this temple forms a strange contrast to the other known work of Pythios, the unique tomb of King Maussollos of Halikarnassos, the Persian governor of Caria who died in 353 BC. The Mausoleum is very different from the Athenian form of tomb. It is an elaboration of a local type of monument and consists of an Ionic temple, standing on a high basement, roofed by an Egyptian-inspired pyramid of twenty-four steps which culminates 136 feet above the ground in a platform on which Pythios had placed his own sculptured group of a chariot and four horses. The remaining sculpture was by the leading artists in Greece: Skopas, Timotheos, Bryaxis and Leochares (*Ills 139, 143*).

This experimentation is not surprising in the Ionic order, which had never been a rigid order, but in the 4th century BC Doric architecture in the mainland of Greece began to show more variety of form. Iktinos' design at Bassae was extremely influential (*Ill. 122*) and the orders were daringly combined in the Temple of Athena Alea designed by the sculptor Skopas at Tegea. But the Doric order had lost its essential quality of massive severity: the columns in the peristyle have very slim proportions (6:1 lower diameters) and the echinus of the capital reduced to almost nothing.

The sanctuary at Epidauros was reconstructed in the 4th century BC when it was finally established as the birthplace of the god of medicine, Asklepios. A small Doric temple was built in his honour about 380 BC, and twenty years later Polykleitos the Younger (perhaps a descendent of the sculptor) designed a tholos to stand in the same sanctuary. The function of this circular building is not clear (an equally mysterious tholos stands in the sanctuary of Athena Pronaia at Delphi); although religious buildings, they were not temples in the con-

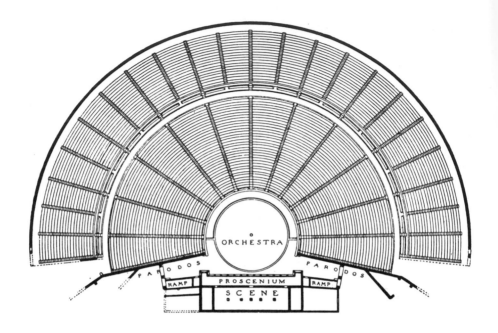

ORCHESTRA

PARODOS PARODOS

RAMP PROSCENIUM RAMP
SCENE

134 Plan of the Theatre, Epidauros

ventional sense and beneath the floor at Epidauros there was a labyrinth which was perhaps a sacred snake-pit. It was surrounded by a pteron of twenty-six Doric columns and inside the cella there were fourteen Corinthian columns, curiously not aligned with the outside pteron. The whole building is extremely ornate with frescoed walls, gilded ceiling and floor inlaid with black and white marble in a radiating design of diamond-shaped blocks diminishing in size towards the centre.

The most famous building in Epidauros was the theatre which Pausanius (the author of a guidebook to Greece in the 2nd century AD) considered to be the finest in Greece (*Ills 134, 135*). It was designed by Polykleitos the Younger who applied the geometrical principles evolved for temple buildings to theatre architecture. Athens, as the home of drama, had set the pattern in a theatre which had developed out of the circular dancing floor for the chorus, called the orchestra, standing near the Temple of Dionysos. This was overlooked by a natural hollow in the south slope of the Acropolis which was used as an auditorium. A stoa, part of the precinct of the Temple of Dionysos, was adapted to hold painted scenery and was used as a setting for the actors.

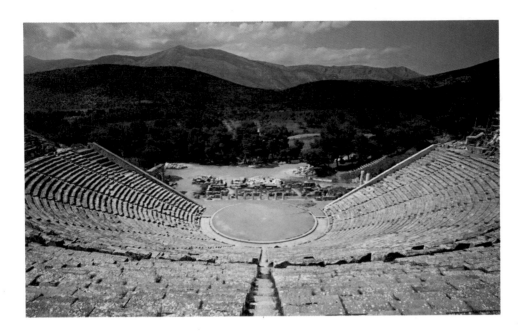

The great innovation of Polykleitos the Younger at Epidauros was to link orchestra and auditorium into one geometrical pattern. The theatre was designed as if the circular orchestra had inscribed within it a regular twenty-sided polygon, and the radii of the circle passing through each of the angles were projected into the *cavea* (auditorium) to divide it into twelve symmetric wedge-shaped compartments: the cavea was two sections larger than a semi-circle. The divisions were created by staircases running between the blocks of stone benches. Later an upper section was added with double the number of divisions. The theatre was famous in antiquity for the perfection of its acoustics. People sitting in the side seats may have had some difficulty in seeing the actors in front of the scene building, but in the Hellenistic period this fault was corrected by building a raised stage on which the actors performed.

The use of a raised stage was an innovation of the New Comedy introduced by Menander in the late 4th century BC, in which the plays were domestic and social comedies concerned with the character of individual people rather than the universal themes of the Old Comedy. A new interest in humanity pervades 4th century BC Greek art.

135 The Theatre, Epidauros, designed by Polykleitos the Younger, c. 350 BC

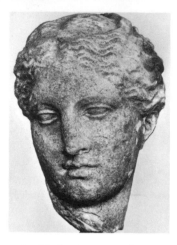

136 *Head of Hygeia from the Temple of Athena Alea, Tegea, c. 340 BC*

137 *The Aphrodite of Knidos, Roman copy of the marble statue by Praxiteles, c. 340 BC. Marble 6′ 8¼″ (204). Vatican Museum*

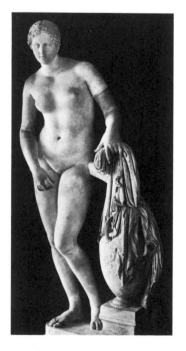

Goddesses are no longer visualized as remote deities but as sensual women. The most famous statue of this period was a naked Aphrodite carved by Praxiteles and bought by the city of Knidos in Asia Minor (it was offered to the island of Kos but they timidly chose a draped figure). It was displayed in a circular shrine (which has been discovered recently) so that it could be seen from all points of view, for the statue was 'equally admirable from every angle', an interesting comment on Praxiteles' ability to compose in three dimensions. Aphrodite is represented laying aside her clothing on an amphora as she prepares for her bath. The statue has survived only in clumsy Roman copies (*Ill. 137*) which give little idea of her original charm. But a head of Hygeia from the Temple of Athena Alea at Tegea, of unknown authorship but obviously influenced by Praxiteles, has soft parted lips and gentle melting gaze which give warmth to the idealized features (*Ill. 136*).

Praxiteles' *Hermes and the infant Dionysos* (*Ill. 138*), found in the exact spot described by Pausanias in the Temple of Hera at Olympia, is perhaps our only surviving original work by one of the great figures of Greek sculpture. The high polish, which has led to doubts about its authenticity, was probably the result of generations of waxing and polishing by temple attend-ants. The ugly strut which joins the thigh to the supporting tree trunk is difficult to explain, but Praxiteles was exploring a new type of composition in which the eye travels without hindrance over the curve of the body. Instead of dividing the body into carefully calculated sections, the whole figure is subtly modulated by delicate fluctuations in its planes. This type of composition was much more suitable for figures in bronze and must have raised considerable practical difficulty in a marble statue, and so a strut was needed for structural purposes.

Praxiteles represents Hermes as a charming youth, an extraordinary change of character for one of the more powerful and disreputable gods of Olympos. He rests against a tree stump, partly covered by an incredibly naturalistic fall of drapery, holding his baby half-brother in the crook of his left arm while he teases him by dangling a bunch of grapes just out of his reach. There is a similar playful attitude in the *Apollo Sauroktonos* (which has survived only in numerous Roman copies): the god is represented as a young boy threatening to kill a lizard

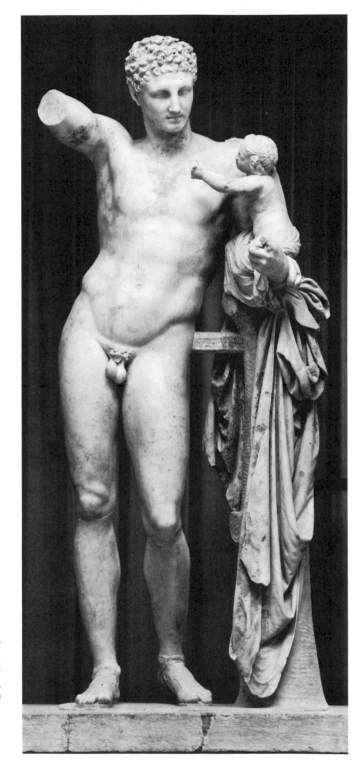

138 Hermes and the infant Dionysos, by Praxiteles, from the Temple of Hera, Olympia, c. 340 BC. Parian marble, 7′ (215). Olympia Museum

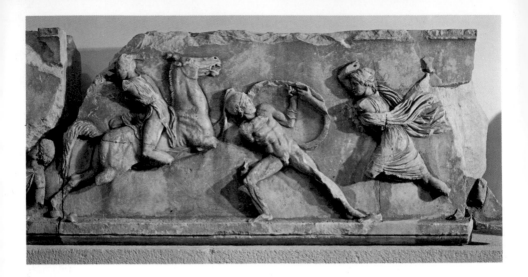

139 Battle of Greeks and Amazons, panel from the east frieze of the Mausoleum at Halikarnassos, attributed to Skopas, after 353 BC. Marble, height 33″ (89). British Museum, London

on a tree stump, though the subject was derived from the deadly combat with the serpent Pytho at Delphi, in which Apollo gained control of the sanctuary.

In contrast to the gentle charm of Praxiteles' figures, the work of Skopas expresses forceful emotions. The east frieze of the Mausoleum at Halikarnassos is attributed to him by some (see p. 139). In one panel a Greek soldier has been forced backwards by the violence of the attack of an Amazon (*Ill. 139*). She pushes aside his protecting shield with her left arm and is about to strike him with her raised sword: the soldier suddenly realizes that death is upon him. The poses show psychological insight and there is no concern for grace in the Amazon who has twisted round to beat off an attack from the rear.

Pliny tells us that Skopas also worked at the temple of Artemis at Ephesos (see p. 135) and his influence can be seen in the sculptured base in the British Museum (*Ill. 140*). It represents Alcestis, who has saved the life of her husband Admetus by taking his place when it was time for him to die. She stands before Hades and Persephone, rulers of the Underworld, between the winged figure of Death and Hermes, who looks up towards the world of light because he hopes to save her. The drama of this crucial decision between life and death is expressed in the intense faces with deep-set eyes and the way in which the figures are linked by their gestures, the folds of the drapery and the broad spreading wings of Death.

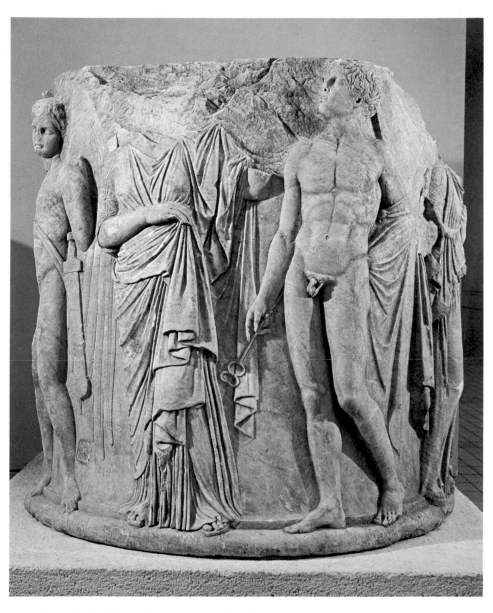

140 *Alcestis in the Underworld, a sculptured column from the Temple of Artemis, Ephesos, after 356 BC. Marble 5′ 11¾″ (182). British Museum, London*

145

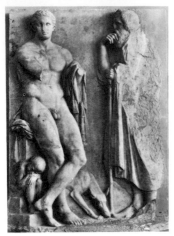

141 Grave stele of a youth, found in the bed of the river Ilissos, Athens, c. 340 BC. Pentelic marble 5' 6" (168). National Museum, Athens

142 Athlete from Anticythera (restored), c. 350 BC. Bronze 6' 6" (194). National Museum, Athens

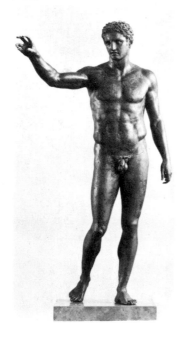

This new expressive style influenced the design of Attic grave stelae. Athenian funeral stelae at the beginning of the 5th century BC were long narrow slabs of marble framing a standing figure (Ill. 99). The later stelae are broader and often shaped like a shrine, with pilasters which support a pediment and frame the figures. The scene is usually a sad leave-taking between husband and wife and expresses a gentle regret at death. A more emotional approach to death is seen in a relief, carved about 340 BC and found in the bed of the river Ilissos, which represents a dead young man as a naked hero leaning against his tomb and looking out at the spectator, indifferent to the people around him (Ill. 141). At his feet a naked slave-boy crouches in misery, half asleep, while his hound snuffles the ground as if searching for him. His father stands in grief, hand raised to his beard in bewilderment as he contemplates the mystery of death. This is a long way from the hoplite Aristion who cheerfully guards his own gravestone (Ill. 99). The dead man is represented as a hero who, like Herakles, might be given immortal life among the gods. Yet at the same time the sculptor expresses the grief of those left behind.

There was a growing interest in individual human personality in the 4th century BC and the tomb of King Maussollos at Halikarnassos (see p. 139) contained a portrait of the king (Ill. 143). He is dressed in Greek style in chiton and ample himation (tunic and mantle) but he has typically Near Eastern features. Long hair, a short curly beard and full sensual lips give individuality to this somewhat corpulent oriental despot. He has power and dignity, but little attempt has been made to idealize him.

Instead of the self-contained forms and balanced actions of 5th century statues, there is a new freedom of movement in 4th century sculpture. This is seen in a bronze statue of an athlete throwing a ball found in the sea off Anticythera (Ill. 142) in which the raised arm, paralleled from the side by the bent leg, creates an outward movement.

This statue still shows the influence of the 5th century master Polykleitos in the powerful muscles and square forms of the shoulders. But the canon which Polykleitos had created in the Doryphoros (Ill. 117), the image of an ideal athlete in the 5th century BC, was challenged by Lysippos, who came from Sikyon near Corinth and

worked in the same medium, bronze. He had a long and prolific life (Pliny attributes fifteen hundred statues to him) and eventually became the court artist of Alexander the Great.

The *Apoxyomenos* (Ill. 144) is a rather casual subject from the palaestra representing an athlete scraping himself clean from mud and dust after exercise. He stands with feet apart, weight on the left leg, but with arms thrust out in front of him, creating a plane at right angles to the body. The figure which moves with such freedom is slender and elegant. According to Pliny, Lysippos

'made the heads smaller than the older artists had done, and the bodies slimmer with less flesh, thus increasing the apparent height of his figures. There is no Latin word for the canon of symmetry he was so careful to preserve, bringing innovations which had never been thought of before into the square canon of the older artists.' (*Natural History* XXXIV, 19)

These new proportions which Lysippos had created for the human figure in the *Apoxyomenos* reflect a general preference for more slender forms seen throughout the 4th century BC in the changing proportions of the Doric column.

But Lysippos' new image of the ideal human being was not entirely governed by mathematics. 'He often said', Pliny continues, 'that the difference between himself and [the older masters] was that they represented men as they were and he as they appeared to be.' There was increasing naturalism in Greek art in the 4th century and Pliny tells a story about another artist from Sikyon called Eupompos. Lysippos had been very impressed by his work and asked which artist he followed, but Eupompos pointed to a crowd of men and replied that nature herself should be imitated, not any artist.

As well as single figures, Lysippos also designed large groups in violent action, an example being the *Lion Hunt of Alexander the Great* which was made for Krateros who had rescued Alexander in an incident in the hunt. The composition is perhaps reflected in the hunting scene along the side of the Alexander Sarcophagus (Ill. 145), probably made for Abdalonymos who had been appointed king of Sidon by Alexander. Its front represents the battle of the Issus (333 BC) in which Alexander defeated Darius III of Persia; the back, on the other hand, represents Persians and Greeks as allies: a Persian's horse has been attacked by a lion, and Alexander, another

143 *King Maussollos, Persian governor of Caria, from the Mausoleum, Halikarnassos, c. 353 BC. Marble 9' 10" (300). British Museum*

144 *The Apoxyomenos, a Roman copy of the bronze statue by Lysippos, c. 320 BC. Marble 6' 8¾" (205). Vatican Museum*

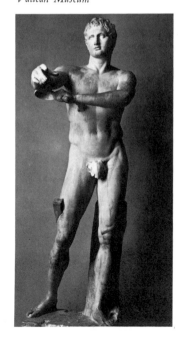

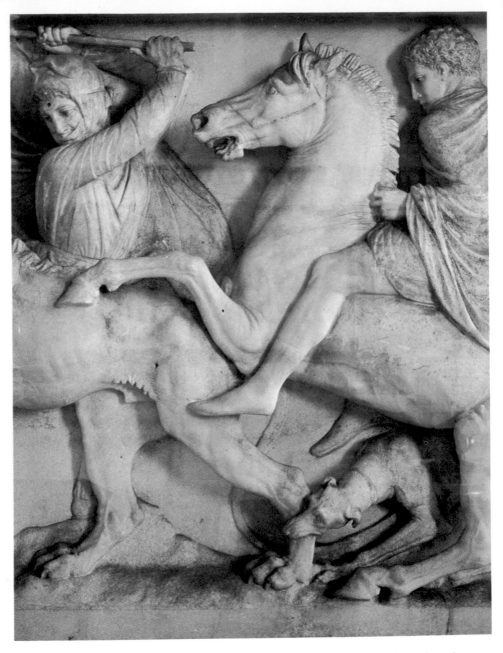

145 *The Lion Hunt of Alexander the Great, detail of the Alexander Sarcophagus, late 4th century BC. Marble with traces of colouring, 23″ (58.5). Archaeological Museum, Istanbul*

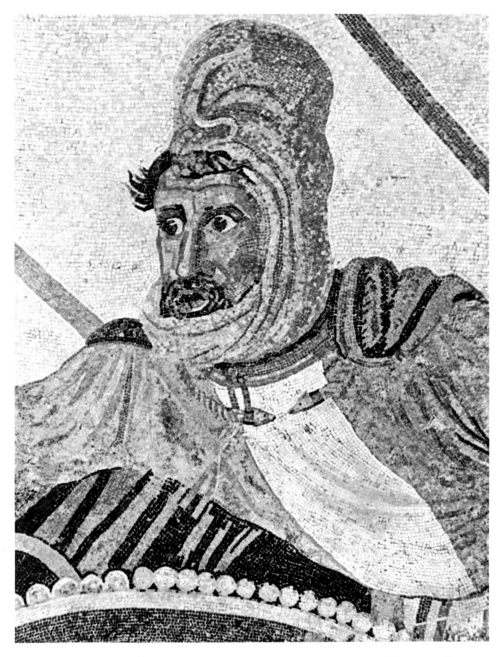

146 Head of Darius from the Alexander mosaic. House of the Faun, Pompeii (probably a copy of the painting by Philoxenos of Eretria, c. 330–300 BC). Before AD 79. National Museum, Athens

Greek and a Persian, probably Abdalonymos himself,
all rush to the rescue. The composition is crowded with
overlapping figures carved in high relief, and there is an
explosive outburst of action radiating from the lion's leap
on to the horse.

This interest in form and movement influenced the art
of painting. The linear style of the 5th and early 4th
centuries BC was abandoned and the figures were
modelled in tone and colour. At first only a limited
palette was used; red, yellow ochre, black and white; but
the Alexander mosaic, a Pompeiian mosaic which
reproduces a late 4th century painting probably by
Philoxenos of Eretria, shows how effectively these few
colours could be used to express form and drama
(*Ills 146, 147*).

Alexander, bareheaded on a chestnut brown horse, is
galloping at full tilt towards the Persian king Darius,
who is wearing a golden headdress and is in a chariot
drawn by black horses. Alexander's eyes are fixed upon
Darius, but his aim has slipped and his spear has struck
a Persian soldier whose wounded horse stumbles. Darius
stands in his chariot, arm outstretched in dismay as he
realizes the closeness of his enemy; his charioteer whips
the horses into flight. The drama of the encounter is
expressed in the ferocious onslaught of Alexander
towards the centre of the work which is crowded with
overlapping figures. Greek battle scenes had always been
violent affairs, but there is a new intensity of action with a
complex interplay of movement which anticipates
Hellenistic art.

*147 The Alexander mosaic, from the
House of the Faun, Pompeii. Before
AD 79. 8′ 10¾″ × 16′ 9½″ (271 ×
512). National Museum, Athens*

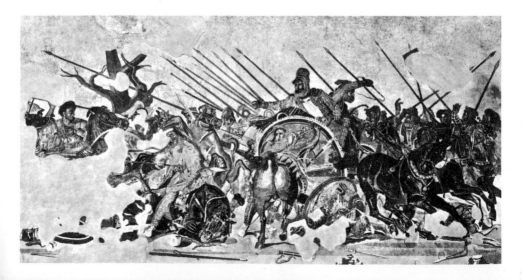

Alexander the Great defeated Persia and extended his empire far beyond the bounds of Greece. After his death this territory was divided among his generals who assumed a semi-divine status and ruled like oriental monarchs. The age of democracy was over.

Egypt had been conquered by Alexander in 331 BC and he appointed his general Ptolemy as governor. Ptolemy proclaimed himself king of Egypt in 305 BC and was succeeded by his son Philadelphus, thus creating a dynasty. These rulers converted the new city of Alexandria into one of the most influential cultural centres of the Hellenistic world by founding the Museum, a temple of the Muses with an attached library and research institute. It was modelled upon the school founded by Aristotle, the Lyceum in Athens, which was above all interested in logic and science. The Museum became the centre of scholarship, for not only was past knowledge systematized, but rapid advances were made in new fields. Euclid showed that previous discoveries in geometry were all logical deductions from a small number of definitions and postulates. At the same time the invention of the catapult as a military weapon encouraged the new study of ballistics, and the geometry of conic sections from which Archimedes laid the foundations of modern calculus.

It was an age of observation, and much work was done in the systematic study of plants, animals and medicine (*Ill. 212*, p. 213). Major advances were also made in astronomy, partly through Babylonian influence, for oriental scholarship had become available to Greek scientists after the conquests of Alexander the Great. When Copernicus suggested in the 16th century AD that the earth revolved around the sun he knew that he was repeating a theory of Aristarchos of Samos, an Alexandrian scholar.

Greek astronomers encountered similar religious difficulties to those experienced in the 16th and 17th centuries AD when it was suggested that the earth was not the centre of the universe. Only the Epicureans regarded the universe as a purely material creation governed by the laws of cause and effect. The Stoics believed in one world state ruled by a supreme power, which had many names but which came to be called Destiny, and that everything was predestined. This notion encouraged belief in astrology, the Babylonian science of discovering one's fate through the stars. The stars and planets moved in the vault of heaven according to fixed laws, and whatever happened in the sideral world was reproduced on earth. As the stars' movements were predestined, so were man's: he was a microcosm, the counterpart in miniature of the universe, and his soul was a spark of that celestial fire which glowed in the stars.

The only escape from this predestination was by magic or initiation into a mystery cult. The Olympian gods were too remote to care about individual people, although they protected the welfare of the cities. They were still officially worshipped but ordinary people turned to other gods who promised salvation. One of the most popular was Sarapis, whose cult originated in Alexandria and was derived from Osiris, the Egyptian judge of the dead; he was worshipped in the great temple built for him outside Alexandria by Ptolemy III. This was a Greek religion, never accepted by the Egyptians, and the cult statue, a noble Zeus-like figure with a corn-measure on his head, was believed to be the work of the Greek 4th century sculptor Bryaxis. The cult of Serapis spread throughout the Mediterranean, and the Roman emperor Hadrian copied the Alexandrian temple in the grounds of his villa at Tivoli (*Ill. 193*). Isis, the wife of Osiris-Sarapis, was the subject of even greater devotion because she claimed to be above fate and promised to liberate those initiated into her mysteries from the tyranny of Destiny.

The *Apotheosis of Homer* by Archelaos of Priene represents the rather cold, academic side of Alexandrian art (*Ill. 148*). It commemorates the victory of a poet, perhaps Apollonios of Rhodes, the Alexandrian Librarian, at a literary contest. Homer is enthroned as a god and crowned by Ptolemy IV and Arsinoe, representing Time and the Universe – a reference to the sanctuary dedicated to Homer, built by Ptolemy in

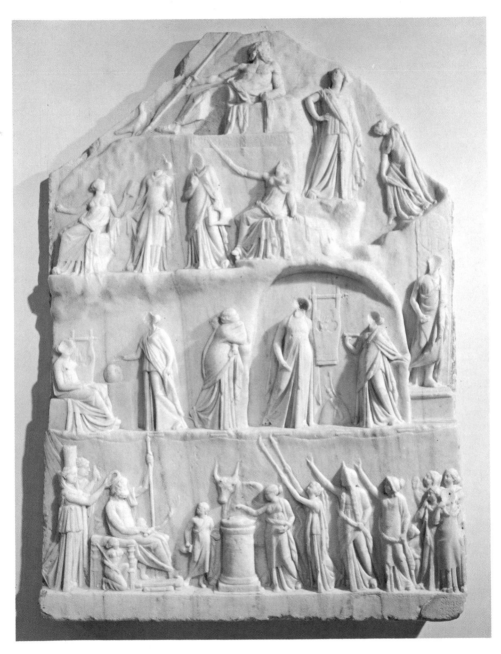

148 *The Apotheosis of Homer, from Borillae, 2nd century* BC. *Marble 45″(115). British Museum, London*

Alexandria. History and Myth are making a sacrifice at an altar and behind them Poetry, Tragedy and Comedy proclaim the new god. At the far end, a child points to the four virtues which come from the study of Homer: Courage, Good Memory, Trustworthiness and Wisdom. In the top section are the Muses, their father Zeus, Mnemosyne, their mother, and Apollo the god of poetry. This is a tortured, intellectual programme for a tortured, intellectual relief, but it shows the close relationship between the visual arts and scholarship in Hellenistic Alexandria.

The cultural rival to Alexandria was Pergamon in western Asia Minor. It was a mountain fortress built by Lysimachos, who became ruler of the greater part of Asia Minor after the death of Alexander. He deposited his treasure within this fortress, guarded by a eunuch, Philetairos. After Lysimachos had been killed in battle in 281 BC, Philetairos gained control of both Pergamon and the treasure, and by skilful diplomacy ensured the independence of the hill fortress. He was succeeded by his nephew Eumenes I (263–241 BC), who established the Attalid dynasty and liberated the city from the control of Antiochos I of Syria. His son, Attalos I, took the title of king after a great victory in 241 BC over the Celts who had settled in Asia Minor.

To celebrate this victory Attalos set up a monument representing his defeated enemies before the Temple of Athena Polias on the upper terrace of the city. The temple was an undistinguished Doric building of the early 3rd century BC, but the monument was a completely new development in sculpture. It was designed to be seen from all angles and to act as the central focus of a temple precinct. In the centre a Celt stabbed himself after killing his wife rather than allow her to fall into captivity. They were surrounded by four dying Celtic warriors, one of them, seen in a Roman copy in the Capitoline museum (*Ill. 67*), is the trumpeter who, having sounded the retreat, has collapsed, head sagging helplessly forward, his brow furrowed by pain. The pose is similar to that of the dying Greek soldier from the 5th century pediment of the Temple of Aphaia at Aegina (*Ill. 108*), but the figure is no longer idealized. It is an accurate representation of a Celt who went into battle naked except for the golden torque around his neck. Although a barbarian, he is portrayed as an individual

human being and his death agony is much more real and arouses far greater emotion within the spectator than the idealized dying Greek.

The kings of Pergamon were brilliant diplomats; Attalos I wisely supported Rome against Philip V of Macedon and his kingdom was extended over a large part of Asia Minor. As Perikles had used the wealth of Athens in the 5th century BC to embelish the Acropolis, so Eumenes II initiated an ambitious building pro-gramme to convert Pergamon from a simple hill fortress into a glittering city. He carved the hillside into a series of terraces, one above the other. At the foot of the hill is the lower agora through which a road passes up to the new ring of walls Eumenes had constructed around the Acropolis. These supported the terraces of two gymnasia, with a covered race-track between. Higher terraces were constructed for the Sanctuary of Demeter, the Great Altar of Zeus (*Ill. 151*), and a vast theatre was carved out of the hillside beneath the terrace of the Temple of Athena. Above this was Eumenes' palace, a relatively modest building arranged around a courtyard in the style of a Greek house. It was richly decorated with mosaic floors, but he did not try to emulate the grandiose arrangement of oriental palaces.

Eumenes' two greatest achievements were the Library and the Altar of Zeus. He surrounded the terrace of the Temple of Athena with a two-tier colonnade, the lower

149 Model of the Acropolis of Pergamon. Staatliche Museen, Berlin

150 A distant view of the Acropolis, Pergamon, from the Sacred Way to the Temple of Asklepeios

151 Terrace of the Great Altar of Zeus, Pergamon, 197–159 BC

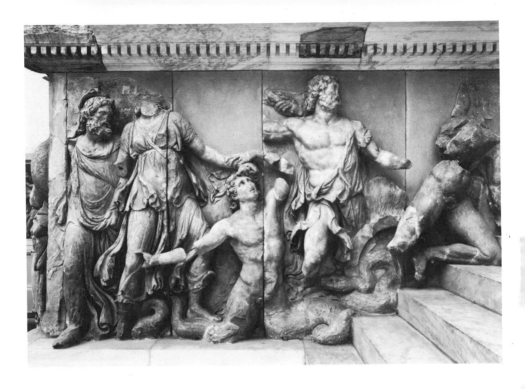

columns Doric and the upper ones Ionic, decorated with relief panels of weapons commemorating Athena as the bringer of victory. One side of this courtyard was used as the façade of the library, a suitable addition to a sanctuary of the goddess of wisdom. Eumenes was an ardent bibliophile and is said to have collected 200,000 volumes, though in fact the surviving building could only have held about 17,000. This library became so famous that the Egyptians prohibited the export of papyrus, used in the manufacture of books in roll form. The scribes of Pergamon had to return to the ancient practice of writing on goat skin; it was too thick and heavy to be rolled up easily, but separate sheets were sewn together to form a codex, a book with pages. Both forms of book were used until the 4th century AD, when the codex finally super-seded the roll. Although diagrams had been inserted into papyrus rolls, the codex gave painters the opportunity to design full-page illustrations (*Ill. 212*, p. 213) and the art of manuscript painting became important only after its adoption.

The Great Altar of Zeus was a free-standing monu-ment not attached to any temple. The altar itself was

152 *Sea gods fighting giants, relief on the northern projection of the west side of the Pergamon altar. Marble 7' 6" (230). Staatliche Museen, Berlin*

157

architecturally insignificant in relation to the surrounding courtyard. It stood on a raised platform approached by an impressive flight of steps on the west side and surrounded by an Ionic peristyle. The base of the structure was decorated with a frieze 7 foot 6 inches high representing the battle of gods and giants. On the east side the twelve Olympian gods are led by Zeus and Athena, on the south side are the Heavenly Bodies and on the north, Night is surrounded by the Stars and Constellations. The western side is divided by the staircase; on its right are the gods of the land, Dionysos and his satyrs, and on the left the sea gods (*Ill. 152*).

There was no difference in appearance between the gods and giants in the 6th century frieze from the Siphnian Treasury at Delphi (p. 103), where they are all represented in human form. But Hellenistic artists were fascinated by the wild and exotic, and emphasized the contrast between the sublime Olympian gods, above human feelings, and the snake-legged giants who expressed their anguish and pain without inhibition. In the narrow space on the left-hand side of the steps, Nereus, the Old Man of the Sea, stands beside his wife Doris, who grasps a giant by the hair and stands on one of his snake legs. The giant arches his back in agony as he struggles to free himself. Behind him, Oceanus attacks two giants in human form who are crouching on the steps of the altar, attempting to fend off the blows. By placing this frieze on the base of the platform the figures are brought into much closer contact with the spectator who becomes personally involved in this violent struggle between order and chaos.

Almost immediately after the reliefs of the battle of gods and giants were completed, a frieze was added to the inside of the peristyle of the Great Altar telling the story of how Herakles met and seduced Auge, whose son Telephos founded Pergamon. This frieze was carved between 164 and 158 BC but the style is calm and lyrical, with emphasis upon the landscape motifs, in complete contrast to the violence of the battle scenes.

The Great Altar was designed by Menokrates of Rhodes, indicating a close relationship between Pergamon and the important school of sculpture founded by Lysippos on the island of Rhodes. Lysippos had visited the island to cast a bronze group of the four-horse chariot of the sun, to which the capital city was dedicated. His pupils, Chares of Lindos, had created one of the most

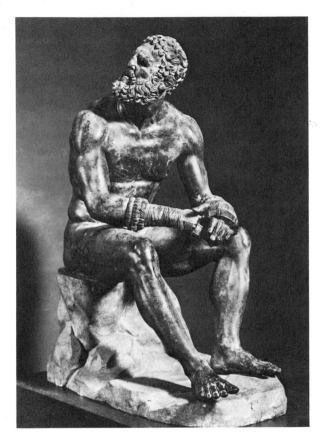

153 *Boxer by Apollonios the Athen-
ian, 2nd or 1st century* BC. *Bronze
4′ 2″ (128). National Museum,
Rome*

famous statues of antiquity, the Colossus, a 100-foot
bronze figure of Helios holding a torch in one hand.
Although the size of the figure may have served a
practical purpose, for the statue stood near the harbour
and was used as a lighthouse, it shows admiration of size
for its own sake.

The Nike of Samothrake (*Ill. 154*) was probably a gift
from the people of Rhodes to celebrate their victory over
King Antiochus III of Syria *c.* 190 BC. She is rep-
resented as if on the point of alighting on the prow of a
ship, her huge wings still open, her massed drapery blown
into a thousand criss-crossing folds which repeat the bold
swing of her wings. The twist of the body and movement
of the drapery invite the spectator to walk around her,
seeing how the composition changes from different points
of view.

159

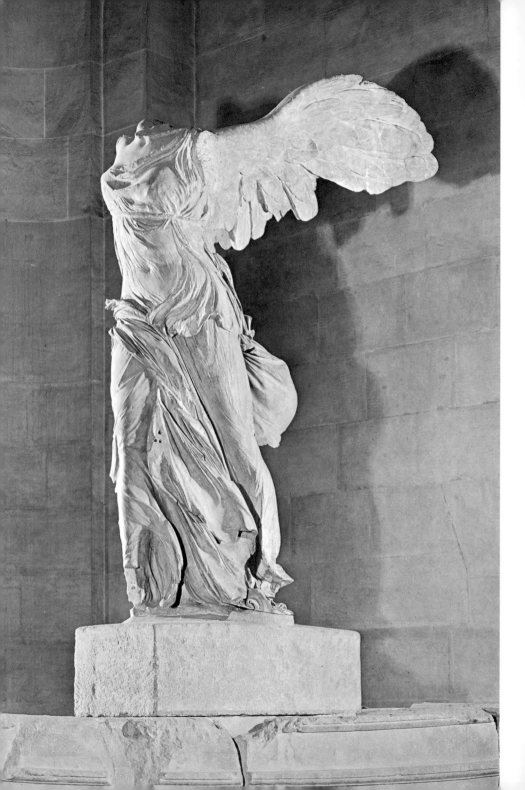

The expression of movement in the figure and its composition in three dimensions is a new 'baroque' device in Greek art. This was a term invented to describe the style of much 17th century AD European art, in which we see a complex analysis of form in space, so that the rigid barriers between spectator and work of art are broken down. We see a similar sense of coherent space in Hellenistic town-planning, in the arrangement of terraces at Pergamon, so that the market-place, gymnasia and temple precincts were all linked together. In sculpture there was a greater expression of movement, and thus the figure seems to break free from the confining block and even invades the real space of the spectator. Two giants in the frieze on the Great Altar of Zeus at Pergamon are represented crouching on the actual steps of the altar (*Ill. 152*). Their emotions are forcefully expressed so that similar feelings are aroused in the spectator.

The spectator could identify himself with the sculpture because the figures were no longer idealized. Athletes were represented when they were no longer at the peak of their form but battered and disfigured by their long career. A bronze figure of a boxer, signed by Apollonios the Athenian, is seated resting between rounds and looks upwards defiantly, perhaps refusing the advice of his trainer. His nose has been broken, his ears are thickened and drops of blood ooze from them (*Ill. 153*). This is not a triumphant figure but one who must soon accept humiliation and defeat.

As a result of this growing interest in the individual, the art of portraiture became increasingly important. Although there was still a tendency to idealize the figures, and to represent kings as heroic athletes, there is a brutal realism in the portrait of Euthydemos of Bactria (*Ill. 155*). The face is dominated by the huge nose and the mouth is dragged down by deeply etched lines which express his aggressive and cynical personality.

As far as we can judge from Roman copies and literary sources, such as Pliny, great advances were also made in painting in the Hellenistic period. New subjects, such as scenes from everyday life and still-life were introduced, and for the first time light and colour became important. But no original works have survived from this period, and the Roman copies were painted at a time when Roman art was developing its own individual character; they will be described in Chapter Thirteen.

155 Roman copy of the portrait of Euthydemos of Bactria, c. 230–220 BC. Torlonia collection, exhibited Villa Albani, Rome

154 (left) Nike of Samothrake by Pythokritos of Rhodes, from the Sanctuary of the Kabiri, Samothrake, c. 190 BC. Marble 8' ½" (245). Louvre, Paris

Mainland Greece came under Roman control after the sack of Corinth in 146 BC. Until the Punic wars with Carthage, Rome had not been interested in the power struggles among the various Hellenistic kings. But Macedonia made the fatal mistake of backing the wrong side for it seemed inevitable that Carthage should win. Rome never forgave this interference and took more and more control of Greek affairs, until finally Macedonia became a Roman province. Although the rulers of Pergamon had skilfully remained Rome's ally, Attalos III bequeathed his city to Rome in 133 BC, and Pergamon became the capital of the Roman province of Asia. Rome had become ruler of one of the greatest empires in world history.

Although Greece continued to be an art centre under Roman occupation, the creative period was over and a considerable export industry was developed copying old masters. Roman art, which up to this date had had its own individual character derived partially from its Etruscan heritage, came under such strong Greek influence that we can only describe the style which appeared in the 1st century BC as Greco-Roman.

Etruscan art 6th–1st century BC

Italy, unlike Greece, had never been in close contact with the great Bronze Age civilizations of the Near East. The Mycenaeans had set up a few trading posts in Italy, but the main cultural contacts were with the north. There was an Urnfield civilization in Umbria in the 12th century BC (see p. 73) and this developed in the 9th century into the Villanovan culture. The Villanovans buried the cremated ashes of their dead in biconical funeral urns, sometimes covered with bronze crested helmets of northern type. Eastern influence came into Italy in the 8th century when southern Italy and Sicily were colonized by the Greeks and at the same time the Villanovan civilization in the north was transformed by the Etruscans into a new orientalizing culture.

The Etruscans are a mysterious race. Their language has not been deciphered, but it is apparent that its structure is completely unlike Latin and it seems to be related to that of a non-Hellenic 6th century BC inscription on the island of Lemnos. According to Herodotos the Etruscans came originally from Lydia, in Asia Minor, and there may be an element of truth in this statement for their culture shows very close connections with that of the east Greek world. But unlike the Greek colonies in the south, the Etruscan nation was not the result of one single migration. It was created in central Italy out of many heterogenous elements.

Their original territory lay between the Arno and the Tiber, but by the 7th century BC they had spread south into Campania and had founded a capital city, Capua, close to the thriving Greek colony at Naples. During the 6th century BC they were at the height of their power and the half-Etruscan dynasty of the Tarquins ruled Rome. The Tarquins transformed Rome from an armed settlement of herdsmen into a Mediterranean city, giving it a civic centre by draining the Forum, and starting work

on the chief temple of the city, the Temple of Jupiter Capitolinus (*Ill. 156*).

It was a major undertaking to build a terraced platform for this temple on the Capitoline Hill overlooking the Forum. The huge building had a typically Etruscan groundplan, almost square, each side being about 200 feet long. It was not peripteral but had a porch of two rows of columns facing south. The sanctuary was divided into three parallel shrines, the middle one dedicated to Jupiter and those on the sides to Juno and Minerva, all under one pediment and one roof. Only the foundations were of stone; the walls were of mud-brick, the columns of wood and the sculpture of terracotta. Pliny tells us that the sculptor Vulca was summoned from the neighbouring city of Veii by Tarquinius Priscus to work on the statue of Jupiter.

After the 6th century BC, Etruscan power began to decline. The Tarquins were expelled from Rome, and the new Republic began to wage war against Etruria. The Romans formed an alliance with the Greeks of Cumae and defeated the Etruscans with the help of Greek cavalry at the battle of Lake Regillus, just east of Rome, in 496 BC. This victory was commemorated by dedicating the Temple of Castor and Pollux in the Forum, for the Greek heroes were believed to have come to the help of the Roman army.

For a time the southern Etruscan territory survived in the isolation caused by the loss of Latium, but in 438 BC Capua was captured by the Samnites, a southern Italian tribe. Only Tarentum and Naples, the largest Greek cities survived, and the Etruscan settlements were wiped out. Rome aided the destruction of Etruscan power by attacking and sacking her northern neighbour Veii, thus gaining control of the west bank of the Tiber. At the same time the Celts were attacking from the north. They sacked the city of Rome in 390 BC, but the Romans repulsed them and they began to settle in Etruscan territory. In 280 BC the Etruscan cities were forced into alliance with Rome, by which they retained domestic self-government but were nevertheless forced to submit to the political control of Rome.

Although eventually defeated by the Romans, the Etruscans had a profound influence on Roman culture. Roman temples were built on Etruscan plans. Greek temples were designed to be seen from all points of view,

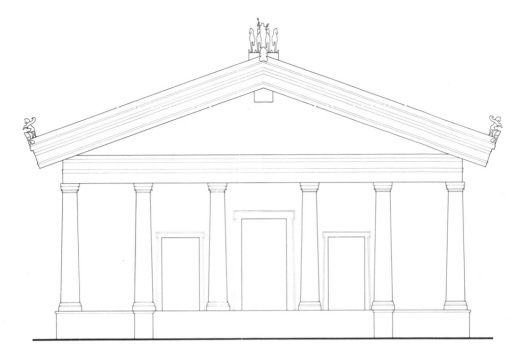

whereas the Etruscan temple dominated the precinct in front of it and could be approached only by the flight of stairs at the front. This plan was followed even in the Forum of Augustus (*Ill. 184*) where the Temple of Mars Ultor, dedicated in 2 BC, stands on a high podium at the back of the forum.

The Romans also copied the Etruscan type of city plan in which the two principal streets pointed to the cardinal points of the compass, the *cardo* running north to south and the *decumanus* east to west. The aim was to copy the chief divisions of the vault of heaven, each a habitation of a deity (this lay behind the whole art of divination which the Romans inherited from the Etruscans).

The Greeks also laid out their cities with streets running at right-angles to each other, and both Greek and Etruscan city plans were probably derived from the same oriental source. This type of plan was crystallized by Hippodamos who redesigned his own city, Miletos, in the early 5th century BC, probably in 466 after the Persian destruction. But it is possible that the grid-iron plan of Marzabotto, an important Etruscan city in the hills to the south of Bologna, is earlier.

156 Reconstruction of the Temple of Jupiter Capitolinus, Rome, dedicated 509 BC. After E. Gjerstad

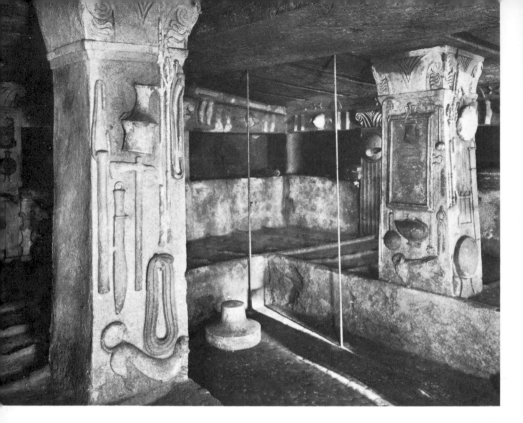

157 *The Tomb of the Reliefs, Caere (Cerveteri), 4th–2nd century* BC

The Greek and Etruscan cultures were completely different in character. The Etruscans did not share the Greek passion for abstract beauty which converted architecture into a form of sculpture; whereas the Greeks had invented town planning in order to create a more beautiful and more efficient city, the orientation and orderly planning of Etruscan cities came from a wish to build according to divine will.

The Etruscans, like the Egyptians, were intensely religious and obsessed by death. We know far more about them from excavations of their necropolises than from the vestiges of their cities. Even their temples were built of flimsy materials and only their fortifications and their tombs were constructed of stone.

Instead of the simple stone stelae which marked the graves of mainland Greece and the islands, the Etruscans buried their dead in chambers which imitated the forms of their houses. These rooms could be either above or below ground. At Caere (Cerveteri) they built huge *tumuli* over the grave chambers and in one of the later

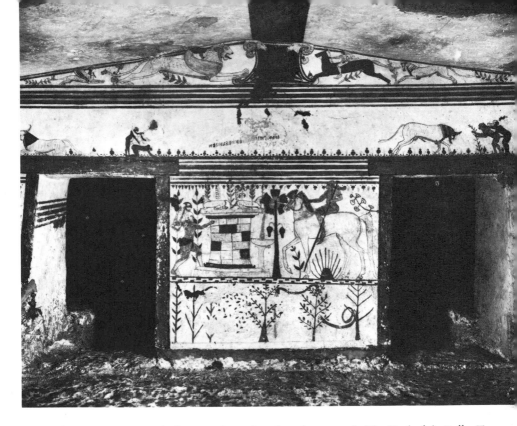

tombs, the Tomb of the Reliefs, in use from the 4th to the 2nd century BC, even the furniture had been copied in painted stucco (*Ill. 157*). The pillars (with curious archaic capitals), are hung with household utensils, an axe, a knife, a truncheon and a coil of rope. One of the niches for the dead body has been provided with pillows, and beside it is a low bedside table with the master's sandals laid out. Prancing beside the bed is a little animal, at first sight a pet dog, but in fact three-headed Cerberus, the grim guardian of the Underworld.

At Chiusi and Tarquinia the tombs, still copying the plans of houses, have been carved out of the rock underground and are painted. They have a vestibule with ridged roof and two or three doorways in the wall opposite the entrance leading to the tomb chambers. The earliest tomb at Tarquinia is the mid-6th century Tomb of the Bulls, named after its paintings (*Ill. 158*). A bull, a horseman, a chimaera and a sphinx confront an altar in the topmost section of the wall opposite the entrance. In the next section, above the two doorways leading to the

158 The Tomb of the Bulls, Tarquinia, c. 550–540 BC

167

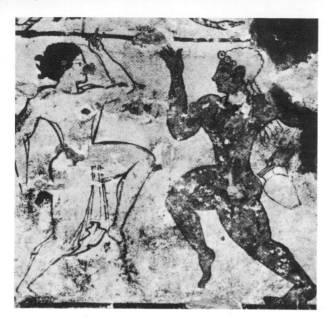

159 *Dancing couple from the Tomb of the Lioness, Tarquinia, c. 520 BC*

160 *(below) Seascape from the Tomb of Hunting and Fishing, Tarquinia, c. 510 BC. Archaeological Museum, Florence*

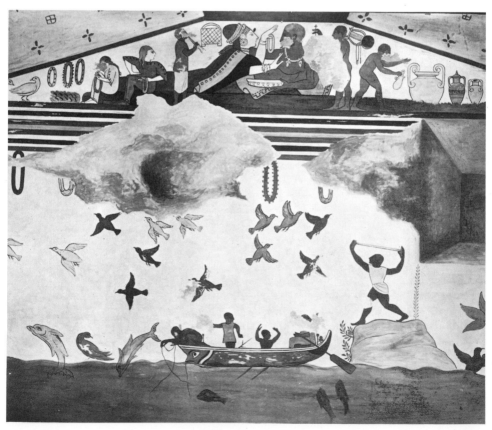

tomb, is a mysterious scene perhaps referring to a fertility religion, in which erotic groups of figures confront two bulls. Between the doorways is an illustration from the *Iliad*, Achilles ambushing Troilos at a fountain. At floor level are groups of bushes. Although the subject of the main scene is Greek, the style does not seem to be Hellenic and the composition is quite different from that on the contemporary 'François Vase' (p. 104; *Ill. 101*). The figures wear Etruscan clothing and are subordinated to the landscape setting.

The Tomb of Hunting and Fishing, painted about 510 BC, shows the importance of nature in Etruscan art. The tomb is divided into two rooms, the first decorated with typically Greek themes of men returning from the hunt, music and dancing. The second room is completely un-Greek in theme, for it is filled with a landscape frieze with various episodes illustrating life at sea (*Ill. 160*) including gaily coloured fishes and birds and boys fishing and diving off rocks.

The normal subject for tomb decorations of the 6th and 5th centuries BC was the funeral banquet and games. The Tomb of the Augurs (*c.* 530 BC) represents the violent side of Etruscan funeral ceremonies (*Ill. 161*). Instead of an entrance to the funeral chamber, there is a painted doorway representing the Doors of Death. Flanking it stand two mourners, hands raised to their heads, while

birds fly past among the trees. On the side walls are the funeral games which included not only Greek athletics but also human sacrifice in which men fought to the death. On one side of the wall two naked athletes compete in a wrestling match for a prize of three vases. Opposite there is much more sinister episode in which a blind-folded man, his head wrapped in a bag, is being attacked by a masked man, a *phersu*, and at the same time by a dog. This was the origin of the brutal gladiatorial combats which the Romans adopted from Etruscan funeral games.

The Tomb of the Lioness, painted about 520 BC, is named after the animals (which are actually panthers) in the upper section of the wall opposite the entrance. There is no funeral chamber, for the body had been cremated and the ashes placed in a niche under a painting of a large funeral urn. To the right of the urn there is a wild dance by a naked boy and a girl in a transparent chiton who makes a sign against the evil eye. On the other side of the urn a priestess in full robes joins in the dance with power-ful, rhythmic movements (*Ill. 159*). They are watched by banqueters reclining along the side walls.

The moderating influence of Greek painting is seen in the Tomb of the Baron, decorated about 510 BC. A procession of horsemen accompany a husband who offers a bowl of wine as a farewell gesture to his dead wife. The figures are painted directly on to the cream-coloured rock, and seen in a dim light, the pale grey underpainting creates an illusion of relief. The restraint and solemnity of the procession are very different from the orgiastic funeral ceremonies normally represented on the walls of Etruscan tombs.

In the later tombs cheerful banqueting scenes were replaced by disquieting views of the Underworld, expressing real horror of death. The Tomb of Orcus was begun in the 4th century BC and was enlarged in the 3rd century. The older part of the tomb contains the portrait of Velia, wife of Arnth Velcha. This is one of the most attractive of Etruscan paintings, though Velia's head is shrouded in dark clouds and next to her stands the demon Charon. In the later chamber are scenes from the Underworld. It is inhabited by heroes, who are menaced by demons, and those who cannot drink of the blood libation are like little grey monkeys gibbering in a tree. A solemn banquet has been prepared for the dead in the Underworld, but the magnificent array of golden vessels

162 *The Banquet of the Dead from the Tomb of Orcus, Tarquinia, 3rd century* BC

has been laid out by a servant accompanied by a winged demon (*Ill. 162*).

Although the uncremated bodies were sometimes laid uncovered on benches within the tomb, they were often placed in sarcophagi in the form of banqueting couches. The deceased were represented reclining on them, pouring libations as if at their own funeral banquet. The terracotta Sarcophagus of the Married Couple from Caere is mid-6th century in date (*Ill. 164*). It represents the husband affectionately sharing his couch with his wife (unlike the Greeks, Etruscan men and women dined together). Although the subject is not Greek, the style is similar to that of archaic sculpture and the faces are illuminated by the typically brilliant smile of that period. Late Etruscan sarcophagi have an almost expressionist quality. The lid of a cinerary urn in Volterra, in the form of a miniature sarcophagus, represents a dead man and a woman in a curiously twisted position (*Ill. 163*). The figures have disproportionately large heads which are modelled with deeply incised lines. The woman might be the dead man's wife, but the position of the figure suggests a hovering spirit and she probably represents the dread goddess of death, Vanth.

Marble is not as common in Italy as it is in Greece and the Etruscans tended to work in terracotta and bronze.

163 Lid of a cinerary urn representing the dead man and the goddess of death, 2nd century BC. Terracotta 16′ × 28″ (41 × 71). Museo Etrusco Guarnacci, Volterra

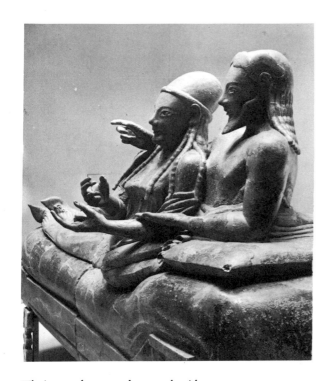

164 *The Sarcophagus of the Married Couple from Caere (Cerveteri), mid-6th century BC. Terracotta, life-size. Villa Giulia, Rome*

Their temples were decorated with terracotta statues, not only in the pediment, but sometimes also along the central beam of the roof, as in the 6th century Portonaccio Temple at Veii (*Ill. 168*). These life-size figures represent the struggle between Apollo and Hercules (Herakles) who had tried to carry off the hind of Apollo's sister Diana (Artemis). This figure is obviously derived from an archaic Greek *kouros*, but it is much more broadly modelled and intended to be seen from the side, not the front. The balanced forms of Greek 5th century BC art had little influence on the Etruscans, and their art remained archaic in style until the 4th century BC. But the greater naturalism of late classical art, especially the style of Lysippos, appealed to Etruscan taste and we can see his influence in the figure of Apollo from the pediment of the dello Scasato Temple at Falerii Veteres (*Ill. 166*). Yet, in spite of obvious derivation from Greek models, there is a fierce intensity in Etruscan sculpture found nowhere else. This is seen in the head of a bald man from the Belvedere Temple at Orvieto who has the brooding expression of a prophet (*Ill. 165*).

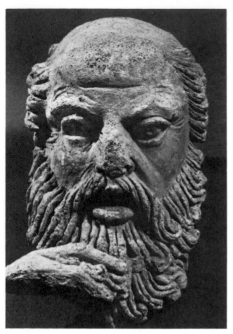

165 *Head of a bearded man from the Belvedere Temple, Orvieto, 4th century* BC. *Terracotta 6¼" (16)*

166 *(below left) Apollo from the pediment of the dello Scasato Temple, Falerii Veteres (Civita Castellana), 4th–3rd century* BC. *Painted terracotta 25½" (64.8). Villa Giulia, Rome*

167 *(below right) The 'Ghost of Night' 3rd–2nd century* BC. *Bronze 22⅝" (57.5). Museo Etrusco Guarnacci, Volterra*

Etruscan and Greek art are superficially similar; they used the same themes and share an interest in human form. But Etruscan art has no interest in abstract proportion, which it ignored for the sake of expression. An extraordinary series of immensely elongated figures used as votive offerings and found in different sites, have such attenuated forms that they seem to represent the spirit of the dead (*Ill. 167*). Etruscan art lacks the balance and harmony of Greek art, and in comparison, can look crude and violent, yet it expresses an intensity of life found in few Greek works.

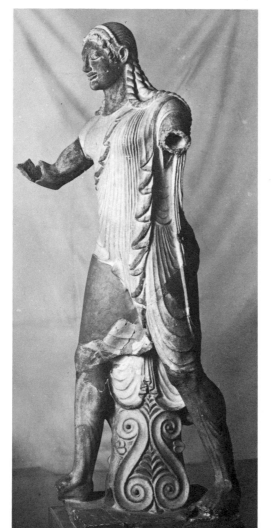

168 Apollo from the roof of the Portonaccio Temple (the Temple of Apollo), Veii, late 6th century BC. Painted terracotta 5′ 9″ (175). Villa Giulia, Rome

175

CHAPTER THIRTEEN

Roman art during the Republic and the early Empire
2nd century BC–1st century AD

Roman art had a struggle to achieve an identity of its own. During the early years of the Republic, the Etruscans were the leading artists in central Italy and the Romans copied their plans for temples, houses and cities. At the same time there was an increasingly strong influence from Greece, not only from the Greek cities of southern Italy, but also indirectly through the Etruscans. After the Roman conquest of Greece in the 2nd century BC, Greek artists came to work in Rome and works of art and copies of old masters were imported. This Greek influence reached its height during the reign of Augustus (27 BC–AD 14).

Nevertheless, Roman architecture had a style of its own. This style was partially derived from the use of local building materials. The most important Greek temples were built out of marble but the Etruscans mainly constructed their buildings out of mud-bricks and wood and there was little marble available in Italy until the Luna quarries were opened at Carrara at the time of Augustus. Roman architects were seeking for more monumental forms than were possible with the humble Etruscan building materials, but the importation of Greek marble was prohibitively expensive. They found that the hard creamy-white limestone from Tivoli, called travertine, could be used as a substitute for marble, and they built the foundations and walls out of a soft volcanic sandstone called tufa. But their major innovation was to make extensive use of concrete, roofing their buildings with arched vaults instead of wooden or stone beams.

Roman architecture acquired its character from this use of the arch and vaulting. It was not an innovation, for arches had been used in Mesopotamia since the earliest times (see p. 28). The Greeks were also familiar with the arch from their oriental trade, and used it occasionally when structurally necessary, for example, the barrel-

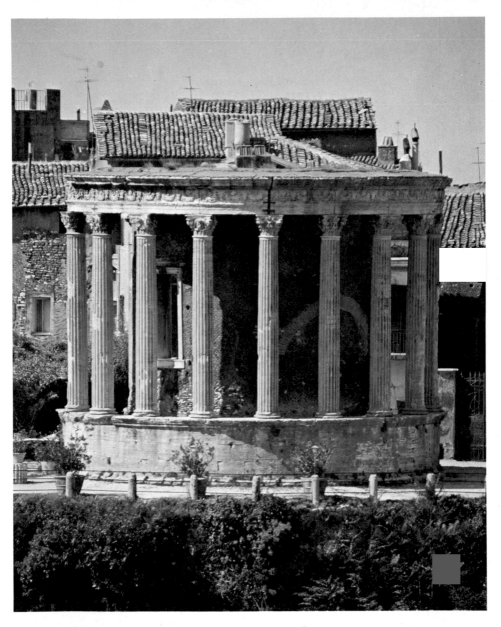

169 Temple of Vesta, Tivoli, 1st century BC

Roman art during the Republic
and the early Empire
2nd century BC–1st century AD

vaulted passageways in the temple at Didyma (see p. 137) and the arched entrance to the market at Priene. The Etruscans also built arched entrances to their cities at Perugia and Volterra.

Although the arch was not a Roman invention, the Romans were the first to make full use of it. At first it was a purely structural feature, used to cover wide spans in bridge and aqueduct construction. The oldest aqueduct is the Aqua Marcia, begun in 144 BC; the arches of the Pons Aemilius, the Ponte Rotto (Broken Bridge) in Rome, were constructed in 142 BC. The succeeding bridges, the Pons Mulvius begun in 109 BC and the Pons Fabricius, 62 BC, increased the span of the arches from 60 to 80 feet. Roman engineers became more and more daring in piling arches on top of each other, not only to span wide gaps, but also to reach great heights. This culminated in the Pont du Gard, built in *c.* AD 14 to carry the aqueduct of Nîmes in three tiers of arches 161 feet high over the Gard valley (*Ill. 170*). This was an amazing engineering achievement, and the structure is still in use as a bridge. The ranges of arches have a severe beauty which reminds us of 19th century railway architecture.

Later Roman architects found endless possibilities in the arch. Free-standing arches were built as triumphal monuments to the emperors (*Ills 185, 202*). They were also combined with the Greek orders, rising directly from columns. But the most important use of the arch was in the development of concrete vaulting. As early as

170 Pont du Gard, Nîmes, c. AD 14

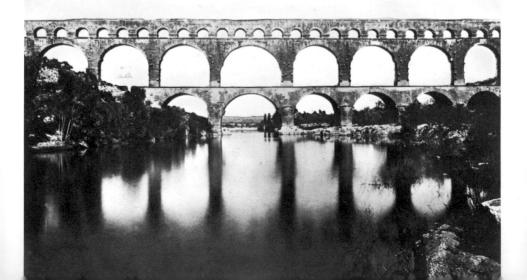

78 BC, the Tabularium, the Record Office in the Roman Forum, was built with a barrel-vaulted roof.

Roman architecture reached maturity with the ambitious building programme instigated by Sulla when he became Dictator in 81 BC after the disastrous Social War. His most grandiose project was the restoration of the Temple of Fortuna Primigenia at Praeneste, a building so vast that the whole medieval town, Palestrina, could be built within its terraces (*Ill. 171*). The overall design of connecting terraces was Hellenistic, for example the acropolis of the city of Pergamon (*Ill. 149*), and ultimately derived from Egyptian architecture. But the Temple of Fortuna Primigenia was much larger than any in Greece and more varied in the contrast between straight and curved forms. Moreover, there is an axial symmetry in the design alien to Greek architecture.

171 Temple of Fortuna Primigenia, Praeneste (Palestrina), c. 80 BC. Axonometric plan after A. Boëthius and J. B. Ward Perkins Etruscan and Roman Architecture, *1970*

During the 1st century BC, Roman architects were able to assimilate Greek influence, modifying the Etruscan plans of their temples without altering their essential character. Whereas Greek temples were intended to be looked at from all points of view, the façades of Etruscan and Roman temples were strongly emphasized. Although the Temple of the Sibyls at Tivoli (near Rome) appears at first sight to be surrounded by a Greek peristyle, the cella is so broad that it engages the columns at the back and sides and it stands on a high podium with steps at the front only. Close by is the circular Temple of Vesta which also stands on a high podium with steps at the entrance only. It has a structural core of concrete, concrete cella walls and was possibly even roofed with a concrete dome. But it is surrounded by a peristyle of eighteen slender Corinthian columns made from travertine, supporting an entablature decorated in a Hellenistic style with a frieze of garlanded bulls' heads (*Ill. 169*).

Roman houses followed Etruscan rather than Greek plans in having an entrance courtyard, the *atrium*, lit by an aperture in the roof, the *compluvium*, with a rainwater tank beneath it. The bedrooms were grouped around the atrium and at the end, opposite the entrance, was the *tablinum*, the family reception room. Beyond was the garden which, under Greek influence, was surrounded by a peristyle giving access to more bedrooms and reception rooms. This was the plan of the old patrician houses at Herculaneum and Pompeii, but in Rome conditions forced ordinary people to live in blocks of flats.

179

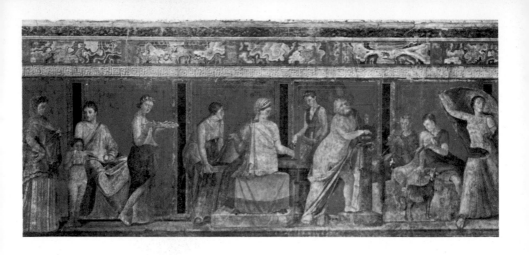

172, 173 *Painted Hall in the Villa of Mysteries, Pompeii, c. 50 BC*

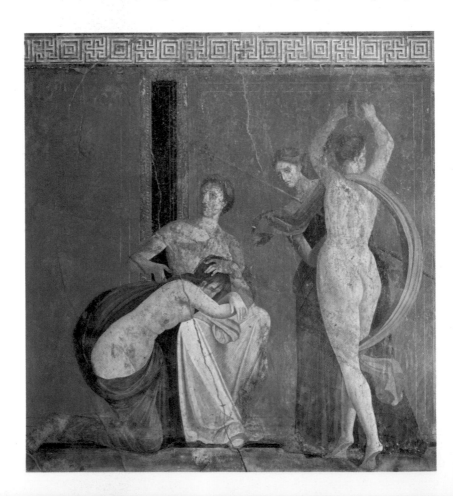

The patrician house presented a blank face to the outside world; no windows looked out on to the street and the only entrance was through a passage guarded by a porter. Inside it was cool and dark, light coming only from the compluvium and the doorways leading on to the peristyle. Although the Romans had invented under-floor heating for their public baths in the 1st century BC, it was not commonly used for houses and in winter the only heating was from a brazier. Some houses had running water, but bathing facilities were primitive; everyone went to the public baths, which became elaborate architectural complexes during the 1st centuries BC and AD. The Stabian Baths at Pompeii have barrel-

174 Garden Room from the Villa of Livia, Prima Porta, near Rome. Late 1st century BC. National Museum, Rome

175 *The* Odyssey *landscape from a house on the Esquiline Hill, Rome, c. 30 BC. Vatican Museum*

vaulted hot and tepid rooms and a concrete-domed circular cold swimming pool.

During the 2nd century BC houses were decorated in the Hellenistic manner with painted stucco reliefs imitating masonry construction and rich marble veneering. This First Style was followed by purely painted decorations, introduced at the beginning of the 1st century BC, which convincingly create an illusion that the room was surrounded by columns. Although the painters of the Second Style did not completely understand the principle of parallel lines appearing to converge at eye-level, they were obviously interested in the theory of perspective. Towards the middle of the 1st century BC the simple architectural decorations were used to frame vistas. A bedroom in a villa at Boscoreale had walls divided into panels by painted Corinthian columns (*Ill. 176*). In one compartment is the shrine of a goddess whose statue stands beneath a 'sacred gateway', and there is an altar before the closed doors of her sanctuary. The ivory and tortoiseshell inlaid gates of a luxurious villa are represented in the next compartment, and in the third is a tholos in a colonnaded courtyard. There seems to be some connection between these paintings and the fashion, mentioned by Vitruvius, of decorating houses with tragic, satyric and comic stage paintings. They were obviously not straightforward imitations of theatre scenery, but stage sets were copied as models of luxurious architecture. Though Roman houses were plain externally their painted decorations inside converted them into palaces.

Roman art during the Republic
and the early Empire
2nd century BC–1st century AD

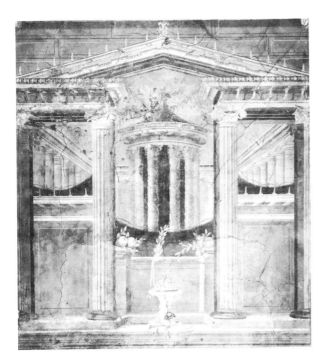

176 Architectural wall painting from the bedroom of the Villa at Boscoreale, c. 50 BC. Metropolitan Museum of Art, New York, Rogers Fund 1903

Although many of the house paintings were purely decorative, one room in the Villa of Mysteries in Pompeii seems to have been decorated for religious purposes, and the paintings have been interpreted as a scene of initiation into the cult of Dionysus (*Ills 172, 173*). The figures, life-size, stand on a shallow platform before a wall with typical Second Style decorations, divided into brilliant red panels separated by black and green strips. The total effect is solemn and impressive. At the entrance is the portrait of the domina of the villa, seated in a cushioned chair, resting her head pensively against her raised hand as she contemplates the ritual enacted before her. The initiate enters and listens to the reading of the ritual by a young boy under the direction of a seated matron. Then follows the lustral purification to the lyre music of Silenus, the companion of Dionysus. After the preparations have been made and the god is invoked, the initiate is struck by terror at the ordeal which faces her on the opposite wall. She starts back in alarm, eyes wide open, nostrils dilated and lips parted as she sees the scene of flagellation. A winged figure flogs a fainting girl, collapsed into the

183

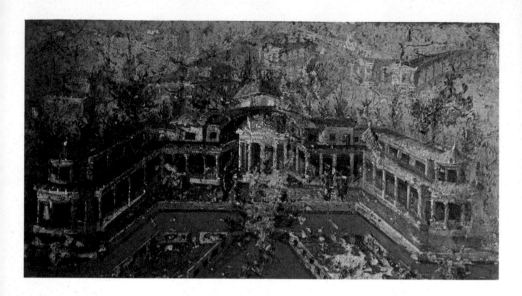

177 Villa landscape from the House of Lucretius Fronto, Pompeii, c. AD 30

lap of her companion, and a bacchante drowns her cries with the clashing of her cymbals. But the ordeal is soon over and she is adorned as a bride for the revelations represented on the end wall. The mystic basket is unveiled, revealing its secret of fertility. The hideous satyr is stripped of his theatrical mask and beneath is the wise and sensitive face of a philosopher resembling Socrates. In the centre, Dionysus relaxes in the arms of Ariadne, who is raised up and enthroned as an immortal through the love of a god.

The paintings of the Villa of Mysteries and of the whole Second Style show the concern of Roman painters in the 1st century BC to create an illusion of volume and space. The figures are basically Hellenistic in style, painted in the round and appearing to move against the architectural background. Real and pictorial space have been blended, as the painted figures look across the room to events taking place on the opposite wall.

The ultimate in naturalism and illusionism was achieved after the middle of the century when the wall was treated as a window opening on to a wide and boundless landscape. The *Odyssey* landscape is from a house on the Esquiline Hill in Rome. It is divided into eight compartments by Corinthian pilasters, but behind these divisions there is a continuous landscape illustrating Books X and XI of the *Odyssey*: the encounter with the

Lastrygonians, Circe's island and the visit to the Underworld (*Ill. 175*). The Underworld is represented as a great rocky cavern, with light flooding through the opening on to tiny figures of the dead flocking to drink the blood libation.

The work was obviously Greek inspired, for nymphs and mountain gods are personified and the names are written in Greek. But this major development in landscape painting was not a purely Greek achievement. According to Pliny, a fashion was started in the reign of Augustus for decorating houses with garden scenes and landscapes by a Roman painter called Studius (another manuscript calls him Ludius). We can, perhaps, see an example of his work in the villa at Prima Porta owned by Livia, the wife of Augustus. A room is decorated with a garden scene, without architecture or figures (*Ill. 174*). A fenced pathway runs all the way round the

178 Still-life from the House of Julia Felix, Pompeii, late 1st century BC. National Museum, Naples

**Roman art during the Republic
and the early Empire
2nd century BC–1st century AD**

room, with recesses for trees which replace the customary columns. Behind the fence is an impenetrable thicket of flowering bushes and fruit trees, with birds flying from branch to branch. The naturalism of this painting has no parallel in Greek work.

Roman landscapes are of two types. Some represent rustic shrines and are soft, sentimental misty paintings of an unreal Arcadia. Both subject and mood remind us of the pastoral idylls written by the 3rd century BC Alexandrian poet Theokritos. In contrast there was a group of landscapes which represent contemporary buildings, villas and harbour scenes, reflecting the Roman's interest in their own surroundings. Unlike the Greeks, the Romans built themselves country houses which were designed to look out over a beautiful view. Such a villa is represented in the *tablinum* of the House of Lucretius Fronto in Pompeii (*Ill. 177*).

Another attractive side of Pompeiian painting is seen in the little still-life panels inserted into the complex of the architectural decorations. The subjects are everyday objects, such as the eggs and game from the House of Julia Felix at Pompeii (*Ill. 178*). They are arranged with a pleasing sense of composition showing interest in tone values and related colours, and are examples of pure painting in which the handling of the tones and colours is more important than the subject. It is possible that they were copied from some pattern book of Greek master-pieces: Sosos of Pergamon was famous for his represen-tation of an unswept floor of a *triclinium* still littered with the debris of a banquet and this subject was copied in Roman mosaics. But still-lifes are also found in Etruscan painting, for example the golden dishes in the 3rd century BC Tomb of Orcus at Tarquinia (*Ill. 162*).

The sources of Roman painting are complex. There is no doubt that Roman painters owed a great debt to the Greek masters of the 4th and 3rd centuries BC whose works they copied on the walls of Pompeiian houses. It was the Greeks who extended the subject matter of painting beyond the confines of mythology, introducing scenes from everyday life, landscape and still-life. More-over it was the Greeks who developed the technique of painting from the linear style of the 5th century BC to one with a limited palette but figures fully modelled in tone and colour at the end of the 4th century BC (*Ill. 146*). In the Hellenistic period painters began to use the full range

179 Portrait of Aule Meteli (the Orator), from Sanguineto, near Lake Trasimene, c. 80 BC. Bronze (right arm and left index finger restored), 5′ 10½″ (179.5). Archaeological Museum, Florence

of colours, and they explored the expressive quality of brushwork, applying the paint in an almost impressionistic technique.

The importance of the Etruscan tradition in painting should not be underestimated. Greek painting was intended for display in public monuments and art galleries, whereas the Etruscans decorated tombs with banquet scenes, landscapes and mythological subjects. The architecture of the tombs imitates that of private houses, which suggests that Etruscan houses, unlike Greek houses, were also decorated with paintings. Artists working in Rome, whether Greek or Italian, transformed house decorations into major works of art.

A mixture of Greek, Etruscan and Roman elements can also be seen in the development of Roman sculpture in the 1st centuries BC and AD. Above all, the Romans excelled at portraiture. Patrician families displayed busts of their ancestors in the *tablinum* of their houses and masks were carried in funeral processions. Portrait sculpture developed in Italy just at the time when Hellenistic artists had become interested in the portrayal of individual personality (*Ill. 155*). It was at this time too, that the Etruscans began to create important portraits; for example the *Orator* in Florence (*Ill. 179*). It has an Etruscan inscription saying that it is a portrait of Aule Meteli, but it was cast about 80 BC when the territory where it was found near Lake Trasimene was under Roman control. It is difficult to distinguish what was basically Etruscan and what had come under the influence of Roman art. Aule Meteli stands rather clumsily with arm upraised in the conventional orator's gesture. Although the pose lacks the elegance of Greek portraits, the face has refined features with sensitive lips, and the bony structure of the skull is visible beneath the soft texture of the flesh. It is a portrait of a cultured man who is aware of the inevitable end of his civilization.

In contrast, the portrait herm of the rich banker Lucius Caecilius Jucundus from his house in Pompeii, represents him as an astute, cheerful man with a confident expression (*Ill. 180*). He has a firm mouth but asymmetrical features further disfigured by large projecting ears and a wart. He was a successful businessman without any pretentions of being a Greek hero. There is a realism in Roman portraits which goes much further than Hellenistic or Etruscan sculpture.

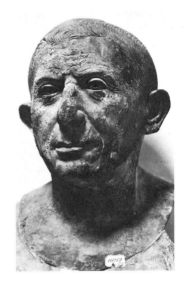

180 Portrait of Lucius Caecilius Jucundus, from his house in Pompeii. Before AD 79. Bronze 18½" (47). National Museum, Naples

187

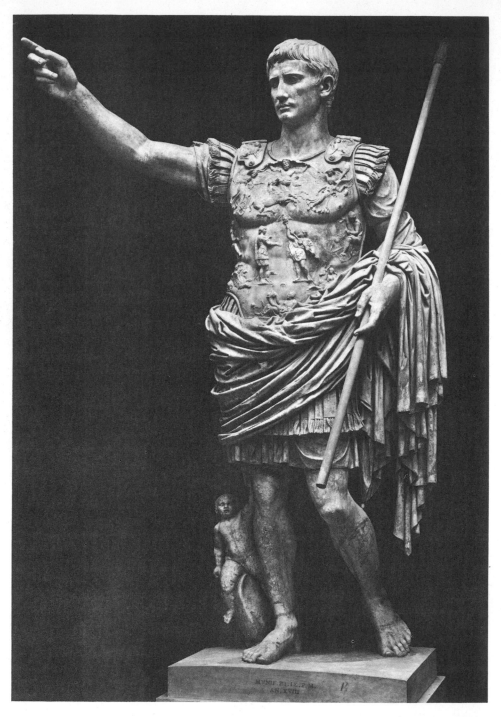

181 Augustus, from the Villa of Livia, Prima Porta, near Rome, c. AD 14. Painted marble, 6′ 7½″ (202). Vatican Museum

The new Roman style, which had been created in the 1st century BC out of Etruscan and late Hellenistic elements, was used by Augustus to glorify his empire. The statue from the Villa of Livia at Prima Porta represents Augustus barefoot as a Greek hero, but wearing Roman armour (*Ill. 181*). Although the figure lacks the realism of the Etruscan *Orator* (*Ill. 179*) and the features have been idealized, this is not an abstract hero but the portrait of a Roman emperor.

The *Ara Pacis* (Altar of Peace) was one of the first great achievements in Roman sculpture. It is a large sacrificial altar of Greek type on a raised podium and surrounded by a sculptured enclosure wall broken by entrances at east and west (*Ill. 182*). It was inaugurated in 13 BC to celebrate Augustus' return from the western

182 Reconstruction of the Ara Pacis, *Rome, inaugurated 13 BC. Luni marble*

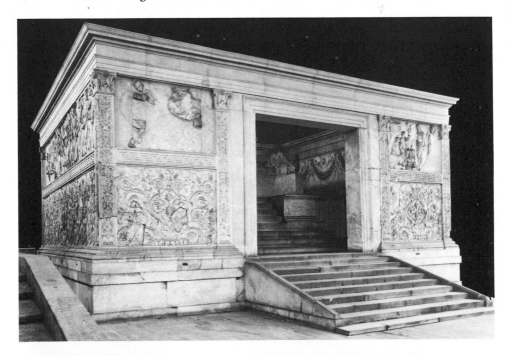

183 Mother Earth, *panel on the enclosure wall of the* Ara Pacis *(Altar of Peace). Luni marble* 5' 1¾" *(157)*

provinces, but it expresses the general feeling of relief in Italy that the civil war following the murder of Julius Caesar was over and that there was once more a strong and capable government. The altar itself was decorated with a conventional relief of a procession of vestal virgins, priests, sacrificial attendants and victims, a theme ulti- mately derived from the Parthenon. The procession continues on a much larger scale on both sides of the enclosure, becoming completely Roman in character; on one side Augustus, consuls, priests and the official family; on the other, the senate and the people. The panels flanking the two entrances are Roman in theme; the basic piety of the city is represented by Aeneas sacrificing at a rustic shrine and on the opposite side of the altar the golden age of Italy under the *Pax Romana* is symbolized by Mother Earth (or Venus, ancestress of Augustus' adoptive family) seated with her children and with her lap filled with fruit (*Ill. 183*). The figures in these reliefs are idealized in the Greek manner, but the details of the landscape setting and the exquisite carving of the plants, trees, and animals, show far more careful observation of nature than is ever found in purely Hellenistic art.

As leader of the Roman army, Augustus converted the triumphal arch, erected in honour of successful generals, into an imperial monument. Several arches were erected in his honour, including one in the Roman Forum, and

they set the pattern for all succeeding monuments. The Arch of Titus, at the eastern end of the Roman Forum, commemorating Titus' conquest of Jerusalem in AD 81, is a single arch of exceptionally fine proportions, and decorated with relief sculpture representing Titus' triumphal procession (*Ill. 185*). On one jamb soldiers carry the booty from Jerusalem, including the seven-branched candlestick, and opposite the emperor riding in his chariot is crowned by Victory (*Ill. 186*).

These reliefs show a significant change of style from the naturalism of the period of Augustus. Although the procession with the booty gives the impression of life and bustle, it is approaching an archway proportionally too small. Similarly, in the relief of the emperor in his chariot, the direction in which the figures are moving is not clearly indicated. The chariot horses are seen in strict profile while the emperor stands full face. The relationship of figures to each other in space was no longer of interest to the artist, and we see declining interest in the values of Greek art at the end of the 1st century AD.

Because the emperors were the richest men in the state, many used their personal fortunes to embellish Rome with new buildings. One of the city's most pressing needs was to increase the size of the administrative centre, for the old Forum was hopelessly congested. The extension was begun by Julius Caesar on the north side of the Forum, and succeeding emperors added to it, repeating the original architectural layout and axial alignment (*Ill. 184*). The most magnificent of these Imperial Fora was the one designed by Apollodorus of Damascus for Trajan (AD 98–117). It was a huge rectangular courtyard with semi-circular recesses on each of the long sides masked by a portico, and the whole of the west side was filled by the Basilica Ulpia, the largest basilica in Rome. (Basilicas, a Roman invention, were all-purpose buildings with rectangular plans.) Greek and Latin libraries were attached to the west side of the basilica and Trajan's Column stood in the courtyard between them.

Trajan's Column was dedicated in AD 113 to commemorate the emperor's conquest of the Dacians in present-day Rumania. It is 100 Roman feet high with an interior spiral staircase winding up to the Doric capital on which stood the statue of the emperor (replaced by one of St Peter in 1587). Instead of flutes, a figured frieze 3 feet high spirals around the column, describing

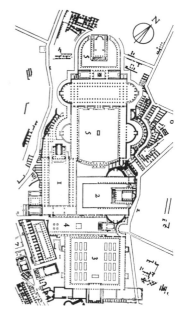

184 Plan of the Imperial Fora, Rome, 1st–2nd century AD

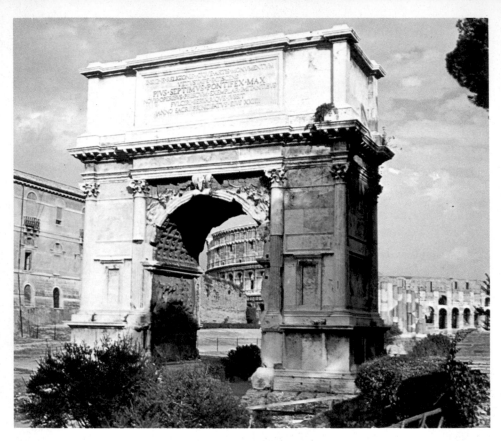

185 *Arch of Titus, Roman Forum, c. AD 81–82*

in detail Trajan's two Dacian campaigns (AD 101–103 and 104–106). It is carved in a very realistic style, for the details of military life have been recorded so accurately that they must have been based upon sketches made during the campaign. For example, the opening scene represents the start of the campaign when the Roman army crossed the Danube, one of the frontiers of the Roman empire, by a pontoon bridge (*Ill. 187*). The bridge is drawn in precise and accurate detail, clearly showing how the wooden roadway was supported by boats lashed together and kept in position against the river current by their steering oars.

The sculptor was not interested in creating an illusionistic landscape. The figures are crowded into the foreground and the buildings are disproportionately small; there is no attempt to create a sense of recession into space. Although the river is symbolized by a classical river god who raises his head above the water to watch

the departing army, this relief is carved in a new style which owes little to Greek art. No Greek artist would have included a pontoon bridge in a battle scene and the Greek convention of heroic nudity would have seemed ridiculous to the literal Roman artist who knew that Roman soldiers wore armour.

The Column of Marcus Aurelius, erected between AD 176 and 193, was obviously copied from that of Trajan. It, too, is 100 Roman feet tall and has a spiral staircase up its centre. The spiral relief commemorates in the lower part the emperor's war with the Germans, and in the upper part his war with the Sarmatians. Instead of being an objective account of a successful campaign, the reliefs express the horrors of war in scenes of sacking German villages with weeping women and children. Moreover, the Roman army did not triumph solely by armed strength but also with the help of divine intervention; the 'age of miracles' had begun. The *Miracle of the Rain* (*Ill. 188*) represents a Roman legion trapped in a narrow defile and saved by a sudden downpour. The rainstorm is symbolized by a huge winged figure which hovers over the drowned enemy, piled on top of each other on the right-hand side of the scene. The Roman soldiers on the left all stand in one plane in the foreground, placed one above each other to indicate recession (though without diminution of size), so that they fill the entire surface of the relief. The outlines of the figures have been emphasized with deep grooving by means of a drill which increases the general flatness of the design. The work is harsh and grim, a monument to warfare and far removed in spirit

186 The Emperor's triumphal pro-
cession, from the Arch of Titus,
Forum, Rome. Marble 6' 7½" ×
12' 8" (202 × 386)

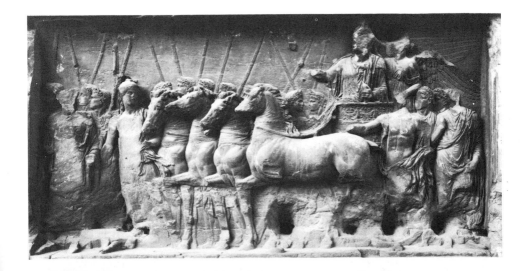

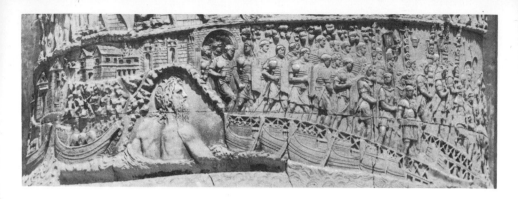

187 Detail of the frieze on Trajan's
Column representing the Roman army
crossing the Danube. Dedicated in
AD 113. Marble, height of column
100 Roman feet. Trajan's Forum,
Rome

from the lyrical naturalism of Augustus' Altar of Peace
(*Ill. 183*), carved nearly two centuries earlier.

Just as Roman sculptors had to a large extent aban-
doned their Hellenistic heritage in the 2nd century AD,
Roman architects combined Greek forms with Roman
concrete construction, producing a completely new style.
The Pantheon, created by Hadrian AD 118–126 (*Ill. 189*),
is the complete reversal of classical architecture, being a
great domed circular building with only an entrance
porch and no peristyle. Even when still sheathed in marble
the outside must have been extremely ugly, and the
entrance portico has extraordinary proportions for the
pediment rises at far too steep a pitch. But inside, the
whole building is dominated by the dome, an architec-
tural simulacrum of the dome of heaven (*Ill. 190*). The
building was not dedicated to the Olympian gods, but to
the planetary deities, whose statues stood in seven niches
which pierce the wall. The arches over the niches are
hidden behind an entablature supported by Corinthian
columns. The concrete walls were faced in coloured
marble and the whole complex structure of the building
was disguised. As a result the great coffered dome appears
to float unsupported, and on entering the building one is
overwhelmed by the great volume of curved space. The
space was defined not so much by form but by light for
in the centre of the dome there was a circular opening
through which the sunlight flooded, moving around the
building with the passage of time.

Hadrian had built himself an enormous villa outside
Rome at Tivoli. Unlike Hellenistic kings who lived in
relatively modest palaces, the Roman emperors lived in
great state. Although Augustus had lived simply as a
private citizen in the fashionable residential area on the
Palatine Hill overlooking the Forum, Tiberius, his

successor, had destroyed all the private property on the north-west side of the Palatine to make way for his palace, the *Domus Tiberiana*, which was extended by Caligula. A new palace was begun by Claudius, or more probably Nero, but it was destroyed in the fire of AD 64. This gave Nero the opportunity to lay out his Golden House, the *Domus Aurea*. Although situated in the centre of Rome, the *Domus Aurea* was designed as a country house overlooking extensive parkland with a lake. After Nero's suicide in AD 68, Vespasian converted the ground into a public park and drained the lake to form the foundations of the world's largest amphitheatre, the Colosseum. But this reaction against personal lavish display was short-lived; his son Domitian, when he became emperor in AD 81, took over the whole of the Palatine Hill as his private and official residence. He was the first emperor to proclaim himself a god within his own lifetime, and his banqueting hall had an apse, reached by steps, where he dined alone to avoid profane contact with his guests.

Hadrian's Villa consists of a number of groups of buildings linked by gardens and pools (*Ill. 191*). It was a sentimental and nostalgic retreat from the bitter realities of a life spent administering an empire which had grown too large. The wealth of this empire had been used to recreate the most famous monuments of the ancient world of Greece, for example the Serapeum in Alexandria (*Ill. 193*). This was not an exact reproduction of the Temple

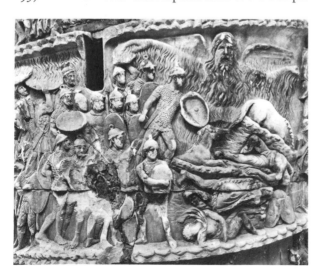

188 Detail of the frieze on the Column of Marcus Aurelius representing the Roman army saved by the Miracle of the Rain, AD 176–193. Piazza Colonna, Rome

189 *The Pantheon, Rome, AD 118–126*

of Serapis, but a highly schematic analogy. The canal from the Nile is suggested by a rectangular pool surrounded by a portico of Corinthian columns supporting flat lintels and curved arches; amongst the sculpture standing on the banks is the Nile river god and a crocodile. The Temple was represented by a fountain with a great semi-circular apse with mosaic encrusted semidome, pierced by niches for waterfalls. Roman architecture had completely outgrown its dependence upon Greece.

The most original and complex part of the palace is the 'Piazza d'Oro', probably the emperor's main reception hall. It is a large colonnaded courtyard entered at one side through a domed octagonal vestibule (*Ill. 192*). On the opposite side of the courtyard is a much larger hall with a square plan but roofed by an octagonal dome supported on eight piers. The bays between the piers curve alternately inwards and outwards. The whole scheme is a monumental development of the atrium house with its entrance opposite the main reception room. But instead of simple rectangular rooms, its halls are vaulted in complex intersecting curves. Hadrian's Villa represents Roman art at its best with its vast scale, lavish materials and imaginative handling of space.

190 *The interior of the Pantheon. Painting by Giovanni Paolo Panini (1691/2–1765). Samuel H. Kress Collection, National Gallery of Art, Washington*

191 *Model by I. Gismondi of Hadrian's Villa, Tivoli, c. AD 118– 134. The park is one mile wide*

192 *Plan of the Piazza d'Oro, Hadrian's Villa, Tivoli. After Winnefeld*

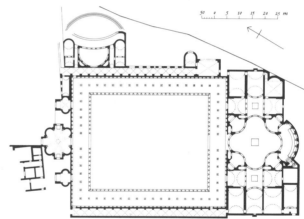

193 *The Canopus and Serapeum, a reflecting pool and fountain in the grounds of Hadrian's Villa*

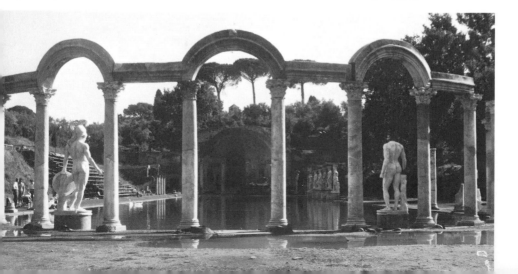

Late Roman art 3rd–4th centuries AD

The Roman empire had been at the height of its power under the Antonine emperors in the 2nd century AD, but it was already beginning to show signs of strain. The empire was too large to be administered efficiently and it was constantly under attack. The Antonine dynasty ended with the murder of Commodus (AD 192). Eventually the North African governor of Upper Panonia, Septimius Severus (AD 193–211), gained supreme power but still had to fight a disastrous civil war for four years against the rival contestants put forward by the different armies. Although he temporarily halted the breakdown of the empire and was succeeded by his son Caracalla (AD 211–217), his rule was harsh and taxation became increasingly heavy. More and more money was needed to pay for the army which became dangerously powerful. In the half century between AD 235 and 285 there was a complete collapse of central administration because of civil war between the different armies who put forward their own generals as emperor. In this period there were twenty-six Roman emperors, and only one died without violence. The frontiers were no longer adequately guarded and Italy was open to barbarian invasion; Aurelian (AD 270–275) was forced to build defensive walls around the city of Rome.

Although Septimus Severus and his son Caracalla had continued the ambitious building programmes of the Antonines, there was a great change in Roman art which lost its self-confidence. This is seen most clearly in the art of portraiture. The bronze head in the Archaeological Museum in Florence, believed to be a portrait of the emperor Trebonianus Gallus, AD 251–253 (*Ill. 194*), could not be mistaken for a work of the early empire. The style is realistic and the head is firmly modelled with contrast between bone-structure and texture of the flesh; the deeply furrowed forehead and the stubble of

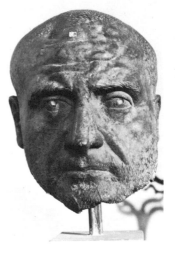

194 Possible portrait of the emperor Trebonianus Gallus, AD 251–253. Bronze 10½" (27). Archaeological Museum, Florence

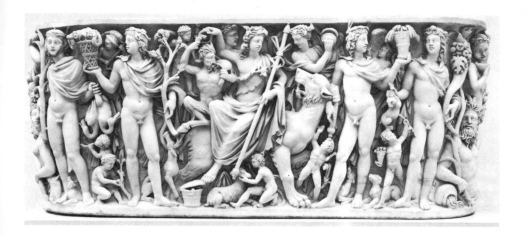

195 The Badminton Sarcophagus:
Bacchus and the Four Seasons, c. AD
220–230. Marble 35½" × 87¾"
(90 × 223). Metropolitan Museum
of Art, New York

hair and beard all contribute to its expressive quality.
But the face is dominated by the large, staring almost
desperate eyes.

The major works of art of this period were funeral
monuments. There had been a change of burial custom
during the 2nd century AD when instead of cremation,
burial in a sarcophagus became increasingly popular.
There were three main types of sarcophagi, Roman,
Attic and Asiatic. The Roman sarcophagi were
decorated on three sides only, and in the 3rd century AD
sarcophagi with rounded ends which were decorated
with figures or animals in high relief, came into fashion.
Attic sarcophagi were manufactured in Greece but
exported to Italy, and their decorations are similar to the
Roman ones except that they cover all four sides. The
Asiatic sarcophagi from Asia Minor usually represented
the deceased reclining on the lid, and instead of a con-
tinuous relief along the sides, the figures are framed by
aediculae, creating a palace peopled by heroes and gods.

Although Greek themes of the battle and the hunt
continued to be used to decorate sarcophagi, the most
popular subjects were connected with the saviour gods
who brought hope of life after death. Bacchus, the
Roman Dionysus, was worshipped as a saviour because
he had given immortal life to Ariadne. Girls were
initiated into the mystery of his cult, and a room was set
aside for his religion in the Villa of Mysteries at Pompeii
(Ills 172, 173). The Badminton Sarcophagus, now in
New York, represents the Triumph of Bacchus (Ill. 195).

The god rides on a panther surrounded by cupids, satyrs and maenads. Alongside him stand four youths, holding symbols of the seasons to suggest the triumph of Bacchus over time.

The figures are densely packed together and there is an almost claustrophobic lack of space in this relief. This new style which rejects spatial relationships first appeared in the imperial monuments of the 2nd century AD, such as Trajan's Column (*Ill. 187*). In the 3rd century it became generally accepted and was discussed in contemporary philosophy. Plotinus (AD 204/5–270) denied the validity of the classical laws of perspective on the grounds that space distorted the appearance of objects to such an extent that one could never obtain true knowledge of an object seen at a distance. Therefore, if an artist is to make a true image he should represent his subject as close to the spectator as possible. According to Plotinus, the aim of the artists was to 'give no bare reproduction of the thing seen but to go back to the Reason-Principles from which Nature itself derives' (*Enneads* V, 8, 1). The problem which faced artists and philosophers in the 3rd century AD was the belief that appearances were completely deceptive. This belief goes back to Plato, who pictured humanity as prisoners bound in a cave so that they could never see the real world of light outside, but only its shadow. According to Plotinus there was so little relationship between the shadow of appearances and reality that there was no point in an artist copying them. Instead, he should create his own image of spiritual reality. Plotinus advocated a selection and intensification of certain important details, but the form and the space in which they exist did not matter.

196 Christian sarcophagus from the church of S. Maria Antiqua, Rome, c. 270. Marble

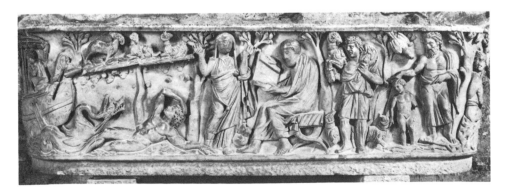

The rejection of the world and the search for spiritual reality led to the growing popularity of a number of mystery religions which offered personal salvation. Among these religions was Christianity. There was no basic difference in form and style between Christian and pagan art in the 3rd century AD, and they often shared the same themes. Grapes were sacred both to Bacchus and Christ, and pastoral themes were also given a Christian interpretation. The figure of the Good Shepherd on a 3rd century sarcophagus in S. Maria Antiqua in Rome (*Ill. 196*) resembles the *Moschophoros* (*Ill. 92*), an Attic farmer carrying his offering of a calf to the temple. Although the forms were similar the meaning was different, for Christ was represented as a shepherd who had saved a lost sheep. This basic theme of salvation, shared alike by pagan and Christian sarcophagi, is developed in the other reliefs on this sarcophagus, which represent the rescue of Jonah. Jonah's escape from the whale's belly was a popular subject because it combined a miraculous salvation taken from the Old Testament with an analogy of Christ's resurrection.

There were no public cemeteries in Rome and people were buried either on their own land or in plots bought from landowners. In the early years of Christianity, Christian burial followed Roman custom except that cremation was never practised. Tombs could be built both above and below ground because the bedrock around Rome is mostly tufa. Long galleries were excavated out of the soft rock and niches were cut for the dead bodies. Larger chambers were also constructed for the burial of entire families, and these were often decorated with paintings imitating contemporary house decorations. The walls and ceilings of the chambers were divided into panels containing figures and decorative motifs.

The subjects of catacomb paintings are similar to those of the sarcophagi, symbolizing the theme of redemption: the Good Shepherd (*Ill. 198*), Daniel in the lions' den, the three children in the furnace, Susanna and the Elders, Jonah and the whale, Moses striking the rock and saving the Israelites from dying of thirst in the wilderness. Favourite subjects from the New Testament were the healing of the Paralytic, the raising of Lazarus, Christ and the woman of Samaria. Salvation through the sacraments was represented in paintings of the baptism of Christ and in still-lifes of bread, wine and fish.

197 Wall painting of Christ as the Good Shepherd over the font in the baptistry at Dura Europus, c. 240

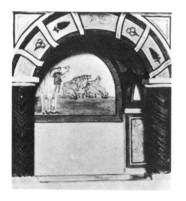

The bread and wine were the elements of the Eucharist and the fish was both the food with which Christ fed the multitude and an anagram in Greek of Christ's name.

We find similar subjects in the earliest known Christian church, in a house built about AD 240 at Dura Europos on the Euphrates in Syria. We know from the Villa of Mysteries in Pompeii that it was a Roman custom to set aside a room for religious purposes (see p. 183) and this custom was continued by the Christians. The house has a central courtyard with the church on the south side, while in the north-west corner there was a baptistry with a font covered by a baldachin. Since baptism was regarded as the death of the old life and rebirth as a Christian, it is not surprising that the decorations of this room have been derived from those of a tomb; the paintings symbolize the redemption of mankind. Above the font, Christ is represented as the Good Shepherd (*Ill. 197*) and errant mankind is indicated by the miniature figures of Adam and Eve.

The Good Shepherd is painted in a flat linear style, standing on a stark groundline without any attempt at landscape setting. This is a revival of the oriental tradition of flat decoration which was not concerned with illusionistic space. It represents a reaction against centuries of Greek influence in Syria and Mesopotamia during the Hellenistic period. Although this was completely independent of the rejection of classical values which was

198 Wall painting from the Cata-comb of S. Sebastiano, Rome, showing Christ as the Good Shepherd, 3rd century. After J. Wilpert, Roma Sotteranea, *1903*

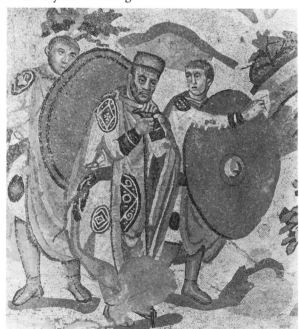

taking place in Roman art in the 2nd and 3rd centuries AD, there is a remarkable resemblance in the two styles which appeared simultaneously at opposite ends of the Roman Empire.

THE REVIVAL OF THE ROMAN EMPIRE AND THE ACCEPTANCE OF CHRISTIANITY

The whole structure of the Roman empire was reorganized by Diocletian (AD 284–305), son of an Illyrian peasant who had risen to power through the army. He co-opted his friend Maximian as joint emperor, and in AD 293 created two Caesars, Constantius Chlorus and Galerius, who were adopted into the deified families of Diocletian and Maximian as their assistants and successors (*Ill. 199*). Maximian and Constantius Chlorus ruled the west and Diocletian, assisted by Galerius, the east. In theory they ruled as colleagues, but in practice the empire was now divided into eastern and western halves. Diocletian made Nicomedia, the capital of Bithynia in Asia Minor, his new eastern administrative centre. Rome had declined so much in political importance that he visited the city only at the very end of his reign.

199 The Four Tetrarchs: Diocletian, Maximian, Constantius Chlorus and Galerius. 3rd–4th century AD. Porphyry, 4′ 3¼″ (130). St Mark's, Venice

200 Probable portrait of the emperor Maximian, detail of the Great Hunt mosaic. Late 3rd century AD. Imperial Villa, Piazza Armerina, Sicily

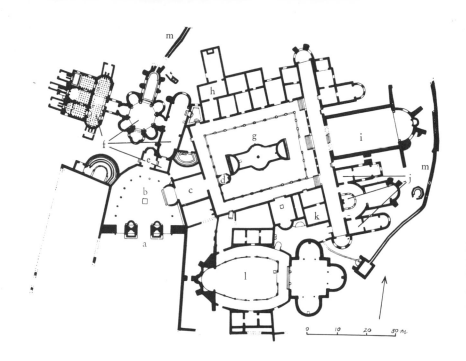

201 Plan of the Imperial Villa, Piazza Armerina, Sicily. Late 3rd century AD. After G. Hanfmann, Roman Art, 1964

With the return of more settled conditions under Diocletian's administration, a lavish building programme was begun. Diocletian built himself a huge fortress palace at Spalatum (Split in modern Yugoslavia) in the plan of a Roman military camp but including the emperor's octagonal mausoleum. In Sicily, a magnificent hunting lodge at Piazza Armerina may have belonged to his colleague Maximian. The different rooms of the palace were arranged according to the basic layout of a Roman atrium house, but the separate buildings were casually grouped together in the manner of Hadrian's Villa at Tivoli (Ill. 201). The palace rooms were grouped around a peristyle and at the far end was a corridor forming a long entrance hall, or narthex, to the basilica in the centre of the east side of the peristyle. This was a hall for official receptions, with an apse at the far end containing a niche for a statue beneath which the throne was placed.

The corridor was covered in mosaic representing Maximian supervising the capture of exotic animals for the circus which was such an important feature of Roman life (Ill. 200). The figures are stiff and formal in their elaborately decorated uniforms and there is no attempt to create a coherent landscape setting.

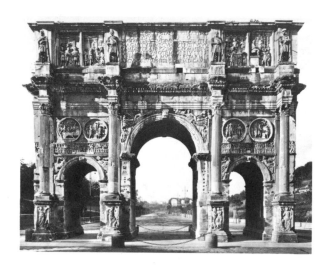

202 Arch of Constantine, Rome, AD 312–315

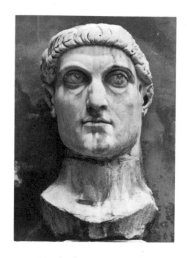

203 Head of Constantine from the colossal statue in the apse of the Basilica Nova, Rome, c. AD 330. Marble, about ten times lifesize. Palazzo dei Conservatori, Rome

In AD 305 Diocletian abdicated and persuaded his partner Maximian to do likewise. But his scheme to ensure the succession of the next emperor broke down in civil war, and Constantine, who had no claim to the throne, seized power in 306 and became ruler of the west in 312.

Constantine celebrated his victory over Maxentius by building a triumphal arch close to the Colosseum in Rome (*Ill. 202*). Its architecture is no different from that of the arches of the 1st century AD, but sculptors were no longer capable of achieving the results the emperor wanted, and earlier relief sculpture had to be re-used. The jambs of the arch are decorated with reliefs commemorating Trajan's victory over the Dacians, and the reliefs in the attic are from a monument of Marcus Aurelius. The eight medallions below the entablature representing hunting and pastoral scenes are Hadrianic. Only the frieze and the winged victories in the spandrels and the captives at the base of the columns, were carved specially for this monument. One is tempted to see this as one of the first examples of 'ready-made' art, for it is a superbly effective structure, incorporating relics of the great emperors which culminate in the long narrow friezes celebrating the principal events in Constantine's victory.

There is a marked contrast in style between the reliefs of the 2nd century AD and those of the reign of Constantine. The frieze to the left of the north side represents

Constantine speaking on the Rostra in the Forum, surrounded by his courtiers and flanked by statues of the emperors Marcus Aurelius and Hadrian (*Ill. 204*). In the background are the Arches of Septimius Severus and Tiberius and the Basilica Julia, all presented on one flat plane, though in reality they stood at right angles to each other. Similarly, the figures in the audience, who in reality would have faced the emperor, all look towards the spectator, for the new style eliminated side and back views. A similar change of style is apparent in portraiture: the colossal figure of Constantine, carved about AD 330 to stand in the apse of his basilica in Rome, gives little idea of his physical appearance (*Ill. 203*). It has become an ikon of the emperor's majesty, expressed by the huge eyes which no longer look at the physical world.

After Constantine had gained control of the west he issued the Edict of Milan which ended the persecution of Christianity, and in AD 325 he called the Council of Nicaea to solve the doctrinal problems of the new religion. With official acceptance the church congregations increased enormously and the old meeting places were no longer sufficient to house them. During the

204 Arch of Constantine, the emperor speaking from the Rostra in the Roman Forum, below, and above, roundels from a Hadrianic monument representing a boar hunt and a sacrifice to Apollo c. AD 124. Marble, diameter of roundel 7′ 7″ (231).

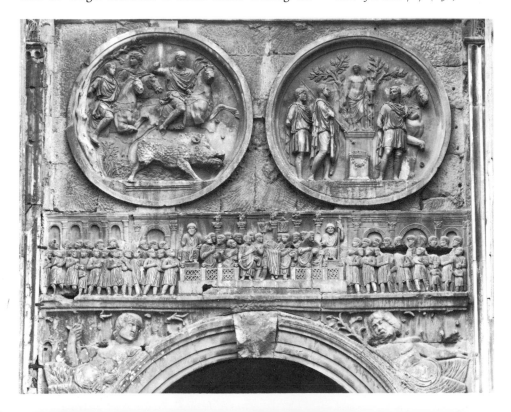

205 *Underground basilica at Porta Maggiore, Rome, mid-1st century AD*

period of persecution Christians had met to celebrate the Eucharist in a room set aside in a private house, as at Dura Europa. They also remembered the anniversary of the death of a martyr by performing the ceremony at his tomb. But these simple buildings were inadequate for the vast new congregations, and in addition the ceremonies had become elaborate rituals requiring special architectural settings.

The new churches commissioned by Constantine in Rome, Bethlehem and Jerusalem were of two types, the basilica and the centralized church. There was, of course, no simple derivation for the early Christian basilica. Roman basilicas were all-purpose buildings, and as early as the 1st century AD one had been adapted to suit the congregation of a mystery religion which met at the underground basilica at Porta Maggiore in Rome (*Ill. 205*). Basilicas were also used as throne rooms, like the one in the late 3rd century imperial villa at Piazza Armerina (*Ill. 201*) which was entered through a narthex, the throne standing in an apse. This was the direct antecedent of the early Christian basilica in which the throne was replaced by an altar (*Ill. 206*).

The centralized church, roofed by a dome, was derived from the circular and octagonal mausolea built for the burial and worship of the emperors. After Theodosius had closed the pagan temples at the end of the 4th century AD, the Mausoleum of Galerius, built by the Tetrarch at the end of the 3rd century as part of his palace in Thessaloniki, was transformed into a church. It was decorated with mosaic on the theme of solar symbolism in which the movements of the planets and the stars are

206 *Plan of St Peter's, Rome, c. 326. After M. Gough,* The Early Christians, *1961*

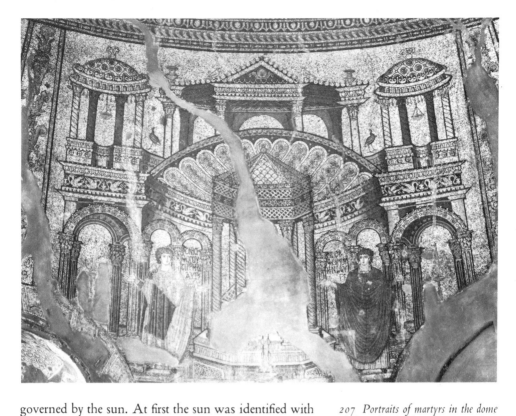

governed by the sun. At first the sun was identified with
the emperor, later with Christ. The dome was divided
into three zones, the lowest filled with architectural decor-
ations reminiscent of the Pompeiian Second Style (see
p. 182), but used here as a background to portraits of
martyrs (*Ill. 207*). Inscriptions give their names and
the dates of the festivals, making it a calendar mosaic in
which time is indicated by saints in heaven instead of the
movement of the stars. In the apex of the dome, above the
temporal zone, is the ascension of Christ derived from
representations of the apotheosis of the emperor, who on
death rises like the sun into heaven. Christ was therefore
represented, like the emperor, as the sun who rules the
revolution of the heavenly bodies which mark the passing
of time. The saints, whose festivals mark the seasons in
the lowest zone, stand before palaces as if the whole of
heaven were one imperial palace.

The architecture and decorations of early Christian
churches were to a very large extent inspired by the
palaces of the Roman emperors. Christ was worshipped

*207 Portraits of martyrs in the dome
of the Church of St George, Thes-
saloniki. Mosaic. Early 5th century*

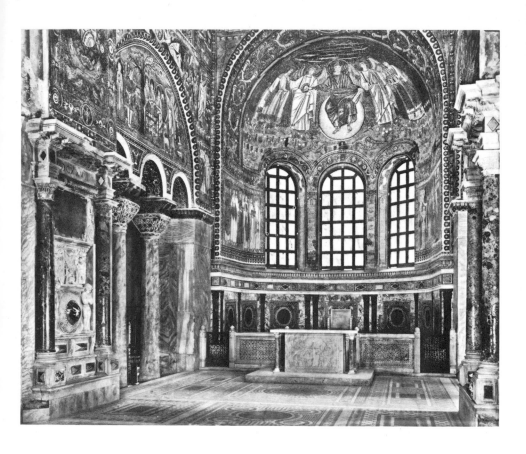

208 *Mosaics in the Church of
S. Vitale, Ravenne, c. 540*

as ruler of the universe but the emperor was His rep⁄
resentative on earth, and so it was natural to transfer the
art and architecture developed for the Roman emperors
to Christ, the supreme ruler.

This image of Christ as emperor culminates in the
sanctuary mosaics in S. Vitale, Ravenna, decorated after
the Byzantine emperor Justinian had reconquered the
city from the Goths in AD 540. In the apse (*Ill. 208*) the
youthful, Apollo⁄like Christ is enthroned on the globe of
the universe flanked by two angels as court attendants. He
receives the church from the archbishop Ecclesius and
gives the crown of martyrdom, an insignia of rank in
heaven, to St Vitalis. The court ceremony continues in
the lower part of the apse where the emperor Justinian
and his wife Theodora present the church with its chalice
and paten.

Two completely different styles existed side by side in early Christian art, and are found even in the same building. One was abstract, little interested in the appearance of the material world, the other continued the illusionist style of Greco-Roman art.

After the Roman empire had been divided, the western capital was finally established in Ravenna, where the emperor Honorius built a mausoleum for his sister Galla Placidia *c.* AD 440. It is a cruciform building roofed with a dome and decorated throughout in mosaic. The lunettes in the side arms are filled with symbolic deer drinking at a pool, illustrating Psalm 42: 'As the hart panteth after the water brooks, so panteth my soul after thee, O God' (*Ill. 210*). The lunette over the doorway represents the Good Shepherd, an illustration of Psalm 23 (*Ill. 211*). The deer are drawn in profile and the dark blue background is filled with an acanthus scroll. The pool is seen in bird's eye perspective from above. In contrast, the Good Shepherd is seated among his flock which is grazing in a rocky landscape with a pale blue sky in the background. Whereas the deer are treated as flat symbols, the Good Shepherd is seated in a landscape which gives the illusion of space.

It is true that the abstract, symbolic style of medieval art was often dominant, but a debased classical style managed to survive. Even after Theodosius had closed the pagan temples at the end of the 4th century AD, artists still continued to represent pagan and mythological subjects. The Symmachus Diptych, an ivory hinged two-leaved writing tablet commissioned to celebrate a wedding *c.* AD 400, represents a priestess sacrificing at an altar of Jupiter (*Ill. 209*). It is a nostalgic work recalling the lyrical naturalism of the Augustan age (*Ill. 183*).

Constantinople, founded by Constantine in AD 330 as his eastern capital, was lavishly decorated with classical

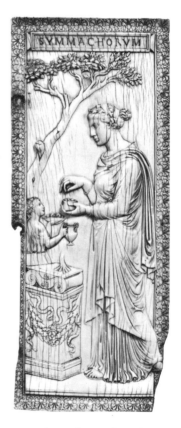

209 A sacrifice at the Altar of Jupiter. Wing of diptych celebrating the marriage of a daughter of Symmachus, c. AD 400. Ivory 11¾" × 5" (30 × 12.5). Victoria and Albert Museum, London

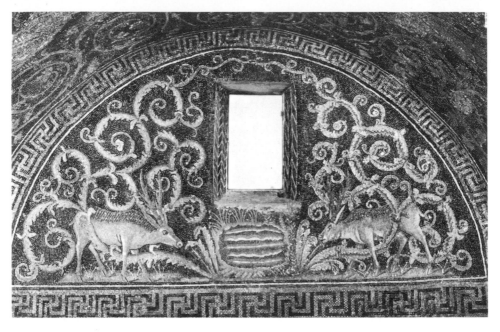

210 'As the hart panteth after the water brooks, so panteth my soul after thee, O God.' Mosaic, c. 440. Mausoleum of Galla Placidia, Ravenna

211 'The Lord is my Shepherd'. Mosaic, c. 440. Mausoleum of Galla Placidia, Ravenna

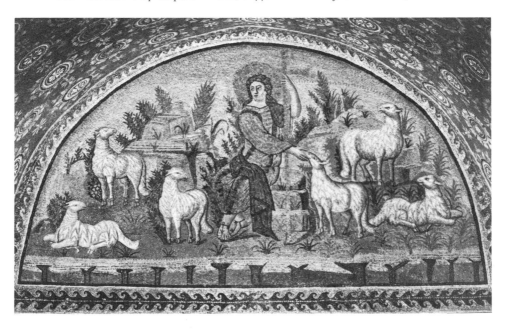

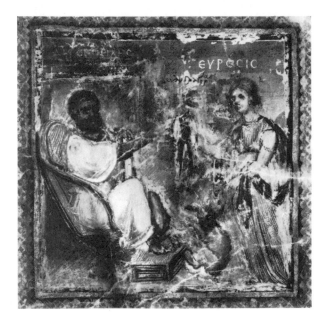

212 *Portrait of Dioscorides, from a manuscript on medicinal herbs, AD 512. illumination on vellum, 21″ × 22″ (53 × 56). National Library, Vienna*

statues from Greece. Homer remained one of the bases of Byzantine education. The imperial library was filled with ancient manuscripts copied in the scriptorium, and many of these must have been illustrated. Even Hellenistic scientific treatises were reproduced, such as the one on medical herbs by Dioscorides, copied for Julia Anicia in AD 512. This contains a portrait of the author, seated in a chair before a personification of Discovery, which is strongly Greco-Roman in style (*Ill. 212*).

Greco-Roman author-portraits, such as the Dioscorides in Vienna, obviously influenced the design of Christian manuscripts, and we find author-portraits of the Evangelists introduced into Gospels from the 6th century onwards. The portrait of Luke, in a 10th century Byzantine Gospel in the library of the monastery of Stavronikita on Mount Athos, clearly shows not just the persistence of this style, but a deliberate revival (*Ill. 213*). Constantinople was a centre of classical revival which lasted until the Turks captured the city in 1453.

It is surprising that there should be any Christian art at all, for representation had been forbidden in the Ten Commandments. 'Thou shalt not make unto thee any graven image, or any likeness of any thing that is in heaven above, or that is in the earth beneath, or that is in

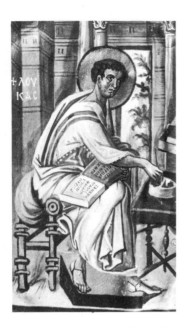

*213 Portrait of Luke the Evangelist,
10th century. Illumination on vellum.
Mount Athos*

the water under the earth' (*Exodus* XX, 4). Yet even the Jews had broken this commandment during the Greek and later the Roman occupation of Palestine and the synagogue at Dura Europos is decorated with illustrations from the Old Testament. Because of the all-pervasive Greek influence at that date no religion could survive without representational art: thus Christian art developed in spite of the Old Testament prohibition.

Most churches contained images of Christ, His Mother and the saints, as well as scenes from the Old and New Testaments. Many of these images were venerated because of the sanctity of their subjects. They were not portraits in the sense of representing the outward appearance of the sacred figure (though many contained an element of physical likeness), but they expressed his true religious nature, sacrificing natural appearances for spiritual reality. This is the type of reality described by Plotinus (see Chapter Fifteen, *p.* 201): 'When Phidias made the Zeus [at Olympia], he did not use any model which could be perceived by the senses but rather he formed a conception of what Zeus would be like if he chose to reveal himself to our eyes' (*Enneads* V, 8, 1). To the Christian artist, the sacred image was an emanation proceeding from the Divine Essence. The sacred figure was spiritually present in his representation.

The veneration of images was dangerously close to paganism and Leo III banned all representational religious art in Constantinople in AD 726. To a certain extent he was influenced by the rise of Islam which strictly obeyed Mohammed's law based upon the Old Testament forbidding representation. But Iconoclasm created such popular ill-feeling in Constantinople and so aroused the enmity of the Church that after more than a century of dispute, in which many men died, it was finally repealed in AD 843. The Iconoclast Byzantine emperors had discovered to their cost that representation is too important and powerful an element in art to be ever completely abandoned.

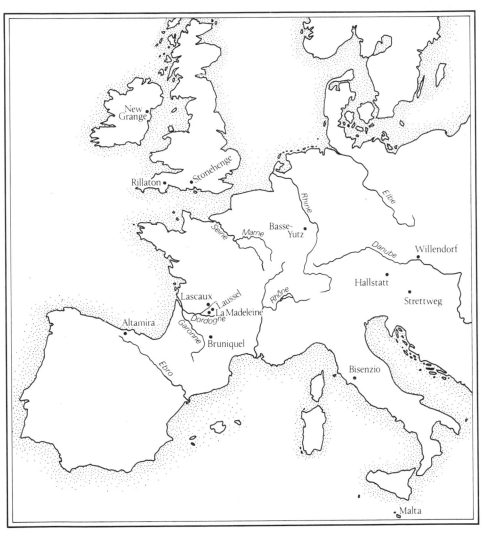

1 *Prehistoric Europe*

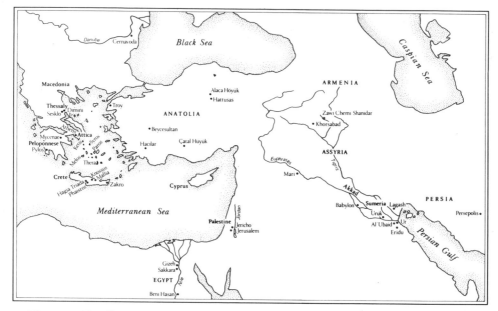

2 *The ancient Near East*

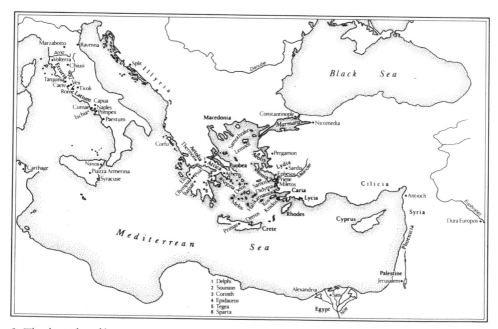

3 *The classical world*

Abacus The upper portion of a capital, usually a square flat slab placed beneath the architrave.

Adytum (-on) The inner sanctuary of a Greek temple.

Aedicule A shrine framed by two columns supporting an entablature and a pediment.

Alabastron Oil vase.

Architrave The lintel carried from the top of one column to the next.

Atrium The inner court or hall of a Roman house surrounded by rooms and lit by a rectangular opening in the roof.

Attic (1) of Athens or Attica e.g. Protoattic – Athenian pottery of the seventh century BC. (2) A storey above the main entablature of a building.

Aurignacian Palaeolithic period represented by remains found in the Aurignac cave of the Pyranees c.30,000–27,000 BC.

Barrow Grave mound.

Basilica (1) Rectangular building used as a public assembly hall in the Roman period, usually divided into three aisles by a double colonnade supporting a clerestory, and with an apse at one or both ends. (2) Form of early Christian church divided into 3 or 5 aisles by colonnades and with an apse at the east end.

Bucranium An ox-head or ox-skull used as a decorative motif.

Capital Head of a column.

Caryatid Sculptured female figure used as a column.

Cavea Auditorium of a Greek theatre.

Cella The main body of a Greek classical temple excluding the peristyle.

Chiton The tunic, short or long, worn by Greek men and women.

Cist A round receptacle for sacred offerings.

Clerestory The upper part of the walls of a basilica, above the aisle roofs, pierced by windows.

Compluvium The rectangular opening in the centre of the roof of the *atrium* of a Roman house.

Contrapposto A position of the body in which the limbs are placed deliberately in opposition to each other in order to produce a subtle twist to the torso.

Corbel A projecting block, usually of stone, supporting another horizontal member.

Cornice A projecting ornamental moulding along the top of a building: the top section of the entablature.

Corona The vertical-faced projection in the upper part of the cornice, above the bed-moulding and below the gutter (sima).

Cubiculum Bedroom.

Dentils A row of small square blocks placed immediately below the cornice of an Ionic temple, imitating beam ends.

Dolmen Megalithic tomb.

Echinus The convex moulding beneath the abacus of a capital imitating the curve of the spheroidal prickly shell of a sea-urchin.

Entablature The superstructure carried by the columns in a Greek temple, i.e. architrave, frieze and cornice.

Entasis A very slight convex curvature in the profile of a column shaft.

Exedra An open recess for sitting in, often containing stone seats. It may be rectangular or semi-circular in plan.

Faience (1) Pottery term derived from the city of Faenza in Italy, used to describe tin-glazed earthenware in general (i.e. with a white opaque glaze). (2) Archaeological term for the glazed quartz frit-ware of the ancient

Egyptians which bears a superficial resemblance to glazed pottery.

Fascia A plain horizontal band on an architrave.

Genre Scenes of every day life.

Gravettian Palaeolithic period represented by remains found in the cave of La Gravette in the Dordogne, sometimes known as the Upper Aurignacian or Perigordian period c.27,000–18,000 BC.

Herm A square pillar surmounted by a head.

Himation A Greek mantle generally of wool.

Hypogeum An underground room or sanctuary.

Interaxial Distance between the centre of one column and the next.

Intercolumniation Distance between the edge of one column and the next.

Jamb The straight side of an archway, doorway or window.

Kore Statue of a girl.

Kouros Statue of a boy.

Krater A vase with a broad body and wide mouth in which wine was mixed with water.

Magdalenian Palaeolithic period represented by remains found at La Madeleine, Dordogne, France c.15,000–8500 BC.

Mastaba Ancient Egyptian tomb with sloping sides and flat roof.

Megalith A large stone used in prehistoric monumental building.

Megaron A rectangular hall with a central hearth entered from an open porch by a single door.

Mesolithic Period in human culture at the end of the Ice Age but before the introduction of agriculture.

Menhir Tall, upright megalithic monumental stone.

Metope Rectangular panel between the triglyphs of a Doric frieze.

Narthex The transverse vestibule of a church.

Neolithic The New Stone Age, period in human culture after the introduction of agriculture but before the development of metal working.

Opisthodomus Porch at the rear of a Greek temple.

Orchestra Circular dancing floor in a Greek theatre.

Ovolo moulding A quarter-round moulding usually decorated with egg-and-tongue.

Palaeolithic The Old Stone Age, period of human culture from the origin of the human species until the end of the Ice Age.

Palaestra Place for athletic training.

Palmette A fan-shaped ornament.

Passage grave A Megalithic grave with an approach passage leading to the burial chamber.

Pediment A low-pitched gable above a portico.

Peplos A woollen garment worn by Greek women fastened on both shoulders.

Peripteral A Greek temple surrounded by a single row of columns.

Peristyle A range of columns surrounding a building or open court.

Pilaster A shallow pier attached to a wall and conforming to one of the Greek orders.

Plinth (1) A square block beneath an Ionic or Corinthian column. (2) The projecting base of a wall.

Porticus Villa A Roman villa with a colonnade along its façade.

Propylaion (propylon) Gate building of a temple.

Propylaea Monumental entrance to the Acropolis of Athens.

Prostyle A porch with columns standing in front of the side walls, not enclosed by them. When the columns stand between the antae of the side walls it is called *in antis*.

Pteron The covered colonnade surrounding a temple.

Rhyton A vase in the shape of an animal's horn or head used for libations.

Shaft grave Burial in a rectangular chamber excavated out of the ground.

Shaman Siberian priest with supernatural power.

Slip Semi-fluid clay for coating or making a pattern on pottery.

Solutrian Palaeolithic period represented by the remains found in the Solutré cave. Saône-et-Loire France *c.*20,000–15,000 BC.

Spandrel Space between the shoulder of an arch and the surrounding rectangular moulding or framework.

Stele Upright stone slab usually used as a gravestone in Greece.

Stoa A covered colonnade with a wall at the back.

Stylobate Platform on which columns of a Greek temple are placed: the top step of this platform.

Tablinum The main reception room of a Roman house opening on to the *atrium* (q.v.) and usually placed opposite the entrance.

Tempera A method of painting where the pigment is mixed with some form of glue or egg yolk.

Tholos A circular building.

Trabeation The post-and-lintel system of construction.

Triclinium Dining room.

Trilithon In megalithic construction a horizontal stone resting upon two upright stones.

Triglyph A rectangular block with two vertical grooves separating the metopes in a Doric frieze.

Volute A spiral scroll.

Ziggurat A Mesopotamian temple-tower built in diminishing stages, each stage being reached by ramps.

Chronology

BC

30,000 Beginning of the Upper Palaeolithic Age in Western Europe.

20,000 Cave paintings at Lascaux *c.*15,000

10,000 End of the 'Ice Age'

9000 Domestication of sheep in northern Mesopotamia. Cultivation of cereals in Palestine

8000 First settlement at Jericho grows into a walled town

7000 Neolithic town at Çatal Hüyük. Development of pottery. Introduction of agriculture into eastern Europe

5000 Use of stamp seals in Mesopotamia. Development of metal working

4000 Beginning of the 'Ubaid period in Mesopotamia. Development of writing in Iran and Mesopotamia. Egypt united into one country *c.* 3100 BC: beginning of the Early Dynastic Period (*c.* 3100–2686)

3000 Foundation of Troy I. Metal working introduced into Greece. First temples built in Malta. Old Kingdom Egypt (*c.* 2686–2258): Pyramids built in the Fourth Dynasty (*c.* 2613–2494). Sargon ruler of Akkad and Sumer 2371–2316

2000 Middle Kingdom in Egypt (*c.* 2134–1786). First palaces built in Crete. Stonehenge begun. Hammurabi king of Babylon 18th century. First grave circles in Mycenae *c.* 1600. New Kingdom Egypt *c.* 1570–1085. Linear B (Mycenaean form of writing) found in Knossos *c.* 1450. Beginning of iron working in Anatolia. Urnfield civilization in Central Europe. Destruction of Mycenae and Tiryns *c.* 1120

1000 Sub-Mycenaean and Protogeometric pottery in Greece

900 Rise of Assyrian power. Geometric pottery in Greece

800 Introduction of the Phoenician alphabet into Greece. First temple of Hera built on the island of Samos. First Olympic Games 776. Epic poems of Homer. Colonization of Italy by Greeks and Etruscans. Celtic (?) warriors buried in the cemetery at Hallstatt. Sargon II (742–705) builds his palace at Khorsabad

700 Assyrian invasion of Egypt defeated 663, and the Babylonians conquer Nineveh 612. Early Doric temple built at Thermon *c.* 640

600 Athenian constitution reformed by Solon 594 and Kleisthenes 507. Development of stone and marble architecture and sculpture in Greece. The Persians capture Babylon 538. Roman Republic founded 510/509

500 War between Greece and Persia 490 and 480–479. Peace with Persia 449. Parthenon begun 447. Peloponnesian War between Athens and Sparta 431–404

400 Celts sack Rome 390. Philip of Macedon gains control of Greece (359–336) and is succeeded by his son, Alexander the Great (336–323). Ptolemy proclaims himself king of Egypt 305

300 Rise of Roman power: alliance with Etruscan cities 280; Wars with Carthage 264–241 and 218–201. Attalos I king of Pergamon 241–197

200 Eumenes II king of Pergamon 197–159. Rome destroys Corinth and Carthage 146. Pergamon becomes a Roman province 129

100 Julius Caesar Roman dictator 49–44. Octavius conquers Egypt 31, proclaimed Augustus and emperor 27

AD

Augustus dies 14. End of the Julio-Claudian dynasty with the suicide of Nero 68. Flavian emperors Vespasian, Titus, Domitian 69–96. Destruction of Pompeii 79

100 The Antonine Age (96–180): Nerva, Trajan, Hadrian, Antoninus Pius, Marcus Aurelius

200 Septimus Severus Roman emperor 193–211. Barbarian invasions of Italy: Aurelian (270–275) builds walls around Rome. Diocletian (284–305) reforms the administration of the Roman empire and persecutes the Christians

300 Constantine Roman emperor 306–337. Edict of Milan legalizing Christianity 313. Council of Nicaea 325. Foundation of Constantinople, capital of the eastern Roman empire, on the site of Byzantion 330

400 Ravenna capital of the western Roman empire. 402–476: fall of the western Roman empire

500 Justinian Roman emperor 527–565. Belisarius reconquers Italy from the Ostrogoths 540.

This is a selection of the most recent publications in English. It does not include articles from periodicals or detailed excavation reports.

I ANCIENT SOURCES

J. J. Pollitt, *The Art of Greece 1400–31 BC* and *The Art of Rome c. 753 BC–AD 337*, Sources and Documents in the History of Art series ed. H. W. Janson, Englewood Cliffs, New Jersey, 1965, 1966; Herodotus, *The Histories*, trans. Aubrey de Selincourt, Harmondsworth 1954; Pausanius, *Guide to Greece*, trans. Peter Levi S. J., Harmondsworth 1971; Caius Plinius Secundus, *The Elder Pliny's Chapters on the History of Art*, ed. K. Jex-Blake, E. Clark, London, New York 1896, Chicago 1968; Vitruvius, *De Architettura Libri X*, trans. M. H. Morgan, Cambridge 1914, New York 1960.

II SURVEYS AND GENERAL ASPECTS OF ART

G. Becatti, *The Art of Ancient Greece and Rome*, trans. London 1968; V. G. Childe, *The Dawn of European Civilization*, 6th ed. London 1957; K. Clark, *The Nude*, London 1956; G. Daniel, *The First Civilizations. The Archaeology of their Origins*, London 1968; W. Fleming, *Arts and Ideas*, 3rd ed. New York 1970; H. Gardner, *Art Through the Ages*, 5th ed., rev. by H. de la Croix and R. Tansey, New York 1970; E. H. Gombrich, *Art and Illusion*, 3rd ed. London 1968; M. Grant ed., *The Birth of Western Civilization*, London 1964; H. W. Janson, *A History of Art*, London 1962; D. Morris, *The Biology of Art*, London 1962; S. Piggott, *D Talbot Rice, A Concise History of Painting from Prehistory to the Thirteenth Century*, London 1967; D. S. Robertson, *A Handbook of Greek and Roman Architecture*, revised ed., Cambridge 1955; M. I. Rostovtzeff, *A History of the Ancient World*, 1925, 1927, reissued as I *Greece*, New York 1963, II *Rome*, New York 1960; G. Sarton, *A History of Science*, vols. I and II, Harvard 1952.

III PREHISTORIC ART

S. Piggott, *Ancient Europe*, Edinburgh 1965; T. G. E. Powell, *Prehistoric Art*, London 1966; N. K. Sandars, *Prehistoric Art in Europe*, Harmondsworth 1968.
Palaeolithic Art P. Graziosi, *Palaeolithic Art*, trans, London 1960; A. Laming, *Lascaux*, Harmondsworth 1959; A. and G. Sieveking, *The Caves of France and Northern Spain. A Guide*, London 1962; P. J. Ucko and A. Rosenfeld, *Palaeolithic Cave Art*, London 1967.
Neolithic and Bronze Age R. Atkinson, *Stonehenge*, Harmondsworth 1960; G. E. Daniel, *The Megalith Builders of Western Europe*, London 1958; J. D. Evans, *Malta*, 1959. *The Prehistoric Antiquities of the Maltese Islands*, London 1971; M. Gimbutas, *Bronze Age Cultures in Central and Eastern Europe*, The Hague 1965; G. S. Hawkins and J. B. White, *Stonehenge Decoded*, New York 1965; S. O'Ríordáin and G. Daniel, *New Grange and the Bend of the Boyne*, London 1964.
Celts and Scythians J. Filip, *Celtic Civilization and its Heritage*, trans. Prague 1962; P. Jacobsthal, *Early Celtic Art*, Oxford 1944; T. G. E. Powell, *The Celts*, London 1958; T. Talbot Rice, *The Scythians*, London 1957.

IV THE NEAR EAST

H. Frankfort, *The Art and Architecture of the Ancient Orient*, Harmondsworth 1954; S. Lloyd, *The Art of the Ancient Near East*, London 1961; J. Mellaart, *Earliest Civilizations of the Near East*, London 1965.
Mesopotamia R. D. Barnett, *Assyrian Palace Reliefs in the British Museum*, London 1970; S. N. Kramer, *The Sumerians*, Chicago 1960; M. E. L. Mallowan, *Early Mesopotamia and Iran*, London 1965; E. Strommenger, *The Art of Mesopotamia*, trans. London 1964.
Syria and Palestine W. F. Albright, *The Archaeology of Palestine*, Harmondsworth 1949; D. Harden, *The Phoenicians*, London 1962; K. M. Kenyon, *Archaeology in the Holy Land*, London 1960.
Egypt C. Aldred, *The Development of Ancient Egyptian Art*, London 1952; British Museum, *Introductory Guide to the Egyptian Collection*, London 1969; I. E. S. Edwards, *The Pyramids of Egypt*, London 1961; A. Mekhitarian, *Egyptian Painting*, Geneva 1954; K. Michaowski, *The Art of Ancient Egypt*, London 1969; W. S. Smith, *The Art and Architecture of Ancient Egypt*, Harmondsworth 1958, *A History of Egyptian Sculpture and Painting in the Old Kingdom*, 2nd ed. 1949.
Asia Minor O. R. Gurney, *The Hittites*, Harmondsworth 1952; E. Akurgal, *The Art of the Hittites*, London 1962; S. Lloyd, *Early Anatolia*, Harmondsworth 1956; J. Mellaart, *Çatal Hüyük. A Neolithic Town in Anatolia*, London 1967.

V THE AEGEAN

P. Demargne, *Aegean Art. The Origins of Greek Art*, trans. London 1964; R. Higgins, *Minoan and Mycenaean Art*, London 1967; S. N. Marinatos and M. Hirmer, *Crete and Mycenae*, London 1960; F. Matz, *Crete and Early Greece*, trans. London 1962; W. S. Smith, *Interconnections in the ancient Near East*, New Haven 1965; E. Vermeule, *Greece in the Bronze Age*, Chicago 1964.
Crete A. J. Evans, *The Palace of Minos at Knossos*, London 1921–35; J. W. Graham, *The Palaces of Crete*, Princeton 1962; R. W. Hutchinson, *Prehistoric Crete*, Harmondsworth 1962; J. D. S. Pendlebury, *The Archaeology of Crete*, London 1939; N. Platon, *Crete*, London 1966.
Troy and Mycenae C. W. Blegen, *Troy and the Trojans*, Princeton 1963; C. W. Blegen and M. Rawson, *A Guide to the Palace of Nestor*, Princeton 1962; V. R. d'A. Desborough, *The Last Mycenaeans and their Successors*, Oxford 1964; G. E. Mylonas, *Ancient Mycenae*, Princeton 1957; H. Schliemann, *Ilios*, London 1880; Lord William Taylour, *The Mycenaeans*, London 1964; M. Ventris and J. Chadwick, *Documents in Mycenaean Greek*, Cambridge 1956; A. J. B. Wace, *Mycenae*, Princeton 1949.

VI GREEK ART

E. Akurgal, *The Birth of Greek Art*, London 1968; J. D. Beazley and B. Ashmole, *Greek Sculpture and Painting*, revised ed. Cambridge 1965; J. Boardman, *Greek Art*, London 1964, *The Greeks Overseas*, Harmondsworth 1964; J. Boardman, J. Dörig, W. Fuchs and M. Hirmer, *Art and Architecture of Ancient Greece*, London 1967; C. M. Bowra, *The Greek Experience*, London 1957; T. J. Dunbabin, *The Greeks and their eastern Neighbours*, 1957, *The Western Greeks*, Oxford 1948; C. M. Havelock, *Hellenistic Art*, London 1971; H. D. F. Kitto, *The Greeks*, Harmondsworth 1951; E. Langlotz and M. Hirmer, *The Art of Magna Graecia*, London 1965; P. Mackendrick, *The Greek Stones Speak*, New York 1962; J. J. Pollitt, *Art and Experience in Classical Greece*, C.U.P. 1972; G. M. A. Richter, *A Handbook of Greek Art*, revised ed. London 1965; C. G. Starr, *The Origins of Greek Civilization*, New

York 1961; B. Schweitzer, *Greek Geometric Art*, trans. London 1971; T. B. L. Webster, *Hellenistic Art*, London 1961.

Greek Architecture, town planning and topography G. E. Bean, *Aegean Turkey*, London 1966; H. Berve, G. Gruben and M. Hirmer, *Greek Temples, Theatres and Shrines*, trans. London 1963; M. Bieber, *The History of the Greek and Roman Theater*, Princeton 1961; R. and K. Cook, *Southern Greece: an Archaeological Guide*, London 1968; W. B. Dinsmore, *The Architecture of Ancient Greece*, London 1950; I. T. Hill, *The Ancient City of Athens*, London 1953; A. W. Lawrence, *Greek Architecture*, Harmondsworth 1957; R. E. Wycherley, *How the Greeks built Cities*, London 1949.

Greek Sculpture B. Ashmole and N. Yalouris, *Olympia: The Sculpture of the Temple of Zeus*, London 1967; M. Bieber, *Sculpture of the Hellenistic Age*, revised ed. New York 1961; C. Bluemel, *Greek Sculptors at Work*, trans. London 1955; R. Carpenter, *Greek Sculpture*, Chicago 1960; J. Charbonneaux, *Greek Bronzes*, trans. London 1962; P. Corbett, *The Sculpture of the Parthenon*, Harmondsworth 1959; F. Johansen, *The Attic Grave Reliefs*, Copenhagen 1951; A. W. Lawrence, *Later Greek Sculpture*, London 1927, *Classical Sculpture*, London 1928; R. Lullies and M. Hirmer, *Greek Sculpture*, London 1960; G. M. A. Richter, *Sculpture and Sculptors of the Greeks*, 4th ed. New Haven 1970, *Three Critical Periods in Greek Sculpture*, Oxford 1951, *Kouroi*, London 1960, *The Archaic Gravestones of Attica*, London 1961, *Korai*, London 1968; B. S. Ridway, *The Severe Style in Greek Sculpture*, Princeton 1970.

Greek Vases and Painting P. E. Arias and M. Hirmer, revised by B. Shefton, *A History of a Thousand Years of Greek Vase Painting*, New York 1961; J. D. Beazley, *Potter and Painter in Ancient Athens*, London 1944, *The Development of Attic Black Figure*, Berkeley 1951; R. M. Cook, *Greek Painted Pottery*, London 1960; A. Lane, *Greek Pottery*, London 1963; E. Pfuhl, trans. J. D. Beazley, *Masterpieces of Greek Drawing and Painting*, 1926, reprinted 1955; G. M. A. Richter, *Attic Red Figure Vases*, New Haven 1958; M. C. Robertson, *Greek Painting*, Geneva 1959.

Greek Coins British Museum, *A Guide to the Principal Coins of the Greeks*, London 1959; P. R. Francke and M. Hirmer, *Greek Coins as Art*, London 1965; C. Seltman, *Greek Coins*, London 1955.

VII ITALY

The Etruscans R. Bloch, *Etruscan Art*, London 1959, *The Etruscans*, London 1958; *Etruscan Culture, Land and People*, Archaeological Research and Studies conducted in San Giovenale and its environs by members of the Swedish Institute in Rome. New York and Malmö, 1962; M. Pallottino, *The Etruscans*, Harmondsworth 1955, *Etruscan Painting*, Geneva 1952; F. Poulsen, *Etruscan Tomb-Paintings, their Subjects and Significance*, Oxford 1922; B. Randall-Maciver, *Villanovans and Early Etruscans*, Oxford 1924; E. H. Richardson, *The Etruscans: their Art and Civilization*, Chicago 1964.

The Romans R. Bloch, *The Origins of Rome*, London 1960; A. Boëthius, *The Golden House of Nero*, Ann Arbor 1960; A. Boëthius and J. B. Ward Perkins, *Etruscan and Roman Architecture*, Harmondsworth 1970; F. E. Brown, *Roman Architecture*, New York 1961; M. Grant, *The World of Rome*, London 1960; G. M. A. Hanfmann, *Roman Art*, Greenwich, Conn. 1964; H. Kähler, *Rome and her Empire*, trans. London 1963; P. W. Lehmann, *Roman Wall Paintings from Boscoreale*, Cambridge 1953; A. Maiuri, *Roman Painting*, Geneva 1953; L. Rossi, *Trajan's Column and the Dacian Wars*, trans. London 1971; D. Strong, *Roman Imperial Sculpture*, London 1961; J. M. C. Toynbee, *The Art of the Romans*, London 1965, *Death and Burial in the Roman World*, London 1971; R. E. M. Wheeler, *Roman Art and Architecture*, London 1964.

VIII LATE ANTIQUE AND EARLY CHRISTIAN ART

D. V. Ainalov, *The Hellenistic Basis of Byzantine Art* (in Russian), St Petersburg 1900–1901, trans. *The Hellenistic Origins of Byzantine Art*, New Brunswick 1961; J. Beckwith, *Early Mediaeval Art*, London 1964; B. Berenson, *The Arch of Constantine, or the Decline of Form*, London 1954; G. Bovini, *Ravenna Mosaics*, London 1957; P. Brown, *The World of Late Antiquity*, London 1971; M. Gough, *The Early Christians*, London 1961; G. M. A. Hanfmann, *The Season Sarcophagus in Dumbarton Oaks*, Cambridge 1951; E. Kitzinger, *Early Mediaeval Art*, London 1940; P. Krautheimer, *Early Christian and Byzantine Architecture*, Harmondsworth 1965; D. Levi, *Antioch Mosaic Pavements*, Princeton 1947; C. R. Morey, *Early Christian Art*, 2nd ed. Princeton 1953; J. Natanson, *Early Christian Ivories*, London 1953; W. Oakshott, *Classical Inspiration in Mediaeval Art*, London 1959; E. Panofsky, *Renaissance and renascences in Western Art*, Stockholm 1960; D. T. Rice, *The Beginnings of Christian Art*, London 1957; M. I. Rostovtzeff, *Dura-Europos and its Art*, Oxford 1938; E. B. Smith, *Architectural Symbolism of Imperial Rome and the Middle Ages*, Princeton 1956; E. H. Swift, *Roman Sources of Christian Art*, New York 1951; W. Volbach, *Early Christian Art*, New York 1961; F. Wickoff, trans. E. Strong, *Roman Art*, London 1900.

Acknowledgments

Aerofilms 62; Alinari-Giraudon 77; American School of Classical Studies 52; Anderson 157–8; Staatliche Museen zu Berlin 149, 152; British Museum 50, 68, 71; Director General, Service des Antiquities, Cairo 20, 21; Oriental Institute, University of Chicago 112; Peter Clayton 25, 28, 185; Walter Drayer 165; ENIT, Rome 189; Fototeca Unione, Rome 187, 205; Alison Frantz 97; Fürböck, Graz 65; Gabinetto Fotografico Nazionale 166; German Archaeological Institute, Athens 2, 72–4, 80, 84, 97; German Archeological Institute, Rome 155, 182, 184; Giraudon 154; Adrian Grant 55; Green Studio 70; Hirmer Verlag 1, 4, 17, 22, 26, 29–30, 37–8, 40, 42, 45, 47, 49, 54, 75–6, 79, 81, 92, 95–6, 99–104, 106, 109–11, 114, 116, 120, 123–4, 127, 132, 135–6, 138, 141–3, 145, 196, 199, 203, 207; Director General of Antiquities, Iraq 17; Irish Tourist Board 60; Photo Kohbroser 105; C. H. Kruger-Moessner 108; Lykides 213; Mansell 67, 93, 115, 117, 147, 153, 160–1, 174, 179–81, 183, 186, 188, 194, 200, 202, 204, 208, 210–11; Bildarchiv Foto Marburg 81; Georgina Masson 164, 176, 193; Leonard von Matt 43; J. V. S. Megaw, Sydney University 69; National Museum, Malta 55, 58–9; National Library, Vienna 212; National Tourist Office of Greece 31, 48, 96; Natural History Museum, Vienna 64; Dr A. Powell 128, 132, 150–1, 172; Josephine Powell 15, 30, 41, 44, 46, 51, 53, 63, 169; Soprintendenza alle Antichita della Campania 113; Soprintendenza alle Antichita, Rome 191; Soprintendenza alle Antichita d'Etruria 166; Eileen Tweedy 173, 178; Vatican Museums 137, 144; Victoria and Albert Museum 209; John Webb 125, 139–40, 148; Roger Wood 23